Architecture:Sculpture

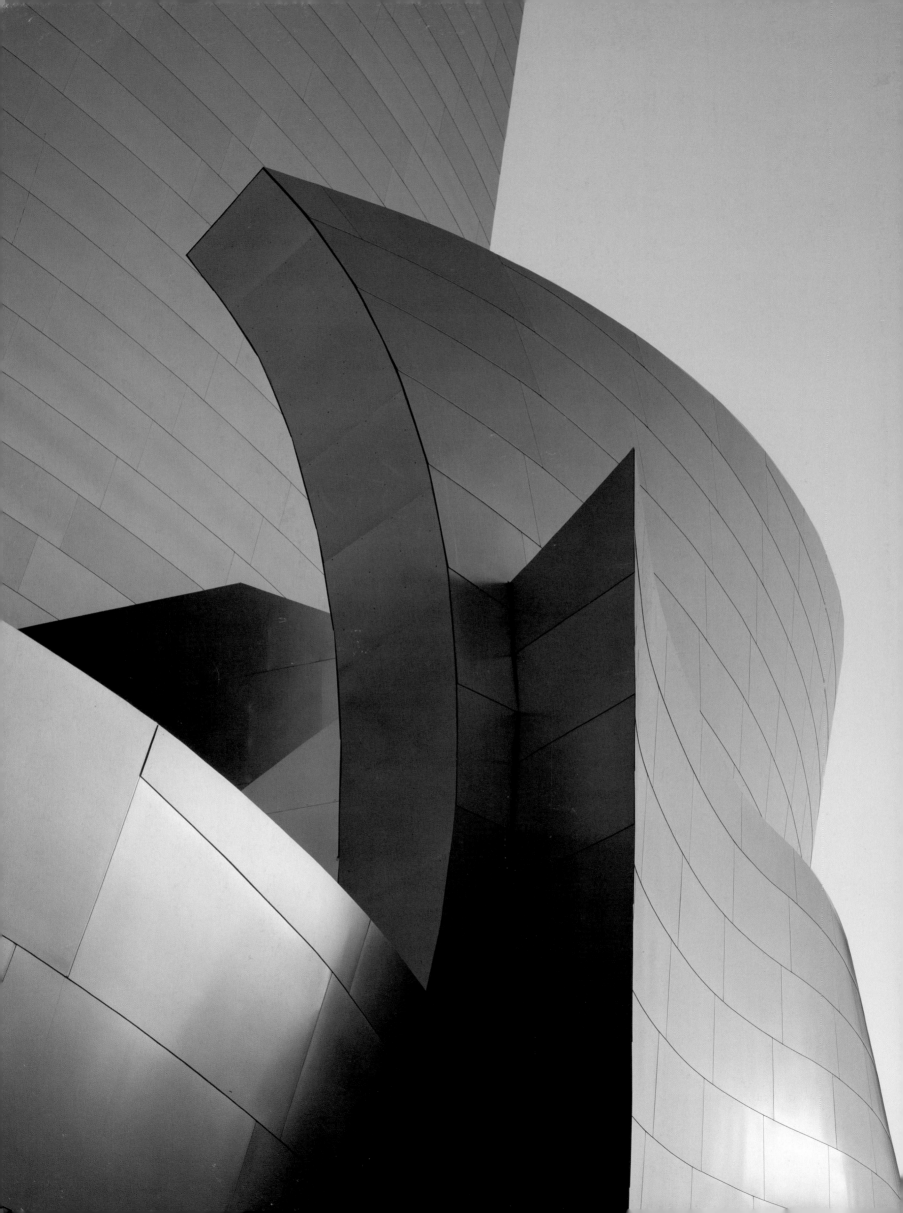

Werner Sewing

Architecture : Sculpture

with contributions by Erik Wegerhoff

Prestel

Munich · Berlin · London · New York

Contents

Architecture as Sculpture:
Staging the Sublime or Architainment?

Werner Sewing

Sculpturality is a property that much architecture possesses, but that does not always have to be the essential aim of the design process. Architecture can be pure sculpture only in a border-line case, for example when, like Adolf Loos, one sees architecture as art only in the building tasks of the tombstone and the memorial. But precisely in these cases, an autonomous architecture threatens to lose its identity. The more powerfully the gesture of the sculptural overpowers the typology and function of architecture, the greater is the danger that the building may achieve an independent move towards pure sculpture: the threat of crossing the boundary between the two genres increases.[1] But the architect only seldom has the sculptor's freedom, as perhaps in the case of the monuments discussed by Loos. Whereas the sculptor is of course dependent on the properties of his materials, the architect is constrained by the content of his programme, the demands of construction, and the cultural codes of the contemporary building culture. Only beyond programme, function and construction can the sculptural play of the liberated form begin.[2]

The fact that building is bound by technical preconditions is one explanation for why sculpturality gained significance as an adversary, as it were, to technoid functionalism only in the modern movement at the end of the nineteenth century. It was precisely the technological innovation of reinforced concrete that not only made industrial building the paradigm for modernism and the *Neue Sachlichkeit* (New Objectivity), but also for the first time offered a design freedom that could release the sculptural potential of structures from their bonds to the iron laws of support and load. Flowing, organic forms now became buildable, and Erich Mendelsohn's Einstein Tower in Potsdam-Babelsberg (1917–1921) is an early testimony to this expressionistic impulse. Conceived as a structure of reinforced concrete whose sculptural curves would symbolise Albert Einstein's theory of relativity, it was executed merely as masonry with some ancillary structure. In view of the limited possibilities of the building trade, such inconsistency was quite common in the early days of modernism, as for example in the Bauhaus buildings in Dessau and Bruno Taut's Hufeisen housing in Berlin. Admittedly pioneer projects in technological engineering, such as Max Berg's monumental Centennial Hall in Breslau of 1913, had long passed the reality test. But only after the Second World War could the technological potential of reinforced concrete, now substantially increased though still not fully matured, enable the sculptural age that was proclaimed in the 1950s.

Nevertheless, what is technically possible must first be intended and imagined. Culturally, socially and psychologically, the sculptural impetus that can be found in architectural history from Babylon right up to the baroque always precedes the question of its technical realisation. Thus, for example, Erich Mendelsohn's early expressionist work, consisting primarily of dynamic architectural fantasies on paper, was influenced as well by the conventionally built brick structures of the expressionist Amsterdam school, or by the powerful stone eruption of the Battle of the Nations memorial in Leipzig by Bruno Schmitz (1898–1913).[3] The latter's massive, almost menacing sculptural effect was attained with traditional materials: rustic, coarse stones for the base and smooth ashlar for the monument itself. It was a work of art, a conservative memorial of Wilhelmine national pride that served as a design model for the architecture of the Einstein

1 Adolf Loos, "Architektur", in *Sämtliche Schriften* (Vienna, 1962), I: 315. The abridged first edition of this lecture was published in 1910.
2 For further differentiation of the concepts compare the seminal contribution to the subject by Klaus Jan Philipp, *ArchitekturSkulptur. Die Geschichte einer fruchtbaren Beziehung* (Stuttgart, 2002).
3 Kathleen James, *Erich Mendelsohn and the architecture of German Modernism* (Cambridge, Mass., 1997). 40.

Tower; although as a laboratory and observatory the latter could not be typologically or functionally classified as a monument, expressively it could quite well be. But this built "will to a monument" (Mendelsohn) was a borderline case. With its somewhat eye-catching symbolism it remained without sequel in the later work of probably the most modern architect of the Weimar Republic.

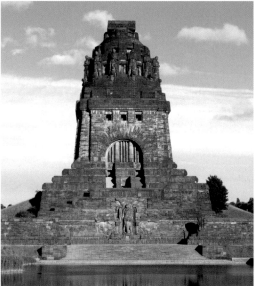 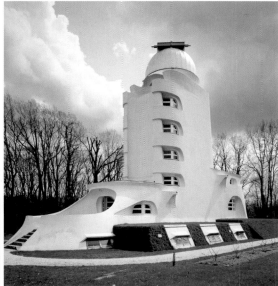

Bruno Schmitz, Battle of the Nations memorial, Leipzig, 1898–1913

Erich Mendelsohn, Einstein Tower, Potsdam, 1920–1924

The Einstein Tower had no great influence on style, but as a unique phenomenon it is thoroughly typical of sculptural architecture. It does not seem meaningful to define sculptural architecture as an independent style; it can be categorised loosely as biomorphic, expressive, organic, or even as a kind of monumental or minimalist rationalism, yet its solitary object-ness, which places it superficially in the vicinity of the monument type, resists any categorisation. It remains autonomous and individual, unique. Sculptural architecture is not an independent genre, nor is it a philosophy. Rather it is the result of a design attitude, a world view or a totally personal idea of form. This attitude elicits from even familiar and conventional building projects a symbolic gesture of heightened presence; it liberates from the narrowness of canon, style or type, but can slip away into subjective arbitrariness just as easily as it can become a hollow gesture. Lacking the support of an established canon, the power of conviction of the "actively radiant structure" (Sigfried Giedion) in sculptural building thus rests solely on the suggestiveness with which it makes clear to the users the appropriateness of its free form in relation to the programme. With every new project, sculptural architecture must create and socially stabilise the fascination that was formerly provided by conventions and the fundamental attitude of expectation, as it were, that accompanied them. Unlike standardised design attitudes, it thus enters into the dialectic of heightened attention and its inflationary deployment.

The forty projects in this volume were chosen and gathered together with the general theme of architecture as sculpture seen from the aspect of an elective affinity in design attitude, rather than membership within a style, let alone a school. They were taken out of other pigeon-holes of architectural theory, and perhaps liberated in the process. For example, Coop Himmelb(l)au and Eric Owen Moss, like, of course, their guiding intellectual force, Peter Eisenman, are considered to be deconstructivists; and even Frank O. Gehry, despite his change of direction towards organic forms as early as the late 1980s, is partly counted a member of this movement. The signal box Auf dem Wolf in Basel by Jacques Herzog and Pierre de Meuron has long been

considered an icon of Swiss minimalism, or could it be "dirty realism"? The somewhat more expressive synagogue in Dresden by Wandel Hoefer Lorch + Hirsch is also committed to a minimalist aesthetic. Aldo Rossi's cemetery in Modena on the other hand is a classic of Italian rationalism, which also includes Botta's chapel in the Ticino. The UFOs in Birmingham and Graz – the Selfridges department store by Future Systems and the Kunsthaus by Peter Cook and Colin Fournier – are again hybrids of sixties pop and nineties blob. The technoid culture machine of the Centre Pompidou by Richard Rogers and Renzo Piano meanwhile stands for a philosophy of High Tech which was still fresh in the early 1970s, whereas José Rafael Moneo and Álvaro Siza Vieira embody the calm continuity of a reduced and lucid modernism transcending fashions.

Each of these buildings can be perceived, even felt, as a sculpture. Sculpturality would seem to be a quality of building that lies, as it were, below established aesthetic codes, and in the narrower sense, below style. In a first approach to the phenomenon this specific repertoire of forms might be defined by the power with which they express their volumes, their physicality and mass: "Their formal concept is the expressive shaping of cubic-sculptural volumes", a definition which must however be expanded to include all imaginable free and organic volumes.[4] If architecture is language, as a sculptural language it exists on the level of a gestural articulation of expression. In contrast to postmodernism, it denies itself the symbolic codification of convention and iconology. Nevertheless as symbolic design it is distinct from a utilitarian understanding of functional architecture, in that it comprehends form as an integrated process in accordance with the organic concept of function of Louis Sullivan's "form follows function".[5]

In this organic sense, sculptural architecture transmits an emotional and atmospheric mood, familiar from the experience of sculpture and plastic art. Its symbolic power is derived from the effect of form and volume, and from materiality, but neither from the semiotics of building and its semantics, as for example in postmodernism, nor from the convention of good taste, as in traditional building. Just as physicality and language are equally methods of human communication, so sculpturality is a structural means of expression, which accompanies, complements or even counteracts a cultural code such as style. Even when a sculptural architecture makes use of an abstract, self-referential language as is the case for example in Peter Eisenman's Wexner Center, or follows a technical-functional rationality like the Centre Pompidou, its effect as sculpture rests on a perceptual process below the level of cognitive reflection, on a mental interaction of two sensual, vital bodies: the human body and the building.[6]

Architecture as anthropo-morphological metaphysics? Indeed, just as all the older theories of architecture, this one too cannot dispense with pre-scientific premises. But unlike rationalism's imbuing of geometry with theology – not only in the case of Palladio, but even in that of Oswald Mathias Ungers – or the naïve metaphor of the classical teaching on proportion, in which the column embodies the standing human being, or, more precisely, embodies man as the measure of building, sculptural architecture makes reference to a thoroughly modern psychological assumption.[7] First formulated by Friedrich Nietzsche, and applied to architecture by the influential art historian Heinrich Wölfflin in his 1886 dissertation *Prolegomena to a Psychology of Architecture*, the perception of building structures can be interpreted as a transfer of human self-perception onto an inanimate object.[8] Both Nietzsche and Wölfflin demonstrate a strong affinity to the lively, dynamic and sculptural restriction of space and form in the baroque. A psychological analysis of this analogy between one's own body and the building, which draws upon Theodor Lipp's theory of empathy, still today remains to be carried out in a scholarly way.[9] The super-historical schematism in Wölfflin's dualistic theory of art (linear versus pictorial, etc.), as well as the danger, present with the concept of analogy, of more or less animistically fictionalising buildings as persons, have always caused this theory to appear suspect.[10] It operates beyond the secure but limited paths of iconology and stylistics. In any case, a number of insights of developmental psychology since Jean Piaget support the basic assumption of a social and

4 Jürgen Pahl, *Architekturtheorie des 20. Jahrhunderts. Zeit-Räume* (Munich, 1999), 62. For Pahl, sculptural architecture is one of five pillars of early modernist architecture, together with functionalism, constructivism, biomorphic and rationalist architecture. I propose, on the other hand, seeking a sculptural design in all directions. Only functionalism for a long time allowed little room for sculptural attitudes, such as the organicism of a Hugo Häring. Not until the mid-1950s was the dam of resistance to burst.
5 David S. Andrew, *Louis Sullivan and the Polemics of Modern Architecture. The Present against the Past* (Urbana, Chicago, 1985), 58 ff.
6 On the many analogies between body and building, see George Dodds and Robert Tavernor (eds.), *Body and Building* (Cambridge, Mass., 2003).
7 A sobering text is George Hersey, *The Lost Meaning of Classical Architecture* (Cambridge, Mass., 1988).
8 Tilmann Buddensieg, "Architecture as Empty Form: Nietzsche and the Art of Building", in Alexandre Kostka and Irving Wohlfarth (eds.), *Nietzsche and an Architecture of our Minds* (Los Angeles, 1999), 267; Karsten Harries, *The Ethical Function of Architecture* (Cambridge, Mass., 1997), 215.
9 Theodor Lipps, *Leitfaden der Psychologie* (Leipzig, 1903), 187ff.
10 Michael Podro, *The Critical Historians of Art* (New Haven, London, 1982), 98ff.

psychological constitution of the object in an early phase of human development. In small children, social interaction precedes the perception of objects as such; objects are thus similarly subjected to the schema of being partners in interaction. The resistance of the object is perceived as pressure actively exercised by a person. Only later does the distinction between animate and inanimate objects come into being.[11]

Understood in this way, architecture mediates itself to the observer as a resistant physical volume. The wall as surface thus comes to be perceived as an expression of depth, of three-dimensionality, of power, of substance – even in the case of a hollow structure. Architecture as sculpture accentuates this volumetric effect inherent in all building in an intensive, often monumental heightening. But sculpturality is not monumental per se, and most monumental structures are not sculptural, but conventional. Nevertheless sculpturality's affinity to the monumental explains the preferred instrumentation of the latter in building programmes and types of building whose declared function is essentially the creation of collective identity and social prestige.

Thus, as can also be seen in most of the projects presented in this book, museums, religious buildings, government and parliament buildings, memorials and concert halls are the preferred contents of sculptural design. Of course sculptural forms can also be used in private houses, such as the T-House in Wilton, New York, by Simon Ungers and Tom Kinslow, or the Möbius-Haus near Amsterdam by UN Studio, and these too are presented in this volume. As with Zaha Hadid's tiny fire station in the Vitra-Komplex in Weil am Rhein, admittedly the independent programmatic or even manifesto-like character in respect to the building task is evident with these objects.

It is this aura of the extra-everyday that explains the outstanding status of many of the projects shown here. Often discredited in the profession as indications of star or show architecture, they enjoy great popularity with the general public. As an exceptional architecture, sculptural architecture rises above the accustomed form and transcends and alienates that which is taken for granted in the built environment. Through its expressive figuration it bundles together freely floating collective energies, or perhaps only the vague need for such. Its symbolic meaningfulness consists in this power of expression, consciously non-specific, and irreducible either historically or functionally. While postmodern images threaten to wear themselves out in their multiplicity, and functionalistic reduction does not adequately challenge the visual power of differentiation, there arises from sculpturality a visual charm of strong immediacy. Thus sculptural architecture cannot be categorised, standardised and reproduced without trivialisation or even ridiculousness. Consumption as architainment and the theme park's appropriation of the forms are the dangers to which a CAD-supported series of designs such as those of "blob" architecture are exposed. The inflation of biomorphic forms since the 1990s threatens to submerge their aesthetic charm and their conceptual productivity.

The Enlightenment and the Aesthetics of Effect: the Eighteenth Century

The fact that, in the current culture of events, sculptural architecture can so easily get caught in the wake of media instrumentalisation, its dangerous proximity to the "economy of attention" (Georg Franck), has its causes in the historical sensibility from which it had already emerged in the eighteenth century and whose basic psychological view even today remains fundamental for the construction of atmospheres.[12] It consists of specifically connecting a body theory of the constructed object with a psychology of perception, which in the Enlightenment was put to the test experimentally as a new constitution of space based on the philosophy of nature. A direct genealogy is nevertheless hardly demonstrable. Not until the early twentieth century would the long-term effect of this revolutionising of space and object psychology become apparent, after the architectural theory of the nineteenth century had lost it from sight through an almost obsessive preoccupation with the semantics of style.

11 Hans Joas, *Die Kreativität des Handelns* (Frankfurt am Main, 1992), 245ff.
12 *Konstruktion von Atmosphären, Daidalos* 68 (1998).

In the eighteenth century the development of the English landscape garden had rendered the perception of space dynamic through the mobilisation of the subjective view, its integration into the dramaturgy of movement. Meanwhile, in France the nearly contemporary architecture of the revolution held fast to the classical central perspective and axial order, but the buildings were becoming solitary, stereometric objects with a new sensuality that was entirely their own. The philosophy of the sublime and its peculiar psychology of the fascinating shudder in the face of nature's endlessness became the common vanishing point of the two innovations, and established a new sensibility for situating the subject in space. This was finally to prepare the way for a sculptural concept of building.

A sculptural sense of space had of course already existed in modern times, in the lively sculptural structures of the baroque, exemplified by Francesco Borromini. Meanwhile, an essential element in the constitution of modernism was the break with baroque and rococo, which had been accomplished by neo-classicism with its return to an idealised antiquity. Architectural theory had thus accomplished two negations, the negation of Gothic through the Renaissance, and on their common foundation, the turning away from the baroque in neo-classicism.

Generally speaking, the beginning of modernism in architecture is seen in the formation of a stereometric language of forms within the neo-classical canon in the second half of the eighteenth century. Primarily responsible for this interpretation was Emil Kaufmann's book that first appeared in 1931 under the title *From Ledoux to Le Corbusier*, and in its subtitle promised to reconstruct the "origin and development of autonomous architecture".[13] Although it was severely criticised in its details of architectural history, and in places considerably corrected, its basic thesis has stood its ground in architectural history. According to Kaufmann, in the architectural visions of Etienne-Louis Boullée and Claude Nicolas Ledoux, a radical reduction of architectural forms to elementary shapes such as the rectangular block, the cube, the cone and, in logical sequence, the sphere had manifested itself. Emil Kaufmann connected this tendency within French neo-classicism, which he referred to as revolution architecture, with the claim that a traditional lineage existed up to the modernism of the twentieth century and its reduction of the architectural object in a way that similarly rested upon stereometric primary structures. His source is Le Corbusier.[14]

The liberation of a body theory of building, moreover, had far-reaching consequences in the eighteenth century for the formal and urban planning application of architecture. Thus revolution architecture explodes the baroque assemblage, as Kaufmann calls it, the subtle hierarchical link, the harmony of structures in a spatial order understandable by all. The individual structures become naked volumes, endowed with the aura of a suggestive lack of standards; style and ornament become superfluous; space is opened up.

Even though the impetus of revolution architecture – which should not be misunderstood as the built expression of the French Revolution – ebbed in the nineteenth century, body theory would again prove itself to be effective in the modernist era; on this point we can follow Kaufmann.[15] As a philosophy of reduction it became a central moving force in the formation of a modern minimalism. As a confirmation of the understanding of architecture as form, in non-material ways it anticipated a victory over the stylistic pluralism that to a great extent characterised the nineteenth century.

What exactly was revolutionary about this theory, if not its political connection, but its effect on the canon of classical building? To answer this question, further recourse to the discourses of the eighteenth century is necessary. Kaufmann's protagonists and their specific achievements become understandable against the background of architectural philosophy in the Royal Academy of Architecture founded in 1671 by Jean-Baptiste Colbert. Joseph Rykwert thus advanced the beginnings of a modern attitude in the 1680s, when a controversy between Claude Perrault and the convention's guardian, Academy President Jacques-François Blondel, had already introduced a break with the teaching of Vitruvius as early as the turn of the seven-

13 Emil Kaufmann, *Von Ledoux bis Le Corbusier. Ursprung und Entwicklung der autonomen Architektur* (Vienna, Leipzig, 1933; unrevised reprint, Stuttgart, 1985). On this discussion compare Georges Teyssot, "Emil Kaufmann and the Architecture of Reason: Klassizismus and Revolutionary Architecture", *Oppositions* 13 (1978): 47–75.

14 In the 1970s Adolf Max Vogt was to identify the Russian constructivists of the 1920s as the actual heirs of Boullée and Ledoux, which would also create a common revolutionary reference, which however is not demonstrable with either Ledoux or Le Corbusier. The thesis is historically even more problematic than that of Kaufmann, but nonetheless enables new insights into the subtexts of the constructivists. See Adolf Max Vogt, *Russische und französische Revolutions-Architektur 1917, 1789* (Cologne, 1974). A positive reception of the thesis is found in the important work of Richard A. Etlin, *Symbolic Space. French Enlightenment Architecture and its Legacy* (Chicago, London, 1994).

15 On the European dimension of this architecture see Winfried Nerdinger, Klaus Jan Philipp, Hans-Peter Schwarz (eds.), *Revolutionsarchitektur. Ein Aspekt der europäischen Architektur um 1800*, exhibition catalogue (Munich, 1990). The introduction by Nerdinger and Philipp is a significant contribution to the clarification of the Kaufman debate and the associated research.

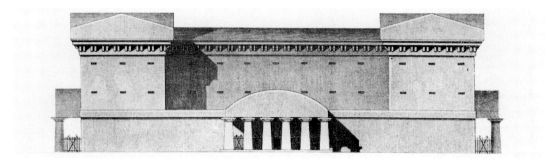

Claude Nicolas Ledoux, view of the prison, Aix-en-Provence, 1786

teenth century.[16] This *Querelle des anciens et des modernes*, rich in consequences for intellectual history, can be interpreted as the beginning of modern progressive thinking. In his *Ordonnance des cinq especes de colonnes selon la methode des anciens* of 1683, Claude Perrault had historicised and thus relativised the ideal, until then absolutely valid, of classical teaching on proportion. Beauty for him was a convention, and thus arbitrary and not an absolute standard and ideal as it was for Vitruvius. It thus became subject to change, and so was relative. But if antiquity was no longer the obligatory ideal, progress in architecture became imaginable. The devaluation of the normative ideal of the classical orders resulted in a liberation of the pictorial aspect of architecture, in which natural forms and exotic architectures as well as new, asymmetrical proportions became legitimate. Meanwhile, with this (in modern terms) social-constructivist dissolution of the architectural canon into social conventions, into taste, the way was cleared for a fashionable equalising. Germain Boffrand countered this tendency with the standard of noble simplicity. But his concept of character, which allocated to structures the task of visually translating both the programme and the profile of the client, also subtly undermines the autonomy of the architect's status. The architect became socially significant as a "man of taste", in that he dominated the values of beauty within the space of social judgements of taste and authenticated them in architectural terms. Once the priest of an ultimately theological concept of order, as he had been since the Renaissance, the architect was now transformed into a virtuoso of courtly and bourgeois society.[17] Perrault was also convinced that in the future only the authority of academies could guarantee the professional standard of architecture.

Whereas with single-point perspective, the Renaissance had both liberated and scientifically banished the subjective viewpoint and thus made it into a calculable resource of the architect, this achievement was socially relativised around 1700. The deistic world view of the Enlightenment, according to which God as creator of nature nevertheless did not intervene in its laws, also freed the human relationship to space from the hold of a theological perspective. This relationship became the object of empirical research into human nature, anthropology and psychology.

The changing aesthetic, which only in the eighteenth century assumed a central position in philosophy, quickly became a psychologically based aesthetics of effect in the sense of sensualism and association theory. French revolution architecture is part of this movement. It repressed the already relativised order of columns of the neo-classical canon in favour of the power of the previously concealed cubic structure, and calculated and presented its effect on the observer. Only now was the potential of geometric primary forms in monumentalising buildings to be fully exploited by abandoning the standards of authority of anthropomorphic columns, so that size could be dramatised as pure form. The affinity of these designs to monumental building tasks allowed so-called revolution architecture to become the spiritual expression of a new understanding of the state, even if, precisely in the case of Boullée, it remained to a great extent architecture on paper. It was no longer the monarchy but the state as the ideal order, as

16 Josef Rykwert, *The First Moderns: The Architecture of the eighteenth Century* (Cambridge, Mass., 1983); on the *Querelle* see Jochen Schlobach, *Zyklentheorie und Epochenmetaphorik* (Munich, 1980).
17 On the general context see Hanno-Walter Kruft, *Geschichte der Architekturtheorie* (Munich, 1991), 144–185.

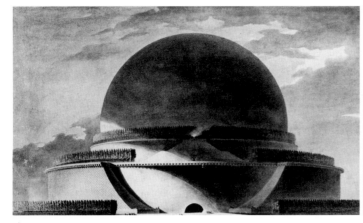 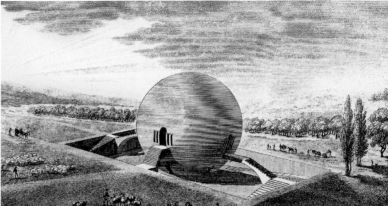

Etienne-Louis Boullée, cenotaph for Sir Isaac Newton, project, c. 1784 Claude Nicolas Ledoux, House of the Tollhouse Keepers, project, 1804

built authority, that was embodied in various characters: in the monument, the prison, the courthouse or the assembly hall. In the character theory of building, then still fairly new, buildings represented social and moral values; Ledoux converted this theory into an associative language of forms for functionally differing building tasks. His house types, including the famous spherical toll houses or the tyre-maker's house resembling a wheel, approach an *architecture parlante*, in which state and civilian society are equally graphically represented.[18] No longer the mercantile corporative state, but the abstract economic functions of the new physiocratic economy are adopted by Ledoux for architectural representation, exemplified by the saltworks at Chaux, designed around 1774.[19] With his concept of *émouvoir*, Boullée adds a new activistic direction to this doctrine of character: architecture must move, create emotions, evoke images in the observer that excite feelings. This purpose is served by the auratisation of monumental stereometric structures, for example in the perfect form of a gigantic sphere in the case of the Newton cenotaph. In the celebration of the new world view, this vision with its presentation of mass parades proved to be an architecture of propaganda. It can therefore be interpreted, not altogether without justification, as the anticipation of an authoritarian age of the masses, which was to delay the reception of Boullée until after 1945.

The liberation of body theory by connecting it to an aesthetics of effect made this radicalisation of neo-classicism into a source for sculptural building. Boullée clearly aimed the monumental presentation of structures at creating specific atmospheres. Architecture represents the order of the cosmos, of the new world view, in an auratised, sublime and monumental gesture. As a result the reference to nature assumes the place of God, the state draws its power from its laws. As nature set to work, architecture lends the appearance of the extra-everyday to built monuments. Thus the gigantic sphere of Boullée's Newton cenotaph creates the suggestion of the infinity of the firmament. The recognition, at that time revolutionary, of this new infinity, of *immensité*, was orchestrated by the aesthetics of effect into an almost religious gesture. For the building task of the basilica Boullée again demands the character of greatness: "The image of greatness has such power over our senses that even the idea that it is terrible still arouses in us a feeling of wonder."[20] Boullée illustrates his sensation of "terrible beauty" with the examples of a spewing volcano, of a man at the mercy of the high seas, and the experience of an abyss and of infinity during a balloon trip. All these examples illustrate the aesthetic category, current from at least the mid-eighteenth century, of the sublime, *le sublime*.

It is this connection that now directs our attention to a parallel current in the Enlightenment. In England the new sensibility of an empirical perception of nature had experienced a different accentuation, which equally, but much earlier, assisted the new aesthetics of effect. Above all, the sublime became a new central category in the reconstruction of modern space, which however was understood predominantly as landscape space, as culturally recoded nature.[21]

18 Michel Gallet, *Ledoux* (Stuttgart, 1983).

19 Anthony Vidler, *The Writing of the Walls* (London, 1987), 35ff.; Bernhard Klein, *Die physiokratische Verlandschaftung der Stadt um 1800* (Munich, 1993).

20 Beat Wyss (ed.), *Architektur. Abhandlung über die Kunst*, introduction and commentary by Adolf Max Vogt (Zurich, 1987), 75. Boullée's work *Architecture, essai sur l'art*, was not discovered until 1933.

21 On the general context see the outstanding interpretation by the literary studies expert Hans von Trotha, *Angenehme Empfindungen* (Munich, 1999); on the landscape garden compare Hanno-Walter Kruft, *A History of Architectural Theory* (London, 1994); John Dixon Hunt and Peter Willis, *The Genius of the Place. The English Landscape Garden 1620–1820* (London, 1975); Adrian von Buttlar, *Der Landschaftsgarten* (Munich 1980); Valentin Hammerschmidt and Joachim Wilke, *Die Entdeckung der Landschaft. Englische Gärten des 18. Jahrhunderts* (Stuttgart, 1990)

French neo-classicism remained embedded in the state metaphysics of rationalist absolutism, which was to be heightened even further by the Revolution, by becoming merged with nation and people. But the English movement had a completely different political and cultural context. As idealised by Montesquieu in the famous tenth chapter of his *Défense de l'esprit des lois* (*The Spirit of the Laws*), England already possessed a division of powers in which the parliamentary taming of the royal court was balanced by the decentralised rule of a country-based aristocracy and an urban elite. Since the revolutions against the Stuarts in the seventeenth century, an ideal of *étatisme* had held no attraction; thus for example Lord Shaftesbury, one of the leading moralists and aesthetes of the early eighteenth century, from this point of view also devalued the baroque geometry of the park of the Palace of Versailles as an expression of absolute monarchy.[22]

Aesthetics was regarded as the expression of the social-moral constitution of society, "moral philosophy". The English culture of "court and country" opposed the axial-symmetrical shaping of space in French absolutism with a free, decentralising and irregular dissolution of space modelled on and idealising nature, as well as its recentring through a multiplicity of viewing relationships, whose centre was the free subject who appropriated nature to himself as an aesthetic pleasure. This Enlightenment ideal from the seventeenth century brought about a new view of landscape in the course of the eighteenth century. As a picturesque new creation of nature after nature, the Arcadian myth of classical antiquity now became a realisable utopia. As a genuinely modern view, the "picturesque", as the modern subject's new image of space, was freed from its association with the ideal of the "English gentleman" and universalised. It acquired the character of a model throughout Europe. As a normative, moral-aesthetic image, the landscape garden now entered into competition with the image of the old city.

Admittedly French revolution architecture was also part of a tendency towards the dissolution of the compact city of the Middle Ages, which had not essentially changed even in the early modern period. But the neo-classical concept of space held fast to the axial geometrising, charting and classification of landscape and city space that absolutism had forced upon the old city after the start of the Renaissance.[23] It did not change the subjective view, or found any new sensibility. Even the radical transformation of Paris in the mid-nineteenth century under Baron Haussmann was still to follow the geometric patterns of the baroque garden.

England on the other hand already had a vision of space in the eighteenth century, in which city and structure had always been seen as parts of a comprehensive image of aesthetic landscape. The new urban designs of Bath or Edinburgh's New Town were already attempting to merge landscape and cityscape.[24] Thus the roots of the garden city movement of around 1900 are already to be found in the English landscape garden, which in this way became a source of modern city building.

But how do the aesthetics of the landscape garden contribute to the formation of a sculptural architecture? In English architecture, with its special historical diversion down the path of Palladianism, typified by Inigo Jones, a more closed cubic concept of the building structure had already been cultivated since about the seventeenth century. The comparatively less ornamented Georgian Renaissance of the eighteenth century was a further sober interpretation of the neo-classical canon. Monumentalisation, however, was conceivable only within narrow limits in view of the lack of the large building projects found under *étatisme*.

In England, more important than architecture was the new landscape construction; this introduced a new tension-filled topography into the landscape garden, in which free-standing solitaires, mediated through viewing relationships, open up the symbolic space of an enlightened view of life. The placement of free-standing solitary structures, whether a Palladian palace, a rocky fragment and a Gothicising ruin as tokens of the sublime, a small antique temple or a tree presented as sculpture, enables the perception of multiple perspectives through movement. The structures are stylised almost as isolated monuments, at their core as sculptures. A

22 Hanno-Walter Kruft, *A History of Architectural Theory*.
23 It is from this logic that the closeness to power of neo-classicism is derived. See Josef A. Schmoll gen. Eisenwerth, *Epochengrenzen und Kontinuität. Studien zur Kunstgeschichte* (Munich, 1985), 26.
24 Mark Girouard, *The English Town* (New Haven, London, 1990).

curved, lively, and thus "natural" system of paths completed the break with the axial principle of central perspective and established the idea of free space for movement. As a vision of flowing space this concept was to be taken up again in the modernism of the twentieth century.

France and England went different ways also in their architectural and spatial versions of the sublime, even if their general ideas of the concept did not differ. While Boullée wanted to show the sublime to its best advantage in the proportionless greatness of the built object, English empiricism made use of that very idea of nature from which the concept of the sublime had been taken in the aesthetics of the eighteenth century. In a long movement of thought stretching back into the seventeenth century, the frightening, fear-inducing experiences of nature – for example of a gigantic mountain massif or the infinity of the ocean – which threw the individual completely back on himself, were reinterpreted in a physical-theological sense. Originally understood as an offence against divine order, from the end of the seventeenth century they became increasingly transformed into spaces of experience, in which terror and shuddering – for example at the sight of the Alps during the grand tour made by English gentlemen – could become a pleasant sensation. The sublime thus became, alongside the beautiful, a second and equally important instance of the aesthetic.

Landscape gardens, in their staging of the picturesque beside the classical beauty of nature, could now also represent the frisson of ruins, rocks, waterfalls or even fire-spewing volcanoes. The landscape with ruins, formerly used only as a mythological example with the intention of pedagogic effect, now evoked a particular kind of temporalisation of space; the structure in decay, in transition, in its reversion to nature, allows architecture to take on almost organic qualities, leading it back into the cycle of arising and falling away that takes place within nature. Beside the power of nature, the charging of Gothic architecture with the aesthetics of decay, but above all its presentation as a ruin, became one of the instances of the sublime. The neo-Gothicism of the nineteenth century, with its play between divine light and worldly shadow on the border of the uncanny, had its precursor here. The expressionist impulse in sculptural architecture, so decisive for the twentieth century, took the neo-Gothic as a source of inspiration for its utopia of a built spiritual community. It was not the volumetric body theory, but the moving body, the free individual in space and the temporalising of the built structure in the ruin that constituted new modes of perception. First among these was an aesthetics of a free, organic sculpturality that abandons the idea, enshrined in neo-classicism, of a stereometric corporeality. It is these two sensibilities or metaphysics that have defined the intellectual horizon of sculptural architecture up to the present day.

"Shell and Kernel of Style": the Nineteenth Century

It is tempting, following Emil Kaufmann's example, to jump from here directly to the early twentieth century, from Ledoux to Le Corbusier, or from the Gothic ruin in the park to the cathedral of light in the expressionism of a Bruno Taut or a Paul Scheerbarth. For not until this time of cul-

Gothic ruins of Fountains Abbey in the garden at Studley, a country house in Yorkshire, England, engraving by Anthony Walker, 1758

tural upheaval, before and then again after the First World War, would an ultimately spiritually based architecture of the sublime as sculpture emerge from the contact of body theory with the impulse to an aesthetics of effect. As an almost cultic exception within the secular architecture of modernism, this above all would occupy the vacant place of the collective creation of meaning. But this recent architectural invocation of the sublime was imaginable only against the background of an experience of crisis, in which the shocking insight into the death of God, announced by Nietzsche in a far from triumphal spirit, was to find expression in a romantically inspired artists' religion. Taking shape as late as the end of the nineteenth century, predominantly in the German-speaking countries, this idealistic theory of culture and art held promise of a new spirituality.

This experience of crisis was as yet unknown to the nineteenth century, but nevertheless the loss of the classical conventions of old Europe was one of its constituent experiences. The romantic movement was the beginning of an intellectual reworking of the upheaval in post-revolutionary Europe, and could thus serve as a paradigm for artists' diagnosis of crisis a hundred years later. About 1800 the subjectifying of the constitution of the senses became a basic experience, which subtly devalued the classical concept of order. In architecture, however, the classical canon seemed to remain unchallenged until well into the 1830s. Revolution architecture did find a few supporters, such as, in Berlin, the very promising young architect Friedrich Gilly.[25] His spiritual heir, Karl Friedrich Schinkel, was not however to follow his vision of a released stereometry, but found his way to a poetically romantic synthesis of neo-classicism and Gothic. Thus Schinkel became one of the protagonists of the stylistic polyphony of the nineteenth century. By way of the appropriation of historical dimensions of depth, this era of historicist sensibilities led not only to a flowering of the new art history, but overlaid the theory of architecture with semantic references.[26] Architecture was more a language than ever before, and the concept of style, which was only now to acquire its present-day connotation, became the key to understanding architecture.[27]

Style was considered a language in which an identity was to be created, from the individual building task to the public expression of political, national or religious values. But with the pluralisation of styles, the coexistence of neo-Gothic railway stations and churches, town halls in Renaissance style and parliament buildings as Greek temples, architecture threatened to disappear visibly behind the visual programmes. This crisis, which began to be defined as early as the mid-nineteenth century on the occasion of the construction of the Ringstraße in Vienna, was to lead towards the end of the century to a new liberation of stereometry from the confines of historicism. Only now could the impetus of revolution architecture be restored.

Meanwhile, in parallel to the debate on style, a theory oriented towards the interior logic of the architectural task and its appropriate constructive expression had gained ground. Often interpreted as organic philosophy, function and construction here became the central theme of architectural expression.[28] Karl Bötticher and Gottfried Semper were the most prominent representatives of this position, but many of the protagonists of style founded their aesthetic preferences on the logic of construction, for example Viollet-le-Duc in the case of the neo-Gothic. Between technical functionality and historical semantics, the impetus of a body theory was to grind to a halt for a long time.

The partial triumphant progress of the neo-Gothic within historicism is an indication of the rehabilitation, in the English tradition, of ideas considered to be medieval.[29] In the nineteenth century this tradition of "medievalism" became a powerful antithesis to the equally dominant canon of the École des Beaux Arts. The romantic movement too had once again lent meaning to the medieval image of order, and at the same time linked it to a genuinely modern concept of subjectivity. Its organic philosophy of a spiritual community of individuals became a congenial identity figure for later artistic cultures. It was the romantic movement which transformed the pleasant frisson of the sublime into a modern sensibility of shock. The paintings of Caspar

25 Berlin-Museum (ed.), *Friedrich Gilly 1772–1800 und die Privatgesellschaft junger Architekten*, exhibition catalogue (Berlin, 1984).
26 Heinz Gollwitzer, "Zum Fragenkreis Architekturhistorismus und politische Ideologie", *Zeitschrift für Kunstgeschichte* 42 (1979): 1–14.
27 Jan Bialostocki, *Stil und Ikonographie* (Dresden, 1966).
28 Caroline von Eck, *Organicism in nineteenth-century architecture* (Amsterdam, 1994).
29 Georg Germann, *Neugotik, Geschichte ihrer Architekturtheorie* (Stuttgart, 1972); Michael W. Brooks, *John Ruskin and Victorian Architecture* (London, 1989).

David Friedrich acquire new qualities of mood from the sea, the mountain peaks, and the broken pillars of Gothic ruins. In the course of this new loading of the sublime, a subtle heroic transformation takes place. The self-assertion of human beings in the face of nature's power moves into the foreground, and the observer of mountains becomes their conqueror, the Alpinist. Bourgeois society's new aesthetics of achievement transforms the sublime into a continual challenge.

Precisely because of its preoccupation with the sublime – the numinous quality that threw the individual back upon himself, and that often seemed difficult to distinguish from the uncanny – did romanticism succeed in translating the Renaissance idea of genius into a heroic image of the artist, to which Nietzsche's later vision of the superman could refer.[30] In Nietzsche's interpretation the sublime became a domain of the artist as leader, an offer of identity that was to characterise a generation of modern artists.[31]

In the face of this, quotations of the sublime in landscape gardens became meaningless. The English ideal of a picturesque city-country continuum, after also conquering the USA in the mid-nineteenth century, became a moral-aesthetic answer to the devastation wrought by the factory system. In this picturesque anticipation of suburbia and garden city the fear of the sublime no longer had a place, while the Moloch of the Victorian industrial town mutated in literature to the symbol of a human mountain, to a modern place of horror.[32]

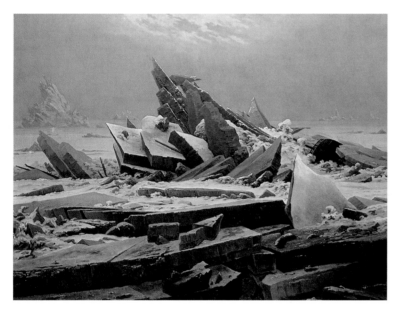

Caspar David Friedrich, *The Sea of Ice*, 1823–1824

Monumentality or Community? Architecture-Sculpture and Early Modernism

Germany was the straggler in industrial development, and so the critique of the modern city, the discomfort with historicist architecture and the new identity of the artist did not culminate until around 1900. The radicality with which a modern architecture was being articulated precisely in central Europe is probably connected with this delay in modernisation, in particular with the great powers of Germany and the Habsburg Empire. In England and the USA, the new building tasks during the phase of high industrialisation and the modern national state, matched by a new monumentality world-wide, were cast moderately in the historic languages of form.[33] But meanwhile in central Europe the new mass society and the theme of national identity acted as catalysts in the formation of a genuinely new, modern architecture. This response to the search for a new style that began around the late 1880s was modern in the sense that it pushed historicism aside with a pointedly forced emotionalism of the functional, and reclaimed modern society's imperative for a new "style of life" (Georg Simmel).[34]

30 Edgar Zilsel, *Die Entstehung des Geniebegriffs* (Tübingen, 1926); Jochen Schmidt, *Die Geschichte des Geniegedankens in der deutschen Literatur, Philosophie und Politik, 1750–1945*, 2 vols., (Darmstadt, 1985).
31 Christine Preis (ed.), *Das Erhabene: zwischen Grenzerfahrung und Größenwahn* (Weinheim, 1989); Dietrich Schubert, "Nietzsche – Konkretionsformen in der bildenden Kunst 1890–1933", *Nietzsche-Studien* 10/11 (1981-82): 278–317. See also the brilliant general summary of this inheritance within early modernism by Beat Wyss, *Der Wille zur Kunst* (Cologne, 1996).
32 Iain Boyd Whyte, "The Expressionist Sublime", in Timothy Benson (ed.), *Expressionist Utopias. Paradise, Metropolis, Architectural Fantasy* (Berkeley, 2001), 125.
33 Barbara Miller Lane, "Changing Attitudes to Monumentality: An Interpretation of European Architecture and Urban Form 1880–1914", in Ingrid Hammarström and Thomas Hall (eds.), *Growth and Transformation of the Modern City* (Stockholm, 1979), 101–114.
34 Characteristic of this attitude is Walter Curt Behrendt, *Der Kampf um den Stil in Kunstgewerbe und Architektur* (Stuttgart, 1920).

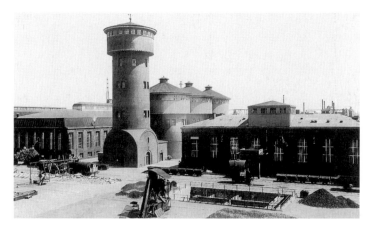

Peter Behrens, Gasworks, Frankfurt am Main, 1910–1911

Around 1900 there were indeed international tendencies in which all developed countries took part: neo-classicism, which reached its high point about 1910, neo-baroque, a neo-Gothic tendency visibly restricted to religious building, and the only new style, art nouveau or *Jugendstil*, at which, apart from Charles Rennie Mackintosh and Antoni Gaudí, Peter Behrens and Otto Wagner at times also tried their hands. Its stagnation as mere décor led to its speedy decline even though, as a rehabilitation of nature as an inspiration for free forms, it would significantly facilitate later expressionism. It was precisely in the western democracies, particularly England and the USA, but also Scandinavia, that a radical push towards innovation in architecture did not seem to be necessary.

In the German-speaking regions, but also in the Netherlands and to some extent in France and Italy, below the cosmopolitan, bourgeois consensus there lay a noticeable search for continuing innovation. The tendency towards functionalism, which had become visible in the work of Wagner in Vienna and Behrens in Berlin, had as its vanishing point the very aim that the revolution architects had already striven after more than a hundred years ago: the liberation of clear stereometric structures and their sculptural accentuation. Taking the discussion in Austria as his main example, Werner Oechslin has described this process using the formula of the Viennese Josef Bayer of 1886, *Stilhülse und Kern* (style: shell and kernel).[35] The shell of style of historicism was successively discarded in favour of the architectural kernel, and replaced by an increasingly reduced ornamentation (even though the logical step towards abolition of ornament, to the naked structure, in Viennese modernism was executed by Adolf Loos alone).[36] The comparison with French revolution architecture is founded not on some reference of Viennese architecture to French neo-classicism – a revolution architecture was after all "invented" only in the 1930s by the Viennese Emil Kaufmann – but on both tendencies' shared affinity, founded on consistency and logic, to criticise style or column order as a mere shell, and instead to seek the essence of building in volumetrics. Oechslin accurately refers to Austrian modernism as an "evolutionary path" to modern architecture. In the parallel German development, historical proximity to the sensibility of the time around 1800 was more consciously perceived, or rather constructed. Friedrich Gilly, probably the most consistent disciple of French revolution architecture, Schinkel (in his classical, not his romantic manifestation) and the spare sobriety of Biedermeier secular architecture are now considered as the historic legitimisation of a new functionality. The period of Goethe serves as a comparable era.[37] But only the subsequent generation was to draw more far-reaching conclusions from this. In specifically German monumental art, a more expressive, thoroughly disturbing gestural language of forms established itself, which pointed to a new activistic and vitalistic mentality. That the large forms of modern society were suited to monumental enhancement was already recognised elsewhere. Thus the round arch style of the American star architect Henry Hobson Richardson made deliberate use of the massive Romanesque language of forms in order to elevate his large structures into mountain sculptures by means of a rough materiality. The art nouveau architect Charles Rennie Mackintosh set a sculptural gesture – the defensive stone library tower – against the finely profiled, extensively glazed window frontage of his Glasgow School of Art (1908). The pioneer of the proto-

35 Werner Oechslin, *Stilhülse und Kern. Otto Wagner, Adolf Loos und der evolutionäre Weg zur modernen Architektur* (Zurich, 1994).
36 Alfred Pfabigan (ed.), *Ornament und Askese im Zeitgeist des Wien der Jahrhundertwende* (Vienna, 1985).
37 Stanford Anderson, "The Legacy of German Neoclassicism and Biedermeier: Behrens, Tessenow, Loos, and Mies", *Assemblage* 15 (1991): 63–87.

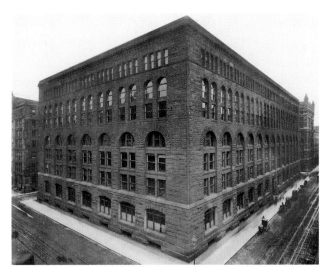

Henry Hobson Richardson, Marshall Field warehouse store, Chicago,
1885–1887

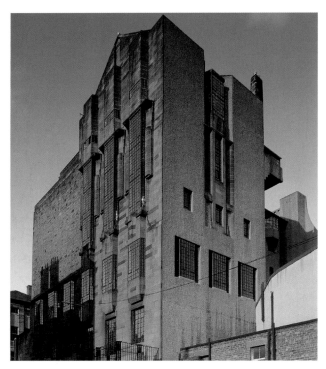

Charles Rennie Mackintosh, Glasgow School of Art, view of the library wing,
1908

modern, Frank Lloyd Wright, also succeeded in heightening an emotionally austere cube in monumental fashion with his Larkin Building in Buffalo of 1904.

In Germany however this tendency was taken considerably further. Above all in the multiplicity of patriotic memorials, in particular the ubiquitous Bismarck monuments, and in the outsize memorials on the Kyffhäuser Berg in Thuringia for Emperor Wilhelm (1889–1896) and the Battle of the Nations memorial near Leipzig (1898–1913), both by Bruno Schmitz, a heightened architectural nostalgia for the sublime was being articulated. Schmitz, who had practised architecture for several years in the USA and was there influenced by the rough aesthetics of Richardson's Romanesque style, transforms the gigantic sculptures of uncut stone, the interiors dramatised in the form of caves, into the almost religious structures of a heathen cult of the dead.[38] A similar dramatisation is found in the neo-baroque law-court buildings in Berlin of about 1900, whose opulent stairwells, in their playing with light and shadow, resemble Piranesian underworlds. Their upwards movement with its constantly new perspectives creates that

38 Peter Hutter, *Die feinste
Barbarei. Das Völkerschlacht-
denkmal bei Leipzig* (Mainz,
1990).

39 Richard Hamann and Jost Hermand, *Stilkunst um 1900* (Munich, 1973), 348 ff.; Julius Posener, *Berlin auf dem Wege zu einer neuen Architektur. Das Zeitalter Wilhelms II* (Munich, 1979), 81ff.

40 Beat Wyss, *Der Wille zur Kunst* (Cologne, 1996), 123.

41 The conservative continuity however persisted into the Weimar period, although in a more disciplined and restrained manner. See for example Frank-Bertolt Raith, *Der heroische Stil. Studien zu Architektur am Ende der Weimarer Republik* (Berlin, 1997).

42 Wolfgang Pehnt, *Die Architektur des Expressionismus* (Stuttgart, 1973); Iain Boyd Whyte, *Bruno Taut. Baumeister einer neuen Welt. Architektur und Aktivismus 1914–1920* (Stuttgart, 1981); Iain Boyd Whyte, "The Expressionist Sublime", in Timothy Benson (ed.), *Expressionist Utopias. Paradise, Metropolis, Architectural Fantasy* (Berkeley, 2001); Akademie der Künste Berlin, *Bruno Taut 1880–1938*, exhibition catalogue (Berlin, 1980); Rosemarie Haag Bletter, "Expressionism and the New Objectivity", *Art Journal* 43, no. 2 (1983): 108–120.

43 Iain Boyd White, and Romana Schneider (eds.), *Die Briefe der Gläsernen Kette* (Berlin, 1985).

very theatricality of outsize sculpture that would later be attempted by modern architects such as Hans Scharoun, I. M. Pei, Louis I. Kahn and Frank O. Gehry. It seems as though the burst of energy of the Wilhelmine national consciousness (whose reverse side was to become evident at the latest in 1914) makes possible, in artistically sensitive architects, exactly the form of godless religiosity that for the first time allowed sculpturality to be translated into a metaphysics of the sublime and thus established it as an architectural theme.

The change of direction towards pure form, to the power of the cubic, was understood, with Nietzsche, as a vanquishing of the nineteenth century, whose life-opposing immersion into "history and critique" (Nietzsche) was countered with the powerful gesture of the built structure as an expression of magnitude and will to live.[39] *Das Grauen* (horror), to use Nietzsche's definition of the sublime, had always been the basis of great architecture for him; beauty was merely incidental. Just as with Boullée, whom Nietzsche however did not draw upon, the sublime is understood as the result of a collective cult. The monumental architects wanted nothing less than the architectural invocation of the Wilhelmine power state. In art theory, this emphasis on pragmatic power is backed up by the combination of an idealistic concept of form – successfully represented by the neo-classical sculptor Adolf von Hildebrand – with a vitalistic theory of will. Alois Riegl's concept of "*Kunstwollen*" (artistic will) here stands at the point of intersection between idealism and a philosophy of life modelled on Nietzsche.[40]

The politically regressive, martial and virile architecture of emotionalism clearly also drew on important stimuli from Boullée, for example in Wilhelm Kreis's proportionless cone of a death memorial by the Dnieper, which follows Boullée's Cénotaphe tronconique. Certainly a path leads via Kreis from Boullée to Albert Speer, but early modernist architects such as Peter Behrens, Fritz Schumacher and the young Ludwig Mies van der Rohe also took part in this brutal volumetrics from the spirit of the fatherland.

This architecture was to go into its initial decline with the Axis powers in the First World War.[41] It seems as though sculptural architecture had always needed certain urges towards irrationalism and mythicising, towards the incorporation of a world view on which to base its eccentric will to form. The greater resistance of western societies to this syndrome indicates the growth in social stability of these societies of the centre, their aversion to the extreme. The sculptural architecture of today is likewise still based on the repertoire of forms of these pioneer architects, but ignores their quasi-religious or nationalist motives just as it does the circumstances of their development. A second strand of the formal revolution of around 1900, far more important for today's organic and biomorphic sculpturalists, is of course expressionism, which took shape in a very brief phase as an artists' religion only after 1918, but was already an element of the innovative currents of life reform in the empire. This too was inspired by the reading of Nietzsche, for example in the case of Bruno Taut and later in that of the younger Erich Mendelsohn, but with them this was to result in a communitary form of sculptural emphasis rather than one of *étatisme*.[42] Above all, Bruno Taut's influential publication *Alpine Architektur* of 1919 proclaimed a new age in which a new spirituality was to take hold of a newly peaceful and community-minded society after the devastation of the war. All the concepts of an aesthetics of the sublime converge in an invocation of moods and atmospheres, quite in the spirit of the aesthetics of effect, which was to lend architectural expression to a new, now often socialistically defined community. Thus the important romantic motif of the peak as crystal and its closeness to the divine light stands in an affinity to the vision of the Gothic cathedral, whose theology of light now becomes the basis for an architecture of glass.[43] Before the First World War Bruno Taut, together with the writer Paul Scheerbarth, had already opposed the monumentalists' metaphysics of the stone with a glassy vision of a "sublime architecture" (Scheerbarth).

Not the "horror" of Nietzsche, one of whose devotees the young Taut had been, but spiritual elevation, the foundation of a communal vision, was here being launched and highlighted, and also expressed in building for the first time in Taut's glass house which attracted so much

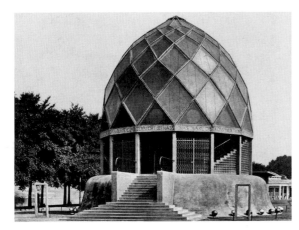

Bruno Taut, glass house, Werkbund exhibition, Cologne, 1914

attention at the Werkbund exhibition in Cologne in 1914. As idealistic as this vision sounded, a modern aesthetic of the translucent wall was created here equally pragmatically in the spirit of the Werkbund philosophy, admittedly with the active support of a highly developed glass industry. It is from this aesthetic that today, once again, sculptural and minimalist concepts take their nourishment – think of the steamy glass walls of Herzog and de Meuron, or the opaque crystal of José Rafael Moneo's Congress Building in San Sebastián.

The image of the cathedral on the other hand, which was indebted to a long-standing enthusiasm for the Gothic in the German Empire, was liberated after 1919 from the earlier nationalistic and nordic undertones, and became the synonym of a democracy which, although somewhat mythological, was oriented towards the model of medieval urban cultures.[44] Taut's *Stadtkrone* (city crown) became the symbol of an architectural intensification and crystallisation of the intellectual centre of society.[45] After all, the Middle Ages had served as inspiration for aesthetic practice and social democracy ever since the arts and crafts movement, and was now being rediscovered by architects such as Eliel Saarinen, Hans Scharoun and Frank Lloyd Wright as well as theorists such as Lewis Mumford.

Classical Modernism and the Displacement of Architecture-Sculpture

Organic architecture in Germany, represented by Hugo Häring and Hans Scharoun, translated the fantasies of expressionism into a design attitude which takes its organic forms from the characteristics of life of the residents, individuals and communities.[46] As with the rationalist functionalists, it was not form but function that stood at the beginning of the design. Nevertheless it was precisely the expressive-organic sculpturality developing out of it that here spectacularly introduced an alternative interpretation of the purpose of architecture. Häring and Scharoun remained of marginal importance to modernism throughout their lifetimes and are only today being rediscovered as precursors of biomorphic design. But with their organic definition of spaces for movement, in which public and private spaces interpenetrate, they also influenced Dutch architecture, at first that of Aldo van Eyck and Herman Hertzberger, and later OMA and MVRDV.

The expressionist impulse was only one of many attempts to overcome the crisis of meaning of the *fin de siècle* by means of a new cultural synthesis derived from artists. Many artists were led towards ideas of social reform less by the social idea of the workers' movement than by the need to gain the people as supporters of such a synthesis. In the centre was the artist's identity crisis in a commercial mass society. The rather prosaic initiative of the German Werkbund, to improve the aesthetic and functional quality of products in co-operation with big industry, had held esoteric tendencies in check before the war. Not until the crisis after 1918 did the quasi-theological, sectarian trait that existed in art also gain its independence in architecture. In con-

44 Magdalena Bushart, *Der Geist der Gotik und die expressionistische Kunst. Kunstgeschichte und Kunsttheorie 1911–1925* (Munich, 1990).
45 Bruno Taut, *Die Stadtkrone*, with contributions by Paul Scheerbarth, Erich Baron, Adolf Behne (Jena, 1919).
46 Peter Pfankuch (ed.), *Hans Scharoun. Bauten, Entwürfe, Texte*, (Berlin, 1993); Peter Blundell Jones, *Hans Scharoun* (Stuttgart, 1980); Jörg C. Kirschenmann, and Eberhard Syring, *Hans Scharoun* (Stuttgart, 1990).

trast to how historians of modernism for a long time wanted to see things, even those modernists later described as functionalists shared the mythological motifs that were merely more openly displayed in expressionism. The later stylisation of modernism as a social and technically constructive avant-garde, seen in this way, is a myth.

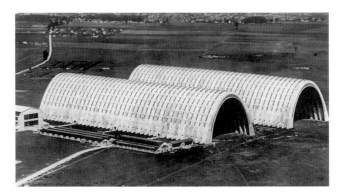

Eugène Freyssinet, airstrip hangars, Orly, 1916–1921

Certainly, before the First World War the younger and older representatives of functionality shared the fascination of new technologies, of steel skeletons and reinforced concrete structures. Technology as an element of design had already been a major theme in the nineteenth century. In France, where civil engineering took priority over architecture, Eugène Freyssinet's airstrip hangars at Orly near Paris (1916–1921), for example, could be considered a paradigm for the aesthetic potential of pre-stressed concrete. In addition, Walter Gropius's 1913 yearbook of the German Werkbund displayed the concrete monuments of American grain silos and factory sites, whose powerful stereometric volumes in fact embodied the intentions of a Boullée or Ledoux more ideally than did the neo-classical confection architecture in the USA. In this segment of architectural culture the impulse of body theory found pure expression, precisely because these functional buildings were not intended by their constructors as architecture. For the same reason American architects did not exploit the opportunity for a sculptural creation of form in precisely that structure where a new architectural typology offered them the chance: the skyscraper. The skylines of the inner cities became a sculptural *Gesamtkunstwerk* only as a side-effect. With the exception of the expressive drawings of Hugh Ferriss, sculptural visions of high-rise buildings remained reserved for European architects, among them, interestingly enough, expressionists and representatives of the German Cyclopean architecture of the empire. Siegfried Kracauer even saw in the high-rises a new opportunity to configure Taut's unbuilt *Stadtkrone* out of secular office towers.

In the 1920s the invocation of secularity and the sobriety of the silos were part of the canon of the New Objectivity. Le Corbusier also illustrated his programme texts with their sculptural rhetoric.[47] As an element of Americanism and Fordism in the modernist movement, these icons were ideally and typically able to bring the aesthetic impression of sculpture made of concrete into line with technological rationality. Also the "Wohnford' (Ford for living: Gropius's term) – the solution of the residential problem by means of industrialised building – was still part of this American complex; it did not necessarily arise from the body of socialist principles.[48]

As is well known, in its inaugural manifesto, the Bauhaus had shared the motifs of the expressionist movement, to which Gropius himself had belonged in Berlin: the invocation of the medieval community, the spiritual unity of people and art, the vision of a cathedral of light, and the cult of craftsmanship. The name Bauhaus, the invention of Gropius, also alludes to the idea of a spiritual affinity with the workshops of the Gothic masters. The "dark side" (Rykwert) of the Bauhaus embeds these in the teachings of Theosophy – successful predominantly in the

47 On the general context compare Reyner Banham, *Das gebaute Atlantis – Amerikanische Industriebauten und die Frühe Moderne in Europa* (Basel, 1990)
48 On Americanism see Stiftung Bauhaus Dessau, RWTH Aachen (ed.), *Zukunft aus Amerika, Fordismus in der Zwischenkriegszeit* (Dessau, 1995); on industrialised building see Christine Hannemann, *Die Platte*, 2nd ed. (Berlin, 2002).

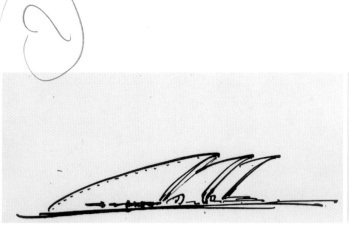

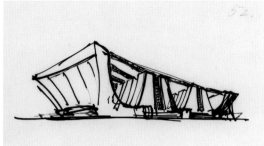

Erich Mendelsohn, *Architectural fantasy*, 1914

Erich Mendelsohn, *Sketch for a hall (?)*, c. 1915

Netherlands and Germany – and its splinter group dating from 1913, Rudolf Steiner's Anthroposophy. This community of faith provided sculptural architecture with an important early witness, the erratic concrete mountain of the Goetheanum in Dornach, Switzerland (1924–1928).[49] Just as Piet Mondrian was under the spell of Madame Blavatsky, the leading light of the Theosophists, so Wassily Kandinsky, the director of the Bauhaus, was a disciple of the metaphysics of Rudolf Steiner. This system of metaphysics continued to exert its influence subliminally as a private artists' religion even after the return, accomplished in 1923, to the functionalist objectivity of the pre-war German Werkbund. Nevertheless the predominant tendency at that time was towards Fordism and the New Objectivity; this left no room for a sculptural and expressive idea of form in the context of the New Architecture. The organic idea was outlawed and even the cool but lively dynamics of Mendelsohn's buildings in their big-city gesture remained unloved in Bauhaus circles.

In the avant-garde modernist groups which came together in 1928 at the Congrès Internationaux d'Architecture Moderne (CIAM), from this point on rationalist and technoid interpretations of stereometric reduction held their ground.[50] The representatives of organic building, above all Hugo Häring and Hans Scharoun, also remained excluded from this international community, as did the old master of organic building to whom they were theoretically closest, Frank Lloyd Wright, despite the fact that many modernist architects had learnt decisively from his innovations, at any rate since the German publication of his designs in 1903.[51]

If one disregards its technocratic urban visions – for example Gropius's Dammerstock settlement in Karlsruhe, Ludwig Hilbersheimer's functional big-city utopia or Le Corbusier's absolutist-

49 Klaus Jan Philip justifiably devotes a section of his overview volume to the absurd building. See his *ArchitekturSkulptur* (Stuttgart, 2002), 102ff.
50 See the overview in Eric Mumford, *The CIAM Discourse on Urbanism, 1928–1960* (Cambridge, Mass., 2000).
51 Significantly, of the German emigrants to the USA only the temperate expressionist Erich Mendelsohn was able to establish a close relationship with him.

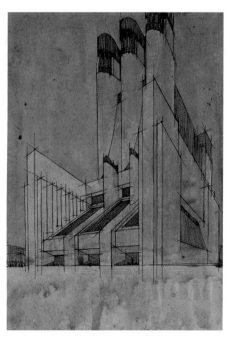

Antonio Sant' Elia, *Theatre*, 1913

Ilya Golosov, Zuyev Workers' Club, Moscow, 1927–1928 Konstantin Melnikov, Rusakov Workers' Club, Moscow, 1927–1928

baroque city ground plans such as the Ville Radieuse – classical modernism contributed above all in its new, open concept of space to overcoming the neo-classical idea of order. As space for movement, it followed instead the path of the open urban landscape, sketched out in the landscape gardens of the eighteenth century and overly picturesquely developed in the garden city movement. The human perspective in the active appropriation of a flowing space drew the building into this movement. Paradigmatically, even Mies van der Rohe, committed all his life to neoclassicism, had immortalised the open space as icon in the Barcelona Pavilion of 1929–30. For these modernists, axiality and symmetry was abandoned in favour of a free architectural sculpturality, even for impressive building commissions such as the Bauhaus building in Dessau of 1925, or, even more spectacularly, Le Corbusier's design for the Geneva League of Nations palace of 1927. As sculptures they become accessible only through the synthesis of the dimensions of space and time brought about by the active movement of the user.[52] The search for the fourth dimension, now topical again in the virtual generation of form in architecture, here experienced a modern interpretation of the English Enlightenment's inspiration. Le Corbusier's Villa Savoye of 1928–29 not only takes as its theme the interpenetration of outer and inner space within the structure, but also mediates the interpenetration of movement and space by means of a system of stairs and ramps that is sophisticated in terms of the psychology of perception.[53] This motif is today found, newly reworked, in the Möbius-Haus by UN Studio, in the inner access streets or "trajectories" of Rem Koolhaas, or in the Dutch Embassy in Berlin opened in 2003.

But that fact that Le Corbusier's elegant and impressive design for Geneva was rejected and the League of Nations instead placed a massive neo-classical monumental building beside Lake Geneva signalled, as early as 1927, that modernism was going on the defensive in the face of a renaissance of the neo-classical will to order.[54] The hegemony of the École des Beaux Arts had not yet been broken. On the contrary, because of the threatening world situation since the economic crisis and the growing number of totalitarian regimes and movements, the conservative trend towards monumental order had actually gained in appeal in the 1930s.[55]

In the Soviet Union a radical modernism had taken shape out of the multiplicity of constructivist and supremacist currents, in which a preference for stereometric primary forms was coupled with a technological radicality, and in which it is certainly possible, with Adolf Max Vogt, to see a futuristic return to Boullée. In the 1930s however this laboratory of architecture was closed, and socialist realism, a blend of neo-classical monumental architecture and elements of a popular style based on sentimental provincialism, would dominate for twenty years.[56] In Italy, too, the heritage of futurism and the rationalist modernism of Gruppo 7 was visibly sacrificed to a monumental, strikingly austere neo-classicism.[57] The Third Reich from the outset preferred a

52 On the analysis of both projects, see Colin Rowe and Robert Slutzky, *Transparenz*, commentary and addendum by Bernhard Hoesli (Basel, 1989), 29ff., 36ff.
53 William J. R. Curtis, *Modern Architecture since 1900* (Oxford, 1982), 186–195.
54 Werner Oechslin (ed.), *Le Corbusier und Pierre Jeanneret, Das Wettbewerbsprojekt für den Völkerbundspalast in Genf 1927* (Zurich, 1988).
55 Franco Borsi, *Die monumentale Ordnung. Architektur in Europa 1929–1939* (Stuttgart, 1987); Hartmut Frank (ed.), *Faschistische Architekturen. Planen und Bauen in Europa 1930–1945* (Hamburg, 1985).
56 Vladimir Paperny, *Architecture in the Age of Stalin. Culture Two* (Cambridge, 2002).
57 Dennis P. Doordan, *Building Modern Italy. Italian Architecture 1914–1936* (New York, 1988).

rather crude neo-classicism, although it was precisely the former adherent of expressionism Josef Goebbels who had at first been considered the great white hope of the modernists.[58]

Thus, a significant domain of sculptural architecture, that of the collective celebration, remained firmly in the hands of the canons of neo-classicism. In the USA in particular democratic architecture, "civic architecture", an ideal example of which was represented by Paul Cret's building for the Federal Reserve Board Building in Washington, was identified with a solid, reduced Beaux Arts language.[59] The further reduction of this canon, the so-called starved classicism, was approaching a modern traditionalism, such as had already been attempted, for example, in the Weimar Republic by the monumentalist Wilhelm Kreis. If, even in this world-wide neo-classicism, Boullée's motifs were endemic – one need only think of Gunnar Asplund's City Library in Stockholm – his sculptural body theory, nevertheless, was kept in check in this tradition.[60]

Monument and Modernism: the Long Road to the Brief Sculptural Age

After 1945 it was not only the geopolitical state of the world that had altered radically. In architecture too a new age was to dawn, even though, as in politics, one cannot speak of a zero hour. Modernism, still oppressed by neo-classical competition, was to become the aesthetic lingua franca of world-wide architecture for at least a quarter of a century. For this reason the concept of International Style, coined for the MoMA exhibition of 1932, was now appropriate, even though classical modernism wanted to be only New Architecture, but by no means a style.[61] But its very formal handling of its heritage is typical of post-war architecture, as it is of culture in general. "All we have left now of modernism is the name. And the forms! The art of the post-war period is nourished on fruitful misunderstandings in looking back on the avant-garde; these have left behind a coral reef of formations from which the life of the 'great intellectuals' has been extinguished. [...] The forms have remained; the faith that was put in them has faded": this is Beat Wyss' summary in his study of the aesthetic mentality of modernism.[62] The International Style embodied the language of a transparent aesthetic of glass and steel, released from its 1920s precondition of representing a world view. Ultimately this amounted to the teachings of the Bauhaus, accepted in America scarcely ten years earlier, transplanted to Chicago, Harvard or Black Mountain College. The co-ordinates had reversed. The monumental order, which was still being built in 1937 in the Federal Triangle in Washington, had become a synonym for totalitarianism; and in fact this architecture, somewhat awkwardly dismissed as Stalinist wedding-cake style, still survived, an anomaly of architectural history, in the Communist world until the mid-1950s. The gigantic tower blocks in Moscow, almost religious in aspect with their multiple naves, and the countless large sculptures, attained a degree of sculpturality within the classical canon, which their models, the New York skyscrapers of the period between the wars, had not achieved.[63]

Against this now clearly anachronistic emotionalism of the monumental, western modernism distinguished itself as emphatically non-monumental, as friendly functionality and humanistic will to form. Whereas the interpretation of International Style as democratic architecture represented an understandable over-reaction by West German post-war architecture to the heritage of National Socialism, the rejection of monumentality and axially organised space in the International Style were indeed understood world-wide as a pointedly reasonable gesture by the free world.[64] Here the dispassionate architecture of classical modernism proved congenial, and even the need for imposing structures could be satisfied in the new "corporate architecture" by the coolly elegant, subliminally neo-classical glass-walled offices of Mies van der Rohe and Skidmore, Owings and Merrill. At first, then, there was little to suggest that within these new canons of post-war modernism sculptural forms would have a chance, and in fact it was another ten years before Carola Giedion-Welcker could announce the "sculptural age". It was how-

58 On this ambivalence of the modernists towards the Nazi regime compare Winfried Nerdinger (ed.), *Bauhaus-Moderne im Nationalsozialismus: zwischen Anbiederung und Verfolgung* (Munich, 1993) and Elaine S. Hochman, *Architects of Fortune. Mies van der Rohe and the Third Reich* (New York, 1989).
59 Elisabeth Greenwell Grossman, *The civic architecture of Paul Cret* (Cambridge, 1996); Richard A. Etlin, *Symbolic Space*, 55ff.
60 Claes Caldenby, and Olof Hultin, *Asplund* (Stockholm, 1985), 92 ff. Scandinavia was a centre of neo-classical continuity. See *Nordic Classicism 1910–1930*, exhibition catalogue (Helsinki, 1982).
61 On the admittedly not quite so unambiguous influence of the Bauhaus see Regina Bittner (ed.), *Bauhausstil. Zwischen International Style und Lifestyle* (Berlin, 2003).
62 Beat Wyss, *Der Wille zur Kunst,* (Cologne, 1996), 251f.
63 On the mutual influence between the USA and the USSR compare Jean Louis Cohen, *Scenes of the World to Come. European Architecture and the American Challenge 1893–1960* (Paris, 1995), 151ff. and, more broadly based, Susan Buck-Morss, *Dreamworld and Catastrophe. The Passing of Mass Utopia in East and West* (Cambridge, Mass., 2000).
64 On the example of the modern embassy buildings of the USA after 1945 see Jane C. Loeffler, *The Architecture of Diplomacy* (New York, 1998) and generally. Henry-Russell Hitchcock and Arthur Drexler (eds.), *Built in USA: Post-war Architecture* (New York, 1952).

ever to be a rather short-lived one, even though her husband Sigfried Giedion gave his blessing to this rapprochement between architecture and sculpture (as secretary of CIAM he was the voice of Le Corbusier from the 1920s and, as an authoritative historiographer and leading theorist of the modernist movement an opponent of expressive modernism).[65] Of course in practice it was no less a figure than Le Corbusier who had pursued this rapprochement since the 1940s; he now realised it with the striking concrete sculptures of the Unité d'habitation in Marseille, the church at Ronchamp, the La Tourette monastery and the government buildings in Chandigarh, but also with the tent structure, awkwardly modelled on expressionism, of the Philips pavilion in Brussels.

But how could a sculptural inspiration that in Jørn Utzon's Sydney Opera House or Eero Saarinen's Dulles Airport in Washington so openly alluded to the expressionist visions of the young Erich Mendelsohn, obtain the blessing of the CIAM's guardian of the Holy Grail? Certainly, these visions were already in the process of dissolving. But whereas the young innovators in the CIAM, the members of Team Ten, were certainly harsh brutalists, even they were not suspected of expressionism, let alone nostalgia for monumentalism. Receptivity towards sculptural forms occurred in a period of serious self-examination by post-war modernists, which was initiated by the "old gentlemen" and finally completed by the young ones with the dissolution of the CIAM.

As a "self-criticism of modernism" that had always been practised, the organic traditions now became more acceptable to the extent that their criticisms identified precisely that deficiency which the CIAM was now tackling: the inability to contribute architecturally to the expressive articulation of a vital feeling of community.[66]

The incubation period of the sculptural age had already begun in the 1940s. The key concept was, significantly, monumentalism, or more precisely a new monumentalism, which Lewis Mumford, a critic of functionalist modernism committed to a moderately modernist regionalism, had demanded as early as 1937 in an essay, and then in 1938 in his book *The Culture of Cities*.[67] Referring to his teacher, Patrick Geddes, he demanded a new centrality for the heart of the city. As with Bruno Taut's expressionist idea of a *Stadtkrone*, Geddes too had proposed an intellectual core to the centres of cities, which would be manifested in monumental buildings of collective significance.[68]

65 Carola Giedion-Welcker, *Plastik des XX. Jahrhunderts: Volumen und Raumgestaltung*, (Stuttgart, 1995); Sigfried Giedion, *Raum, Zeit, Architektur*, rev. ed. (Ravensburg, 1965), 29ff., 406ff.
66 On this interpretation see Gerd de Bruyn, *Fisch und Frosch oder die Selbstkritik der Moderne* (Basel, 2001).
67 Lewis Mumford, *The Culture of Cities* (San Diego, 1970), 433ff. On the general context see Volker M. Welter, "From locus genii to heart of the city. Embracing the spirit of the City", in Iain Boyd Whyte (ed.), *Modernism and the Spirit of the City* (London, 2003), 35–56.
68 On the similarity of Geddes' Cultural Acropolis to Taut's *Stadtkrone* see Volker M. Welter, *Biopolis. Patrick Geddes and the City of Life* (Cambridge, Mass., 2002), 214ff.

Le Corbusier, Unité d'habitation, Marseilles, 1947–1952

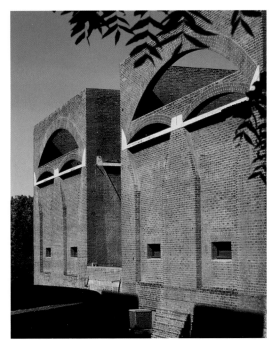

Louis I. Kahn, Classroom building, Indian Institute of Management,
Ahmedabad, India, 1962–1974

Only five years later, leading protagonists of the CIAM took up this initiative. In their *Nine Points on Monumentality* of 1943, Sigfried Giedion and José Lluís Sert, together with the painter Fernand Léger, first adopted the idea of a monumental accentuation of the city centre.[69] Into the intellectual vacuum of the empty centre of the functional city, there now entered the idea of the monumental, now however not as an expression of power, but rather as the symbolic elevation of the community. A year later, Giedion was even taking for granted an "eternal" need for monumentality.[70] But a modern version of the monumental had not yet been found. The resistance to the "pseudo-monumentalism of our era" (the reference was to authoritarian neo-classicism) nevertheless excluded a return to organic modernism's visions of community.

On the other hand, the young architect Louis I. Kahn, an American modernist with a classical Beaux Arts training under Paul Cret, dared to make this very appeal to the spirit of Gothic in 1944, in a symposium on *The Problem of a New Monumentality*, at which Giedion also delivered his thesis on *The Need for Monumentality*. He illustrated his paper on monumentality with a modern citation of a cathedral as spiritual centre; this took the form of a drawing of a singularly functionless, abstractly neo-Gothic steel pillar structure as sculptural air space with gently vaulted glass cupolas as the centrepiece of a civic centre.[71] This constructive expressionism, halfway between Viollet-le-Duc and Calatrava, was at first to remain without consequences. Kahn however was prominent for only two decades as the master of an archaic-modern monumental stereometry modelled on Boullée.

After 1945 the theme of the lost centre became the subtext for a general revision of town planning according to the Charter of Athens. No city or settlement had yet been built according to the functional principles of a separation of work, leisure, living and traffic. But in 1947, at the CIAM Congress in Bridgewater, the creation of local identity was recognised as the central problem of functional urban planning.[72] Not as a revision, but as a supplement to the functional schema, the CIAM founders proposed a fifth zone as city centre, in which monumental community buildings and office blocks arranged loosely around an agora would define the heart of the city. The model of this idea of the centre was the unrealised design by Le Corbusier for the destroyed town centre of St. Dié in the Vosges. This figuration composed of solitaires in a flowing space contained the potential for sculptural intensification of the community buildings, without the need for monumental axes. In 1951 the debate on the heart of the city became the central

69 Sigfried Giedion, *Architektur und Gemeinschaft* (Reinbek b. Hamburg, 1956; reprint in Joan Ockman, *Architecture Culture 1943–1968, A Documentary Anthology,* New York, 1993) 40ff.
70 Sigfried Giedion, "The Need for Monumentality", in Paul Zucker (ed.), *New Architecture and City Planning* (New York, 1944), 549–568.
71 Louis I. Kahn, "Monumentality", in Paul Zucker (ed.), *New Architecture and City Planning* (New York, 1944), 577ff.; also in Joan Ockman, *Architecture Culture,* 48ff. See also Kenneth Frampton, "Louis Kahn and the French Connection", in *Labor, Work and Architecture* (New York, 2002) 169ff. On the problem of sculpturality of the only structurally suggested air space, exemplarily in Eisenman's Wexner Center, see Klaus-Jan Philipp, *ArchitekturSkulptur,* 80ff.
72 See Werner Sewing, "Reflexive Moderne. Das Erbe des Team Ten", in *Bildregie* (Basel, 2003), 65ff.; Jos Bosmann, "CIAM after the War: A Balance of the Modern Movement", *Rassegna* 52/4 (December 1992): 6ff.

theme of the eighth CIAM Congress in Hoddesdon, England.[73] To this romantic metaphor of the heart, which significantly was illustrated with medieval marketplaces, was added the concept of the "core". This again was derived from Patrick Geddes, who had introduced it at the beginning of the century as an analogy to Bruno Taut's concept of the *Stadtkrone*. This inheritance from the expressive and religious search for identity of the generation of urbanistic grandfathers still characterised by spirituality was now, in a watered-down form, written into the dispassionate rationalism of post-war modernism. But this influence remained below the surface; no one thought of honouring the idea of the *Stadtkrone*.

Indirectly, however, the CIAM representatives had confirmed a diagnosis that had accused this very modernism of the loss of centre. In 1948 a book with this title (*Verlust der Mitte*) had appeared by the conservative-Catholic art historian Hans Sedlmayr, a former member of the Nazi Party in Vienna, in which he had adopted the analysis of Emil Kaufmann.[74] But what had been the history of emancipation for Kaufmann was for Sedlmayr the history of decline. The liberation of the stereometric solitaire appeared here as an indication of the loss of the intellectual centre. From this culturally conservative viewpoint, which exerted its influence in the 1950s and 1960s, the idea of the "core" as a free grouping of solitaires was of course only a further syndrome of crisis. From this point of view only a return to the old city and its spatial hierarchy would have been a step towards urban healing. Twenty years later, this theory, now given a post-modern twist, would be used as a decisive counterstroke against post-war modernism; the old city once again became the model.

But the younger generation of the CIAM, which came together in the 1950s in Team Ten, did not take up the idea of the "core" either, any more than the offer it contained of a plasticity of its forms. Rather, their revision of the functional urban planning of the Charter of Athens found expression in the image of an increasingly dense, network-like structure, which again merged all functions and organised them on different infrastructural levels. The idea of the agora was here; in the case of the Dutch architects in the circle of Aldo von Eyck for example, it was integrated into a non-hierarchical carpet structure with complex public spaces.[75] The English faction in Team Ten on the other hand, centred around Peter and Alison Smithson, launched an urban landscape oriented towards the picturesque room for movement of a polycentral metropolitan region, constituted by dispersed settlement cores or "clusters". The urban landscape garden, accessible now not to pedestrians but to motorists, contained the potential of a sculptural shaping of the clusters, to some extent a regional interlinking of communities culminating in city crowns, not so dissimilar to the Middle Ages. But this probably utopian vision of a landscape of urban sculptures was one which these representatives of the third generation of modernism no longer dared to formulate.[76]

With his idea of an "urban garden" full of romantic motifs, including the aesthetic of ruins, and the later "city archipelago", Oswald Mathias Ungers was later to develop the Smithsons' ideas further in the direction of large sculptural forms in a flowing space.[77] In the early 1990s, not altogether without irony, he was to propose such forms as a playful architectural capriccio from icons of modernism for Berlin's inner city. His earlier colleagues Rem Koolhaas and Hans Kollhoff were to suggest this model of architectural sculptural collages in a free space – the synthesis of the aesthetics of effect of the eighteenth century, of the landscape garden and of body theory – for the automotive society. In Eurolille, Koolhaas was able to some extent to realise the concept of an infrastructural cluster, while Kollhoff's large sculptures, such as the Atlanpole for the periphery of Nantes, remained on paper. But Kollhoff's idea of the "sculptural block", which he was able to build in exemplary fashion in Amsterdam in an expressive large form, served him in the late 1980s as a signal to retreat to the block structure of the old city, from Kaufmann to Sedlmayr.

As the high point of a rebirth of modernism from the spirit of sculpture, the sculptural age was, on closer examination, a peculiar and rather brief diversion. It began in the early 1950s

73 Jaqueline Tyrwhitt, Jose Luís Sert and Ernesto Rogers (eds.), *CIAM 8. The Heart of the City: Toward the Humanization of Urban Life* (London, 1952).
74 Hans Sedlmayr, *Verlust der Mitte. Die bildende Kunst des 19. Und 20. Jahrhunderts als Symptom und Symbol der Zeit* (Salzburg, 1948). See also Willibald Sauerländer, "Hans Sedlmayrs ›Verlust der Mitte‹", *Merkur* (June 1993): 536ff.
75 Ingo Bohning, "Die Agora Bauten der siebziger Jahre" *Bauwelt* 36 (1987): 1350ff.; Wim J. van Heuvel, *Structuralism in Dutch Architecture* (Rotterdam, 1992).
76 Miles Glendinning and Stephan Muthesius, *Tower Block, Modern Public Housing in England, Scotland, Wales and Northern Ireland* (New Haven, London, 1994), 121ff.
77 On the genealogy of these ideas, see Wilfried Kühn, "Tabula rasa und dergleichen" *Umbau* 18, (2001): 51–64.

Oswald Mathias Ungers, *Icons of architecture*, project idea, 1990

and ended in the early 1970s during the crisis of late modernism, to which it had made reference as a counterpoint. The liberation of the sculptural stereometric form from rationalism – which, as Emil Kaufmann had rightly observed, was initiated in the 1920s by the young Le Corbusier – now became, together with an archaising material language of rough exposed concrete, probably the most important stimulus for the opening of post-war modernism to the sculptural. The brutal presentation of primary forms in concrete, which, with the shell method of building, clearly enabled round, organic movements in space, gave Le Corbusier's religious buildings of the 1950s an aura of timeless sublimity. That these experiments should unleash an unsuspected innovative thrust towards sculptural forms and new typologies in church architecture is one of the great surprises of this period: the large official churches were at last opening up to the sculptural impulse that had always been founded upon religion.[78]

In Chandigarh, India, Le Corbusier was able from 1951 up to his death in 1965 to develop the civilian plan for St. Dié into an impressive government centre. A few years later the Brazilian Oscar Niemeyer, who was influenced by Le Corbusier, followed his model in the new Brazilian capital, combining a playful variation on the sculpture park of the state institutions with highly schematic urban planning for the rest of the capital.

Meanwhile, with the Sydney Opera House and the Berlin Philharmonic Hall the heirs of expressionism were announcing their return. Whereas the older Hans Scharoun represented the continuity of this tradition with his vision of a Berlin cityscape in which the Philharmonic Hall, itself a synthesis of nature and city (one can see the rows of seats as "vineyards"), the young Jørn Utzon represented a new generation of alternative modernism. The energy of the early Erich Mendelsohn swells the sails of Sydney, just as today it inspires Frank O. Gehry's sails at Bilbao and Los Angeles, and more recently the sails of an auditorium at Santa Cruz in Tenerife (2003), built by Santiago Calatrava.

In the sixth edition of his programme text for 1962, Giedion had attempted to place Utzon in the CIAM genealogy as representative of a "third generation". This attempt was doomed to failure, since, under Alvar Aalto's influence, Utzon was in fact committed to an organic model of the cityscape, as represented for decades by the outlawed Häring and Scharoun. Giedion did not want to admit the existence of a second genealogy of an "alternative modernism".[79] But his attempt to incorporate some of its representatives – not only Utzon but also Alvar Aalto (never cited in the earlier editions, but excessively so in the sixth) – was a silent tribute to the outlawed organic position.

78 Walter M. Förderer, *Kirchenbau von heute für morgen?* (Würzburg, 1964).
79 Colin St. John Wilson, *The Other Tradition of Modern Architecture: The Uncompleted Project* (London, 1995); further, de Bruyn, *Fisch und Frosch oder die Selbstkritik der Moderne* (Basel, 2001).

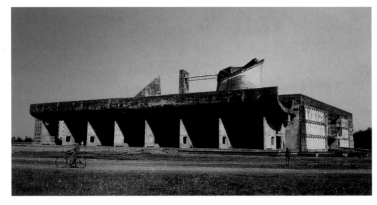

Le Corbusier, Parliament building, Chandigarh, 1953–1962

I. M. Pei, Everson Museum of Art, Syracuse, New York, 1961–1964

The sculptural theme now became a field for experimentation for several years, in which innovations long ago tried out by building engineers such as Pier Luigi Nervi were aesthetically applied to sculptural *Gesamtkunstwerke*. Free-standing supports, deeply overhanging or shell-shaped concrete skins as roofs, sculpturally free-standing staircases and large tent forms displayed the technical potential of the concrete shell structure. With their stadium buildings Kenzo Tange and Eero Saarinen opened up a series of innovations that would later be added to the stock of a free, organic architecture. In 1968, an almost cultic collection of icons was dedicated to this flowering of sculptural concrete architecture with Michel Ragon's overview of the project, *Esthétique de l'architecture contemporaine*.[80] By this point in time the sunset of the sculptural age had long since begun.

The free sculptures in Ragon's collection, such as the buildings in Brasilia and Chandigarh and the zoomorphic TWA airport terminal by Eero Saarinen in New York, drew their power not only from their isolation as solitaires but also in the city context from their contrast with the serial anonymity of the urban backdrop. Sculpturality thus seemed to be not only a response to the symbolic emaciation of the modern city, it equally seemed to require it. To the same extent to

80 Michel Ragon, *The Aesthetics of Contemporary Architecture* (Neuchâtel, 1968).

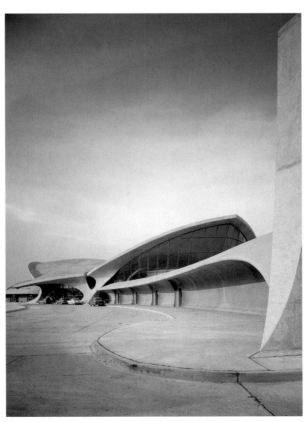

Eero Saarinen, TWA terminal, New York, 1956–1962

Ron Herron/Archigram, *Walking Cities on the Ocean*, project, 1944–1966

which postmodernist urban planning preached a return to the small-scale historic city, the large sculptural form also had to be combated as being inimical to the city. In this way even the diversification of the repertoire of sculptural forms through the pop architecture of the 1960s did not escape sculpturality's speedy devaluation.[81] Nevertheless, by reverting to, for example, the technoid spherical forms of Buckminster Fuller and by trying out new materials such as plastic, it was able to introduce the biomorphic forms that today enable the boom of blob architecture with new CAD programs and animation software. As the Centre Pompidou of the 1970s shows, even though high tech architecture preserved the continuity of the large forms of the 1960s, the sculptural impulse was comprehensively strangled in the historicist renaissance of postmodernism: the shell of style was again encrusting the kernel. An excessive semantic theory of signs crowded out the debate on form, against whose multilinguality, however, a new classicism was about to assert itself. As neo-traditionalism, it is still rampant today. The repackaging of the philosophy of the city allowed Hans Sedlmayr to triumph over Emil Kaufmann for more than 15 years, approximately from 1970 to 1985.

Only now did it become evident just how much, if not exclusively, sculptural architecture had been sustained by the idea of a free cityscape. Postmodernism, as demonstrated, for example, by its protagonist Aldo Rossi with his almost Boulléean theatre cube in Genoa, did not need to renounce monumental structures; rather, its typological method was positively committed to a reduction to stereometric primary forms. It was in fact Aldo Rossi's earlier and probably best

81 The Museum of Modern Art, *The Changing of the Avant-garde* (New York, 2002); *Utopisches Bauen*, DU 742 (2003).

Zaha Hadid, Hong Kong Peak, project, 1983

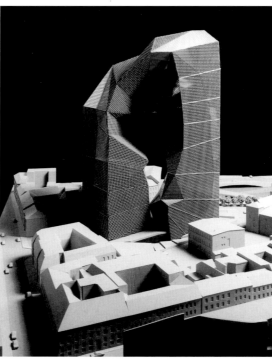

Peter Eisenman, Model view of the Max Reinhardt house, Berlin, project, 1992

design, the cemetery at Modena, that most closely approached the body theory of Boullée, whom Rossi, as a journalist, had brought back to public notice in the preceding years.

What was needed to restore a sculptural aesthetics of effect back to its rights was first of all the provocative devaluation of postmodernism through a deconstructivist aesthetics of shock, in which the constructivist impetus with its breaking up of conventional spatial theory became a sensual experience between the sublime and the uncanny.[82] Whereas minimalism represents an emphatic reduction to pure physicality, thus increasing the weight of the volumes in the spirit of body theory in contrast to the postmodernist inflation of images, most biomorphic attempts today feed upon the pioneer achievements of the organic tradition.

deconstruction, minimalism and biomorphism are today the significant sources of sculptural architecture. The most recent projects in this volume bear eloquent, indeed powerful and timely witness to this.

82 Anthony Vidler, *Warped Space: art, architecture and anxiety in modern culture* (Cambridge, Mass., 2000); ibid., *The Architectural Uncanny. Essays in the Modern Unhomely* (Cambridge, Mass., 1992).

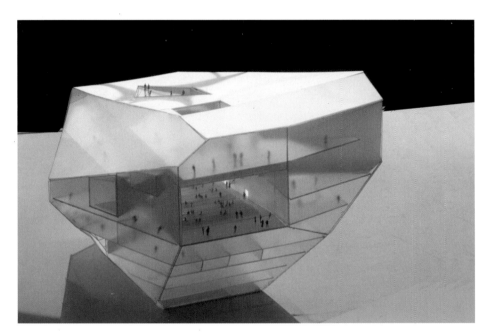

Office for Metropolitan Architecture, Casa da Musica, Porto, 1999–2003

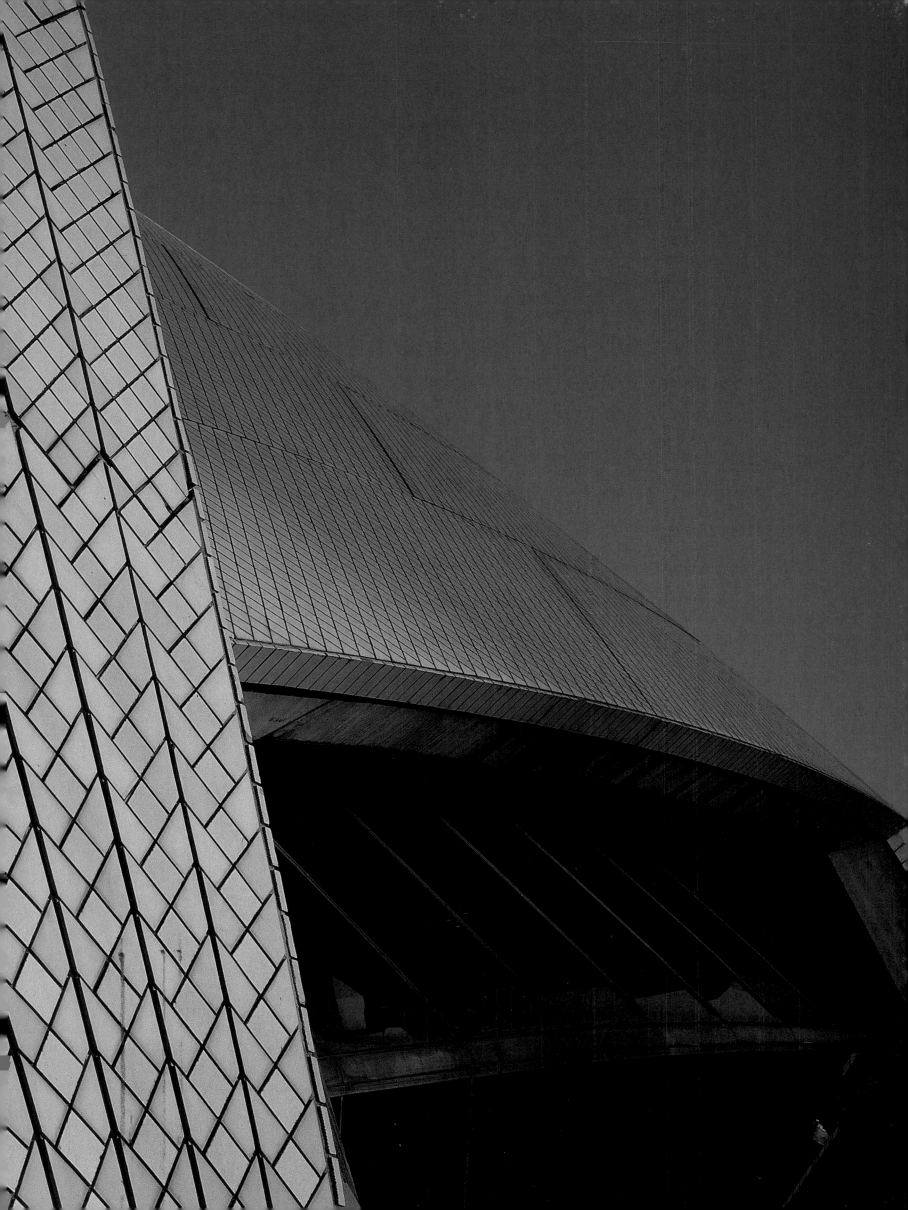

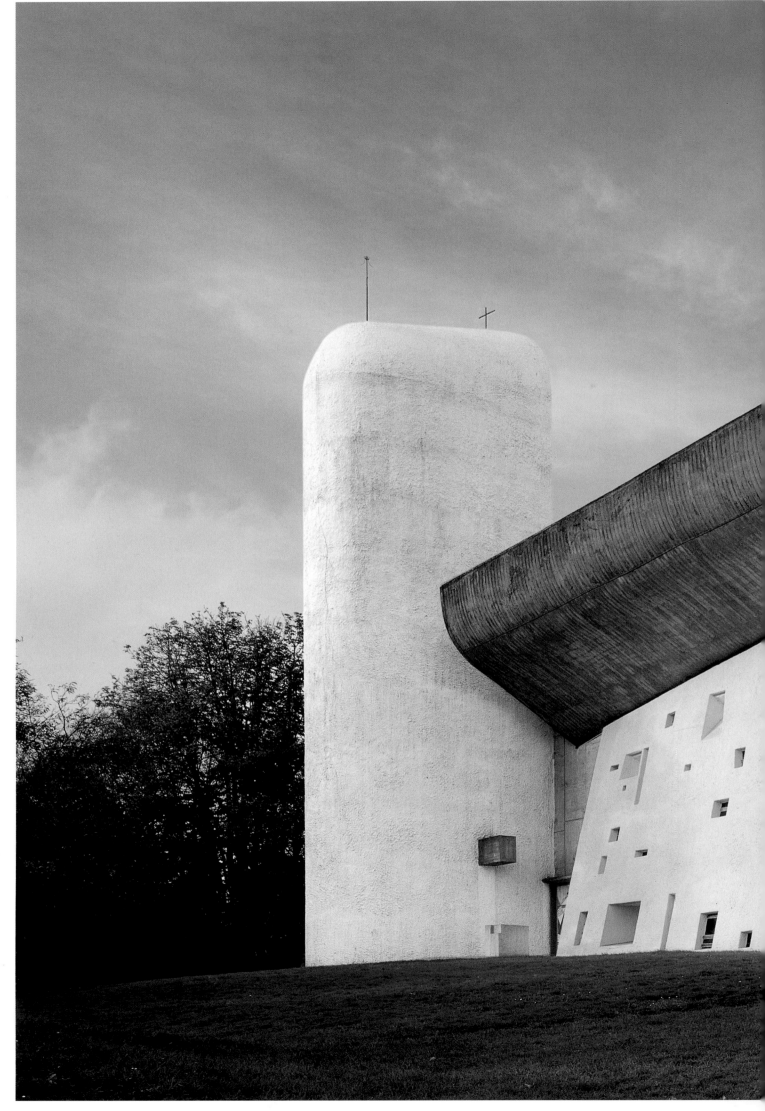

General view of the chapel, seen from the south-east

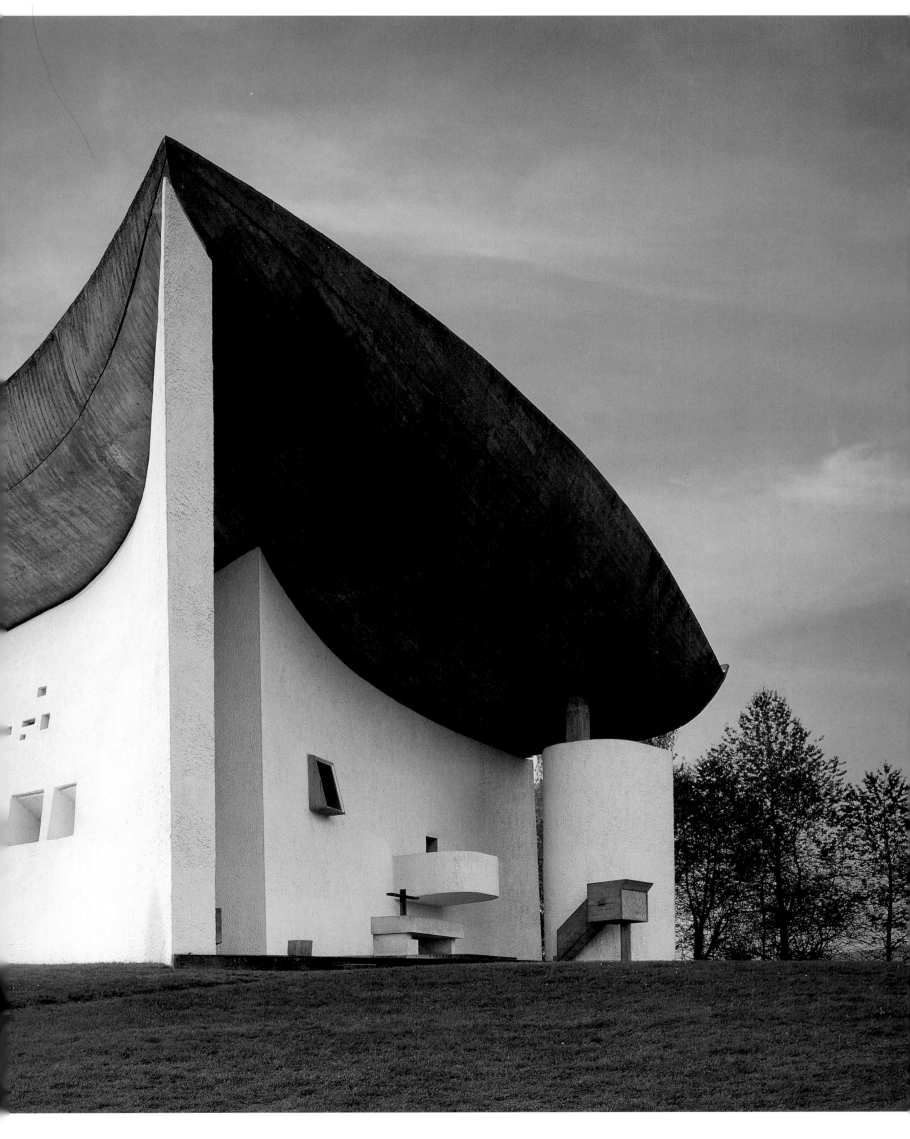

Notre-Dame-du-Haut The pilgrimage chapel at Ronchamp visibly dominates the Haut-Lieu on the last southern foothill of the Vosges, above the Sâone valley, not far from Belfort. The view from the "High Place" extends far into the richly forested hilly landscape of the Burgundy Gate at Belfort, and to the east also includes the nearby Swiss Jura. Here, in the early twentieth century, in his home town of La Chaux-de-Fonds, the young Le Corbusier, at that time still known as Charles-Edouard Jeanneret, absorbed from his teacher L'Eplattenier the idea of a centre of cult worship: a shrine dedicated to nature, consecrated to the spirit of the Jura landscape.

When Le Corbusier rose to become one of the heroes of classical modernism in 1920s Paris, his radical rationalism seemed to exclude any idea of a mystical, spiritual concept of space, particularly one with a regional character. In fact, by cultivating increasingly expressive forms since the 1930s, he had developed a sculptural language whose subliminally religious character was not to become apparent until after the Second World War. A commission for four religious buildings in the 1950s – of which the most spectacular was

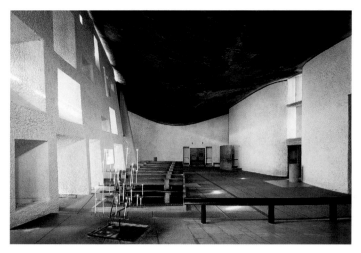

The interior of the chapel

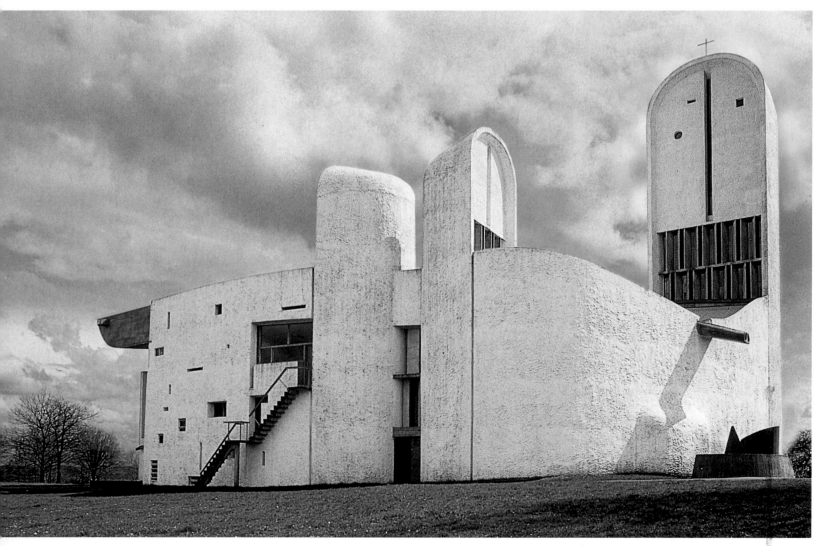

View towards the north and west façades

Sketch for the exterior elevations and the plan Interior elevation sketches Axonometric view of the chapel, seen from the north

the Ronchamp chapel – finally gave Le Corbusier the opportunity to stage his idea of the grandeur of natural religion. Just as in his government buildings in India of that period, he deliberately employs the sculptural means of dramatising space and form in buildings that are places of collective ritual.

The place of pilgrimage at Ronchamp stands on the site of a pre-Christian centre of cult worship; from the Middle Ages it had been the site of a cult of the Virgin Mary, whose last church was destroyed in the fighting in 1945. In its monumental strangeness, Le Corbusier's chapel, consecrated in 1955, also seems to refer to an unknown rite, an almost incomprehensible yet unequivocally sacred composition, reminiscent of an Acropolis, mosque, tent or megalithic tomb. The interior of this "container of intense concentration", as the architect called it, consists of a large central space on an irregular, almost organic ground plan, surrounded by three smaller, more intimate devotional spaces indirectly lit by towers from above. The cement floor follows the natural topography, sloping down towards the altar. This space, which serves to support inner composure and meditation, makes a magical impression, mostly due to the light coming through the irregular, partly colourfully glazed deep openings in the mighty south wall. The sculptural effect of the building, from the viewpoint of the pilgrim climbing the hill, is most striking in the monumental, acute-angled, expressive south-east corner, and is strengthened by the eye-catching roof. In 2.26-metre-thick concrete, the shell of the roof arches over the building like a billowing sail, creating an almost archaic aura. The curved white walls, partly tilted

inwards, intensify this effect. These wall sculptures have no function: the roof is supported on steel and concrete. In addition, a window slit between the south and the east wall transforms the massive volume – particularly when seen from the inside – into a floating, hanging, tent-like roof of almost textile appearance.

The east façade, set well back, provides space for an outer choir area, from which masses are celebrated in the forecourt. To the north and west, the façade, curving all around, is marked only by the white, decidedly rough walls, behind which the roof retreats. Two smaller towers to the north and one large tower on the south-west corner give the building its vertical counterweight. An almost Arabic aesthetic is suggested, and indeed, motifs from Algerian mosques, visited by Le Corbusier in 1931, are found here. Seen in this way, the little chapel with its monumental grace could be evidence of a new world religion, the quintessence of spirituality in a globalised world.

As a space for movement for the ritual of pilgrimage, this religious structure, skilfully composed out of single discs and walls, is built up as a succession of *événements plastiques*, as a sculptural sequence of events, and thus thoroughly follows in the tradition of Christian places of pilgrimage. But with its free organic forms – the roof, for example, was suggested by a shell found by Le Corbusier on Long Island in 1947 – it leaves all conventions behind. With this architecture-sculpture, a new concept of religious space is born. The openness which would be shown by the Christian churches towards this momentous innovation is impressive.

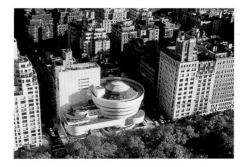

View of the museum from above

Solomon R. Guggenheim Museum Architecture often achieves a strong sculptural effect when it translates just one formal idea, but that in a logically consistent manner. The idea of an ascending ramp, a spiral as the body of a building, familiar from the architecture of Mesopotamia for example, was pursued in modern times by both Le Corbusier and Frank Lloyd Wright. Born in 1867, Wright was a pioneer who anticipated the classic modernists, and had developed a very individual creativity apart from the architectural mainstream. As early as 1924 he had used a car ramp as a dominant element, winding it around a round planetarium for a tourist attraction in the Maryland mountains that was never executed. But the basic idea reappeared in 1943 in a museum project in New York: the spiral as ramp, this time not on the exterior, but as an interior organisational element of the building's construction. This "most courageous building" of Wright's late work, as his contemporaries described it, was to revolutionise museum architecture. For, unlike the multi-storey car park designed by Wright in 1947 as a huge spiral, in the case of

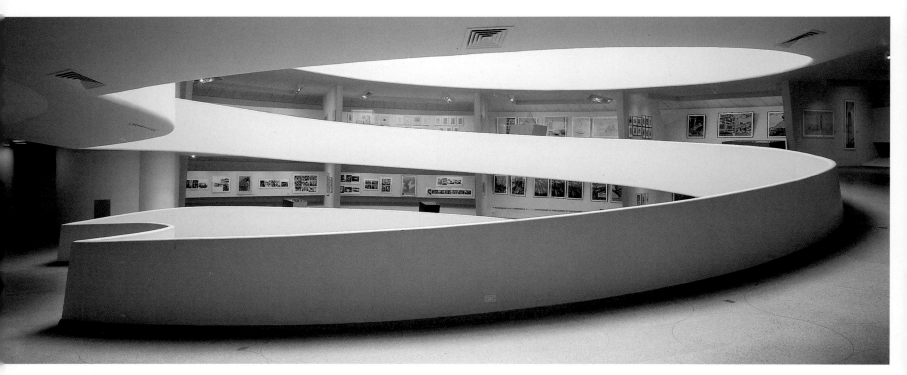

The spiral ramp in the interior

Solomon R. Guggenheim's collection of modern European art the ramp was not functionally necessary. When the building was completed, the hanging of the pictures along a continuous sloping plane was taken by the artists as an affront: architecture as large-scale sculpture was said to degrade the exhibits.

This discussion did not flare up until the late 1950s, for thirteen years had passed (Guggenheim had already died in 1949) before a considerably altered concept finally took shape between 1956 and 1959 as a large, striking building, reminiscent of a fallen ziggurat, on upper Fifth Avenue opposite Central Park. The beige-coloured, round architectural sculpture, consisting of curved layers of wall, succeeded in clearly setting itself apart from the surrounding apartment towers. In doing so this solitary object proclaimed its function

Façade of the entrance to the museum on Fifth Avenue

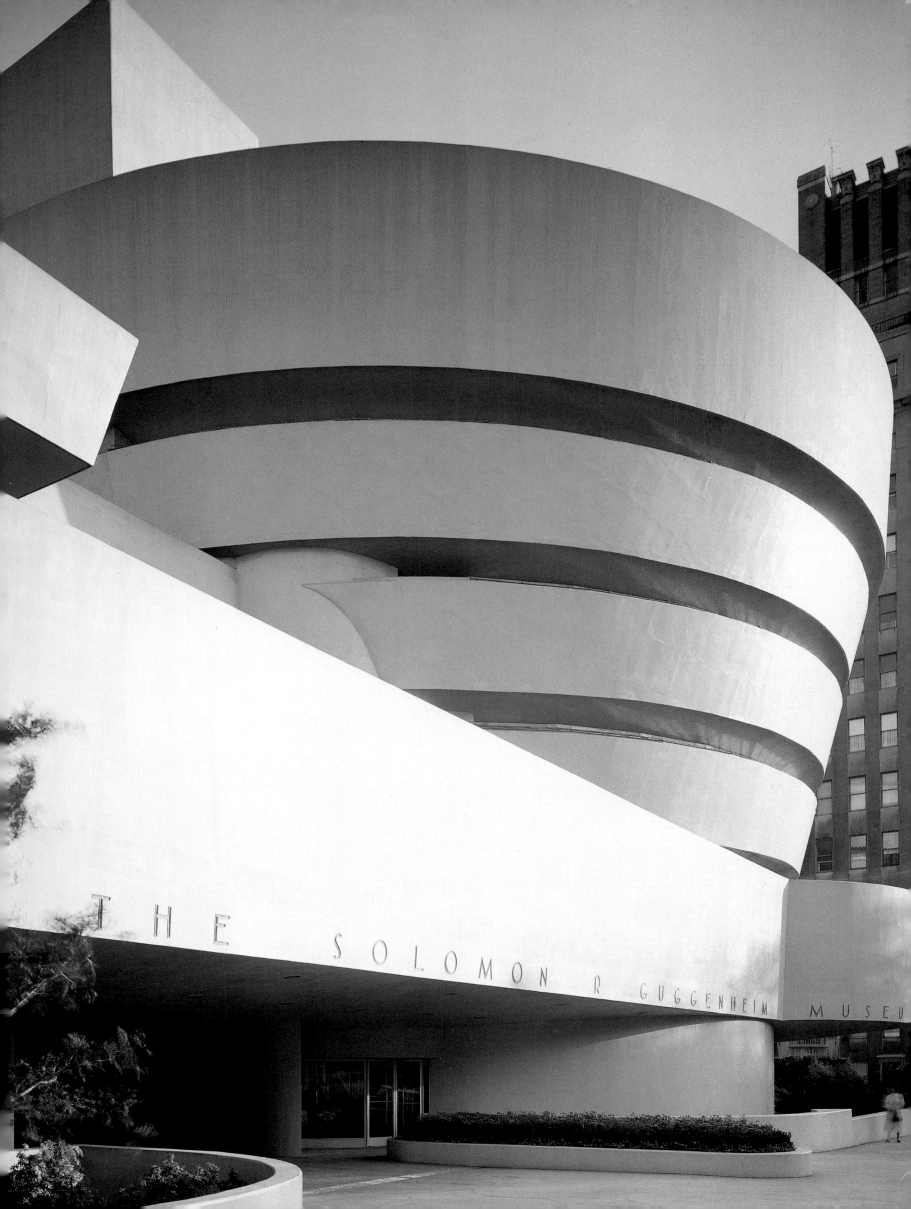

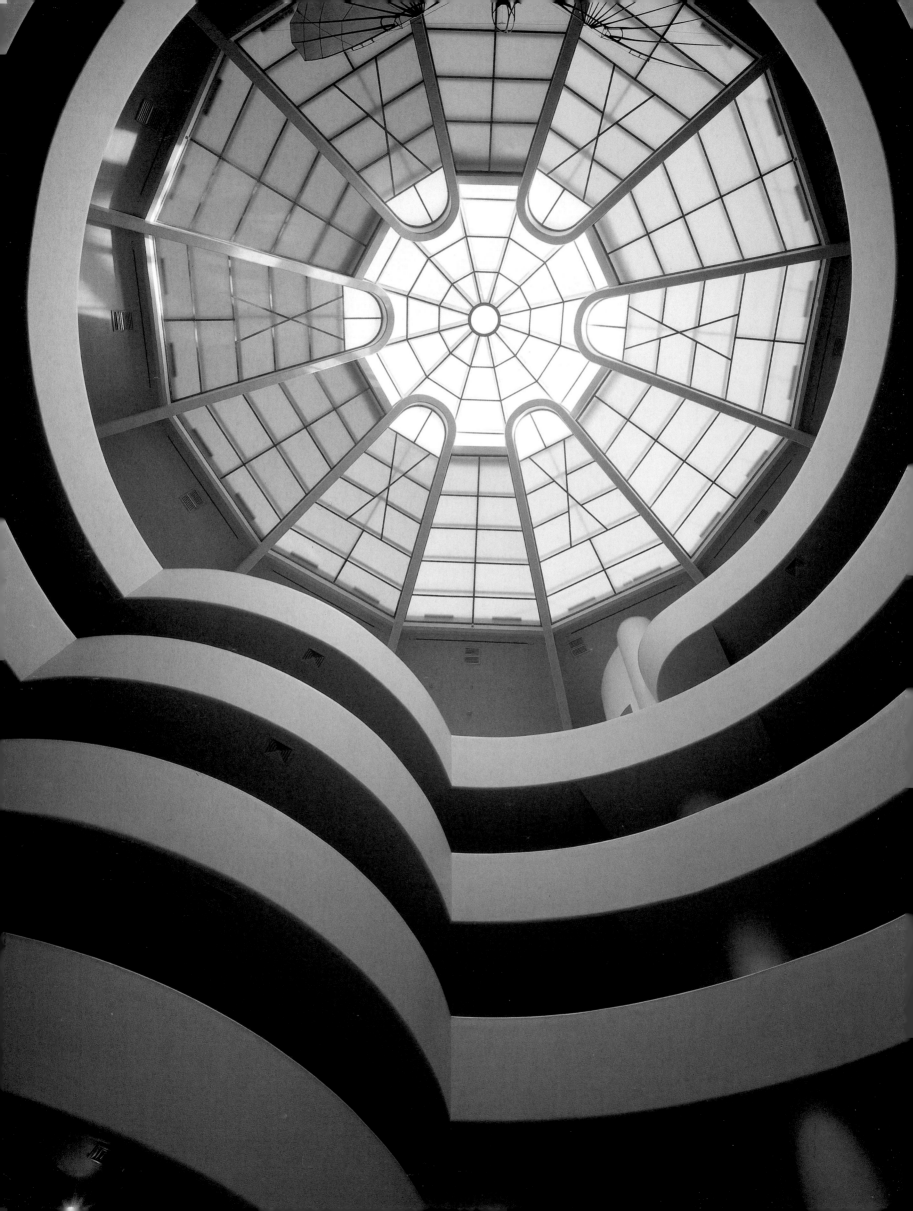

as a public assembly space, as experience architecture. Completed six months after the death of its 92-year-old designer, the building became a predecessor and prototype of a new kind of museum conceived as a sculptural *Gesamtkunstwerk*: the museum as identity-creating sculpture of a new "cult", that of cultural tourism. Perhaps it is no mere coincidence that Frank Gehry's museum in Bilbao is also a Guggenheim museum.

In 1943 Wright was still thinking in terms of a ramp tapering upwards, and in 1956 this form, by being inverted, was given a dynamic and monumental quality. Furthermore, the interior, surmounted by a glass cupola, gained in lightness and brightness. This new interpretation of a classical rotunda, a spacious atrium, whose gently rising ramp widens as it approaches the light, is above all a festive assembly space, but also a gallery. In this function it is served, though not ideally so, by the walls of the ramp, curving back slightly, with their narrow continuous window-ledges. "Form follows function": this maxim here regains its original, organically intended sense. But the function here cannot be the contemplation of the pictures – the critics were surely right in this. Rather the function here is the social interaction of art lovers: assembly and movement as basic impulses in the formation of human communities. Wright for whom, with the Guggenheim Museum, "architecture appears in sculptural form for the first time, … (more like a sculpture)," knew that the spirit of a community must always correspond to a space-creating energy. Here in his late work a powerful vision of a democratic architecture arises once again.

The sculptural attraction of the atrium and its outer shell correspond not only to social ideas. As representative of an "organic architecture" Wright also endows the forms with natural imagery: the flow of the concrete ramps, unhindered by any support was compared by him to an unbroken ocean wave; the body of the building, of smoothed, almost silky concrete, to an eggshell. Was he familiar with the ancient religious significance of the spiral as a symbol of eternal development?

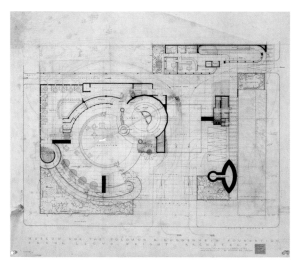

Conceptual drawing of the plan

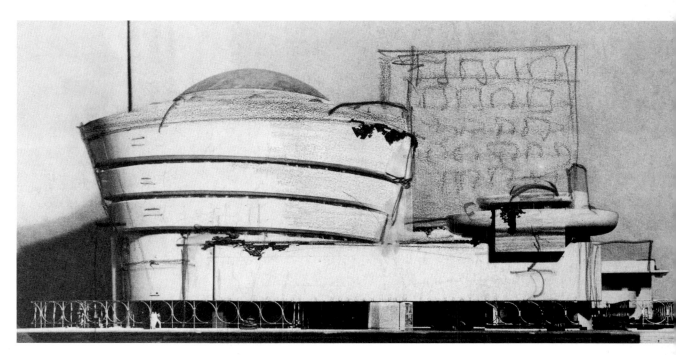

Sketch on a photograph of the model, c. 1955

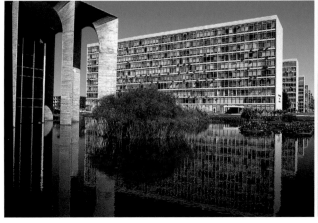

Sketch by Oscar Niemeyer

Square of the Three Powers Within only three years the foundation of the new capital of Brazil was laid for an ideal city of 600,000 inhabitants, on the red dust of the sparsely populated plains, deep in the interior of the country. It was barely a thousand kilometres from the metropolises of Rio de Janeiro, the old capital, and São Paulo. Today more than two million people live in the region, most of them in the widely separated, unplanned suburbs. As early as 1987 the test-tube city was taken up, as a sort of *Gesamtkunstwerk*, into the world cultural heritage of UNESCO. As a gigantic urban sculpture, the Plano Piloto of the architect Lucio Costa proves to be emblematic of the radical urban vision of modernism: the functional city of the Charter of Athens. The striking form of the city's ground plan is meanwhile accessible only from a bird's-eye view. Resembling an aircraft or a bird with outspread wings, the city lies beside an artificial lake. Its torso consists of a monumental twelve-lane axis, and its gently curved wings contain the residential quarters, criss-crossed by broad expressways. Whereas the landscape architect Roberto Burle Marx was, together with Costa, responsible for the urban space, it was predominantly the architect Oscar Niemeyer whose striking governmental and prestige buildings succeeded in making Brasilia into an icon of modernism. Niemeyer had already made his mark much earlier as the inventor of a genuine Brazilian idiom in international architecture. With his teacher, Costa, he worked with Le Corbusier in Rio de Janeiro in the late 1930s. Niemeyer had developed from the latter's architectural language a livelier, lighter organic form with unconcealed erotic connotations.

When President Jucelino Kubitschek, elected in 1955, wanted to build the new capital – already envisaged in the 1891 constitution – within only one term of office as a symbolic heightening of his accelerated modernisation programme, the architects had a unique opportunity to give form to the modern ideal city on a *tabula rasa*. Of course the seat of government is the location of a state's symbolic self-representation. Oscar Niemeyer filled the Square of the Three Powers with large sculpturally accented buildings. The extensive area forms the top of the Avenida Monumental, which represents the torso of the "bird" between the railway station, also built by Niemeyer, and the governmental district. References to the axial urban architecture of absolutism are obvious. The conclusion of the axis is formed by the gigantic, slightly sunken and broadly based building slab of the Congress with its round structures and office towers. The sculptural solitaires form a powerful contrast to the uniformity, even monotony, of the cityscape. The concept is similar to Le Corbusier's government buildings at Chandigarh, India. But the monumentality of Niemeyer's curvy and elegant solitaires entirely lacks the force of Le Corbusier's rough-cast concrete sculptures. The lightness and playfulness of the curvaceous forms reconcile the observer to the feeling of emptiness in the square.

Its extensiveness, however, is taken up by the Parliament building's roof slab, accessible from the square by means of a wide ramp. Thus the roof becomes a meeting-place and observation point for the sovereign, that is, for the people. The view extends far into the endless plain of the highlands. Here is not only the political heart of

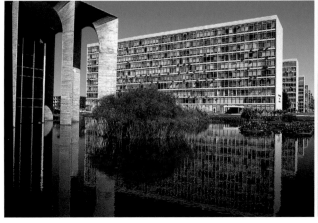

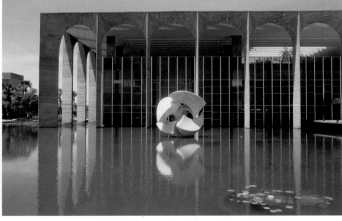

View of the ministry buildings

The Palácio de Itamaraty (Ministry of Foreign Relations)

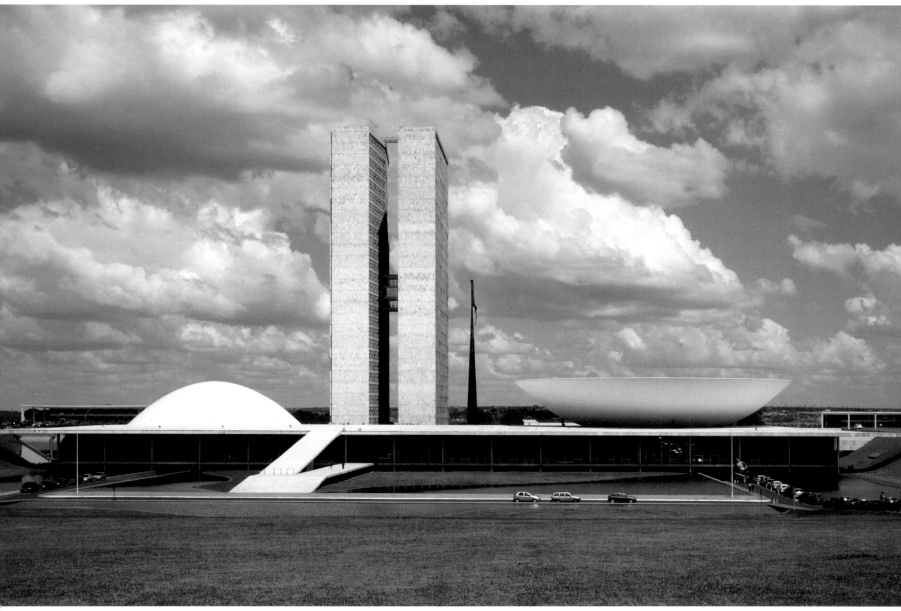

The National Congress building, whose roof terrace is reached via a ramp

the country, but at the same time the vanguard of a dynamic civilisation – this is the spatial message of this Brazilian Acropolis.

The square pond further distances the building from the lake and prairie, emphasising with its reflections the dramatic effect of the architectural sculptures: the low-vaulted, snow-white cupola of the Senate building, the equally brilliant funnel of the Parliament, and the slender slices of the administration towers, placed closely side by side. These resemble a twin-tower version of the UN building in New York. Most of the other government buildings, such as the palaces of the President, the Foreign Ministry and the High Court, are large, multi-storey glass cubes protected from sunlight by light, white overhanging roofs on fanciful, mannerist columns. The religious buildings offered Niemeyer further sculptural possibilities. The cathedral on its monumental axis is a tent made from concrete ribs; the President's chapel is a boldly rolled-up banner: an ironic commentary by the architect, who is still today a professed Communist?

Plan of Brasilia
1 Square of the Three Powers
2 Palácio de Itamaraty (Ministery of Foreign Relations)
3 Ministry of Justice
4 Ministries
5 Cathedral

Architectural fantasy, pencil drawing by Hans Scharoun, 1921–1922

Philharmonic Hall Only a few architects succeed in realising their early visions as mature projects in their later works. Hans Scharoun achieved exactly that with the new Philharmonic Hall on the southern edge of the Berlin Tiergarten (Zoological Gardens), whose tent-like structure was recognised not least in the vernacular name bestowed by Berliners at the time ("Circus Karajani"). This expressively lively, outsize sculpture was handed over in 1963 to the Berlin Philharmonic under their conductor, Herbert von Karajan. In addition, Scharoun's design coincided with the taste of the day. The modernist movement was discovering the attraction of a sculptural language of architecture, as in the tent-like roofs of Utzon's Sydney Opera House and Le Corbusier's church in Ronchamp.

But Scharoun was following the logic of his own development, not the spirit of the age. With the Philharmonic Hall, he was able to draw from the crystalline language of forms of the expressionism of the early 1920s. He had been one of its protagonists and had never given up the organic vision of an alternative modernism. Forty years later, the Hall would demonstrate the realisability of this vision. At the same time, an innovation was achieved in the typology of concert halls. The maxim of liberation from the corset of the conventional peepshow stage was "The music is the focal point". For the first time, a concert hall was organised as an arena with the stage in the centre, and a precedent was established, followed for ex-

ample in the Neues Gewandhaus in Leipzig of 1971, or now in Frank O. Gehry's Disney Concert Hall in Los Angeles. As early as the competition of 1956 – at that time a location not far from the Kurfürstendamm was envisaged – Karajan proposed to the jury the "so happy" design, which made possible an "unremitting concentration of the audience on the musical event". Contrary to appearances, the Philharmonic Hall is not constructed as a sculptural mass, but is developed from the interior to the exterior as a complex space. The intuitive circular form in which music-making takes place at home, according to Scharoun, was translated by him into the dimensions of a large hall with 2,200 seats. The central space allows for a decent proximity, in which a sense of intimate and of public space are not mutually contradictory. The new circular form is broken up into seating blocks, dramatically rising upwards – Scharoun called them "vineyards" – each of which represents a manageable share of space with a view of the whole hall. This enables every member of the audience to sit no further than 32 metres from the orchestra. Under the double-shelled tent roof with its impression of lightness, the music becomes a communal experience, in which the hierarchy of musicians and audience is overcome at least in spatial terms. The seating blocks are admittedly arranged predominantly in an axial-symmetrical manner, with four blocks in front of and four blocks behind the orchestra; but they are preserved from any sense of rigidity

View of the Philharmonic Hall and the Chamber Music Hall

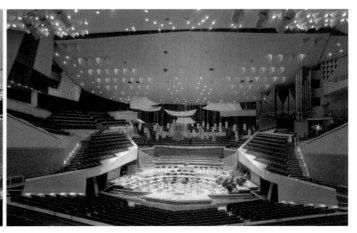

The concert hall was conceived by Scharoun as a central space

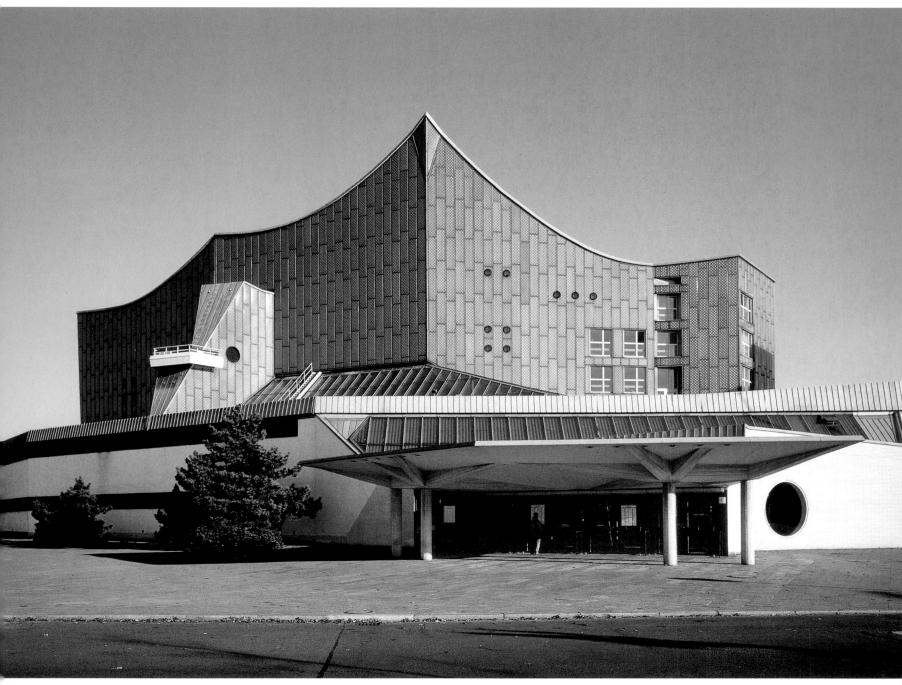

View of the entrance façade

by the expressive, vertical staging of the amphitheatre. Scharoun has succeeded better than his present-day successors in making space perceptible as the expression of a new social quality. In the opulent foyers, which give access to the hall via three complex interwoven levels, this basic social motif is newly orchestrated in space by means of ramps, landings and cascading staircases. Even more strongly than in the concert hall, which concentrates all the senses, the abundance of viewing perspectives here makes movement through space into a public appearance, a social event. An almost baroque delight in space transforms the audience into performers.

The interior wealth of spaces appears to be restrained on the outside in the form of an integrated, many-sided sculpture, which in its heightened dynamic can be experienced only in the round. Rising from a two-storey base – a wide area of which is partly glazed over – its expressive form conveys the scale of the large form to the passer-by. The non-tectonic walls of the architectural sculpture strengthen the impression of the textile-like character of a tent. The

curved roof edges and pointed formations at the edges of this polygonal crystal perhaps dramatise the building somewhat too strongly, as does the sculpture by Hans Uhlmann that crowns the tent roof. The façade's skin of sheet metal, gleaming like gold, was not added until the late 1970s. It had been envisaged by the architect before his death in 1972, but, like the over-large chamber music hall directly next to the main building, is a later addition.

Scharoun's urban planning idea of a continuum of landscape and architecture on the edge of the Tiergarten park, which he saw as a "kind of interior sculpture", his vision of a "musical city landscape", was never realised. Nevertheless, even today the golden sculpture of the Philharmonic Hall majestically asserts itself against the massive backdrop of the new site on Potsdamer Platz: rather than an urban intensification of nature sculpturality as a gesture of self-assertion by culture in the face of consumer society? The philosopher and musicologist Theodor W Adorno, a critic of mass culture, loved the Philharmonic Hall.

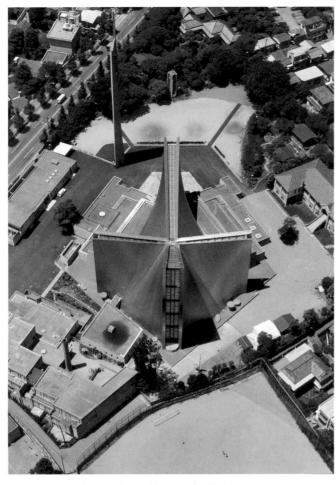

View from above showing the cruciform bands of light

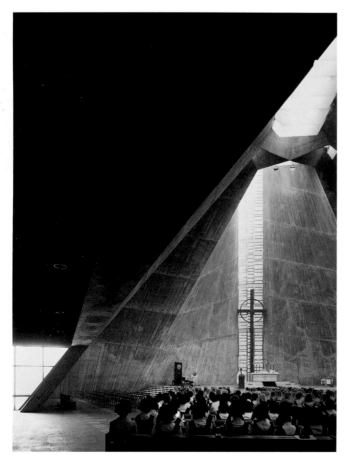

Interior of St. Mary's Cathedral

St. Mary's Cathedral With the building of the Peace Centre in Hiroshima in 1949 Kenzo Tange had become a key figure in modern Japanese architecture. As a representative of structural and metabolistic design concepts, in the 1960s he was among the best-known protagonists of the international modernist movement. Now, if not earlier, the world became aware of the futuristic architecture of Japan. Internationally active since the 1970s, Tange at first represented a very individual adaptation of European modernism, as understood by Le Corbusier, to Japanese architectural traditions. Expressive monumentality was one of the motifs that had not traditionally been cultivated in Japan, and Tange made it into a trademark of his architecture. A high point of his work was represented by the Olympic stadiums in Tokyo of 1961–64, curved concrete shells as dynamic as they were gigantic, with tent-like steel roofs, which he compressed into sculptures of mass entertainment.

St. Mary's Cathedral, although a lesser-known work, was built by him around the same time – following a 1961 competition – in a suburb of Tokyo containing traditional low structures. The previous building on that site had been destroyed in 1945. The new building, on slightly raised ground, with its steep, again tent-like roofs of up to 40 metres in height, and a slender tower placed next to it, nearly 61 metres high, symbolises the self-awareness of the religious minority. After viewing Gothic cathedrals in France, Tange had taken as his model the cruciform ground-plan as a spatial expression of a community of faith, and had moreover engaged the architect of the archbishopric of Cologne, Wilhelm Schlombs, as his collaborator.

The cross becomes recognisable in the lines of the roof, formed with continuous bands of light, which are drawn to floor level from the end points of the cross beams. The gently and elegantly sloping roofs, clad with stainless steel, consisting of eight concrete shells, widen at the base into a rhomboid form which nevertheless incorporates an axial-symmetrical nave. The demands of the Catholic liturgy are taken into account here in a thoroughly conventional manner. The community gathers under the cross, protected by the steep roof walls in a religious atmosphere which provides a modern interpretation of the medieval idea of the heavenly Jerusalem as a manifestation of light. From a distance, especially the reflective steel seems like a sign of the radiant light of faith, and lends an almost aggressive presence to the house of God. The building dispenses with any borrowings from Japanese tradition, but renders the European language of architecture unfamiliar. In this respect Tange admittedly associated himself with contemporary tendencies in European church architecture, whose radical experiments with the aura of the sublime, for example in Le Corbusier's pilgrimage church in Ronchamp, had proclaimed the sculptural potential of concrete. But precisely because Tange, unlike Le Corbusier, preserves the classical symmetry of the nave, he does not exhaust all the possibilities of sculptural intensification of the space.

The sculptural quality of the building is surrounded by a community centre built between 1966 and 1969 formed of low-built cubes, thus mediating between the church and the scale of the surrounding low-lying structures.

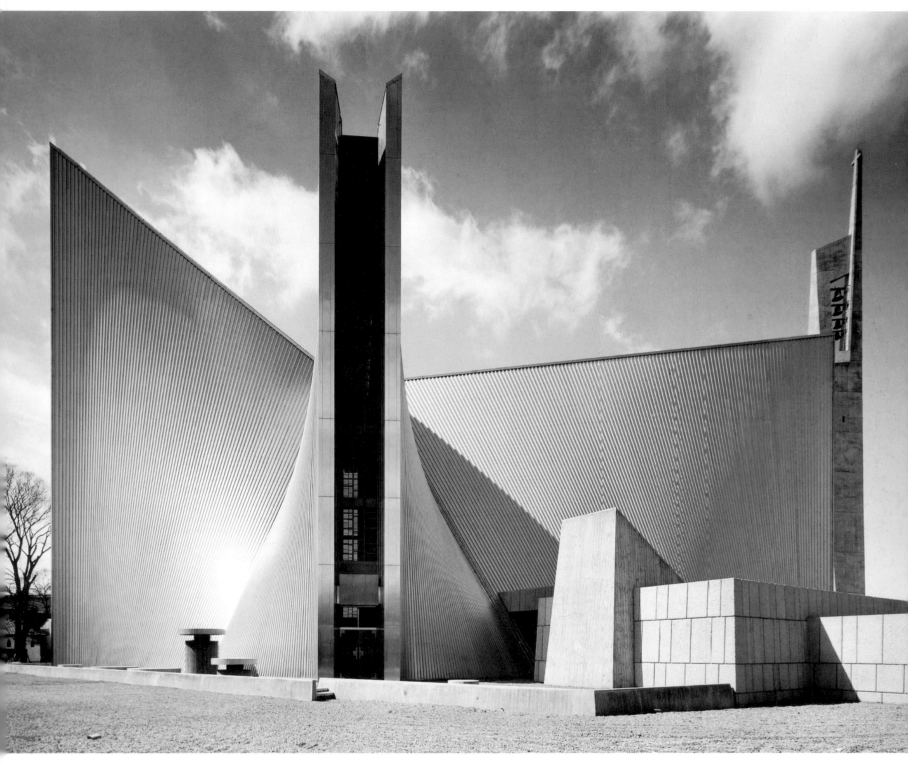

View of the church from the north

Negev Monument Two miles outside Beersheba in the Negev desert, on an elevation visible from afar, lies the Negev Monument. It is a reminder of the advance of Egyptian troops, checked in 1947 in this desert by the Palmach brigade. Thus the southern water supply, of vital importance for the kibbutzim, could be rescued. At that time the brigade also liberated the city of Beersheba, occupied by King Farouk's troops; here was thus an appropriate location for the monument.

The symbolic centre of the war memorial is dominated by a 20-metre-high tower with an Aeolian organ, a visual quotation of a military watchtower, together with a concrete "water pipe" leading out from a symbolic circular fountain: architecture or sculpture? Although a purposeless sculpture – if this structure were not adequately described as a mere monument – it does consist of clearly architectural archetypes. As a collection of sculptural forms, unrelated only at first glance, it is, as Amnon Barzel observed, "a village of sculptures". The settlement as fortress seems a totally appropriate image for the foundation, constantly endangered, of the young state of Israel.

On a surface of a hundred meters by a hundred metres, concrete structures define the space with their physical presence as geometric primary forms or tumbling fragments. But their abrupt materiality merges with the organic forms and thus seems to become a magical place of nature in the wide spaces of the desert. The sculptor Dani Karavan is both the heir to the "sculptural age" of 1950s architec-

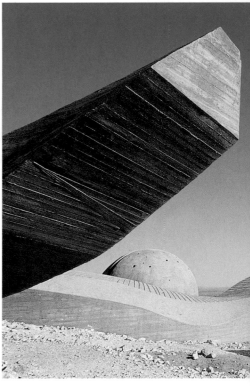

The desert sand and the concrete appear to merge

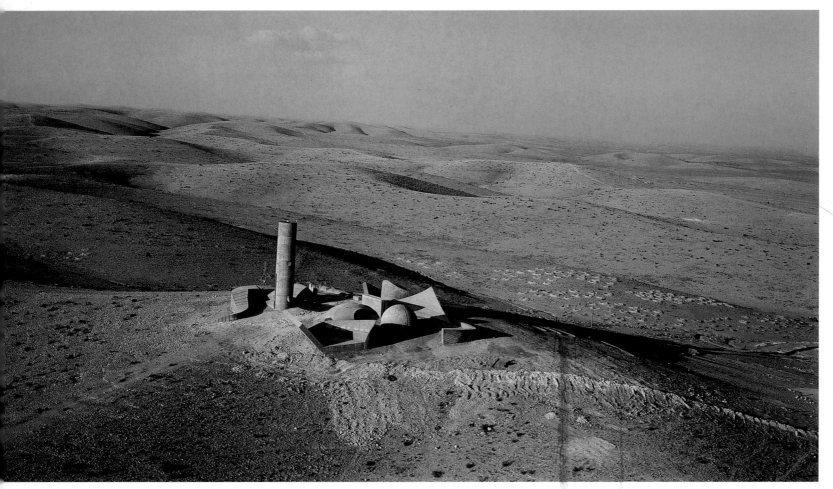

The Negev Monument lies at the highest point of the area around the town of Beersheba

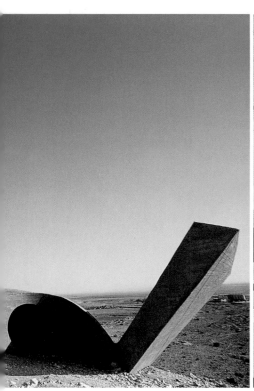
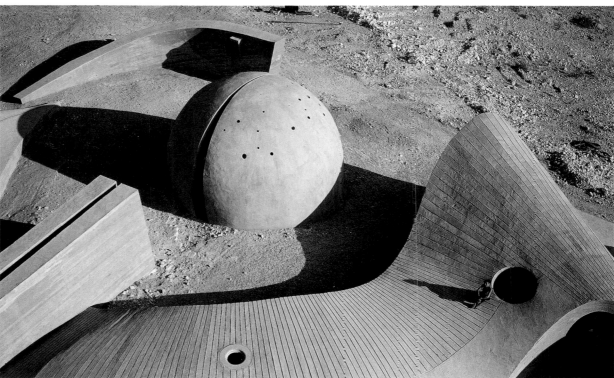

The monument is composed of various sculptural concrete structures

ture and the contemporary of the minimal art and land art of the American sculptors of the 1960s, such as Donald Judd, who allowed his concrete sculptures to become part of the desert at Marfa in Texas.

Among other forms, Karavan makes use of a pyramidal form that can be a dune or a tent, depending on the viewpoint, and the primary form of a sphere, admittedly an exploded sphere, strewn with holes reminiscent of bullet holes, inside of which are the names of the fallen soldiers of the brigade. The archaisation of forms that can definitely also be read as technoid – one s reminded of the concrete massifs of the Second World War ramparts – creates in Beersheba the space for a legendary recharging of history. The merging of concrete and sand, both in any case belonging to the same element, blurs the frontier between history and nature; history slipping into nature was, after all, also his contemporary Roland Barthes' definition of myth. This spatial transformation of symbolically, multiply-codified mythology succeeds, above all, because of the gentle concrete walls with their wave-like curves: organic forms reminding us, however, only fleetingly of the lightness of Oscar Niemeyer's sculptures in Brazil. In the Negev desert they screen off sombre tunnels of concrete, which allow the subterranean system of the "village" paths to become transformed into a labyrinth. But in the end, this opens into the desert in meandering movements; the historical dimension of time is lost in the eternity of nature.

As a visual artist, Dani Karavan can make use of archetypes more freely than can an architect. But it is in fact the architecture of Daniel Libeskind that will later demonstrate an elective affinity. The symbolic occupation of sculptural volumes and their intensification to an almost religious effect are exemplary testimony to the subtext of sculptural architecture in the work of Karavan: the structural invocation of the sublime in a secular world. If, according to Adolf Loos, architecture first comes into being in the tombstone and the monument, the Negev Monument is undoubtedly architecture.

Charcoal drawing of the exterior view by Gottfried Böhm

Pilgrimage Church of Mary, Queen of Peace When one gazes across the tiled roofs of the small town of Neviges into the gently undulating Berg region, the contrast could not be stronger. The striking concrete mountain of Gottfried Böhm's pilgrimage church seems to announce that it is not of this world. For the cult of the Virgin Mary, fostered in Neviges from the seventeenth century up to the present day, Böhm created a building whose abstract qualities in the play of its surfaces positively direct one towards the transcendental qualities of faith.

And yet it is an architecture that remains rooted in the soil. For without its surroundings the Mariendom, or Cathedral of Mary, would be unthinkable. After all, like every other pilgrimage church, it is the conclusion of a path. Its terraces and steps, climbing the slope, belong to the design, as does the pilgrims' hospice that accompanies the path. The last and – spiritually as well as topographically – highest terrace is formed by the space of the church itself. Here religious elevation is combined with cosiness in proportion and structure. At first, it is true, one steps into darkness, in which shine the deep red windows designed by the architect. But the small corners of the large space, the graduated galleries and rows of niches accommodate a few visitors just as easily as up to 7,000 of the faithful on feast days. Not least through the crowning of these forward and backward leaps by the steep roof sections, one is distinctly reminded of a medieval city, or rather of its portrayal in expressionist film sets.

This impression is more than a mere association. Böhm's Mariendom in Neviges is an architectural conversation between the Middle Ages, expressionism and late modernism. A religious atmosphere fa-
miliar from the Romanesque and Gothic periods is here evoked by the folded concrete shell. The Mariendom thus presents a twentieth-century response both to the Middle Ages as the golden age of pilgrimage and also to nearby Cologne Cathedral, with which Neviges shares the status of being the largest religious building in the archdiocese of Cologne.

That the building, despite such references, is a clearly modernistic one, is expressed first of all in the abstract quality of the concrete surfaces, layered one above the other. Their sculptural effect is only heightened by the fact that the bell tower originally planned was never realised. Thus the structure resists any traditional typological classification. The building is modern also in the sense of church politics. The church is unmistakably oriented through the altar opposite the main entrance and the heightened altitude. But the central ground plan appears to reject any authoritarian hierarchy. The underlying intention of allowing a variety of uses for the sacred space, from private prayer to public concerts, can be seen clearly in the sketched scenarios that Böhm appended to his design.

For these purposes, the architect wanted to offer an appropriate "tent". This, in fact, was an assemblage of folds, 30 cm thick in section, of local concrete, which was subsequently sand-blasted. In spite of this heaviness, the cathedral remains a modest refuge in so far as it brings paving stones and street lamps into the interior, and denies itself any insulation from heat loss. This shimmering alternation between durable materials and their origin in the transient, this deliberate conflict between the steadfast architecture and its varying allusions, constitutes the appeal of the Mariendom and makes it a sculpture that remains as formally perfect as it is functional. E.W.

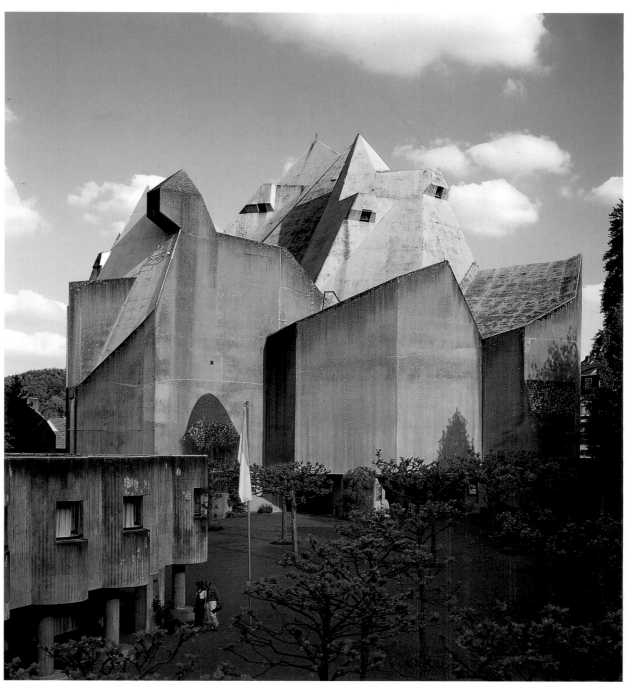

Pilgrims' way to the church of Mary, Queen of Peace

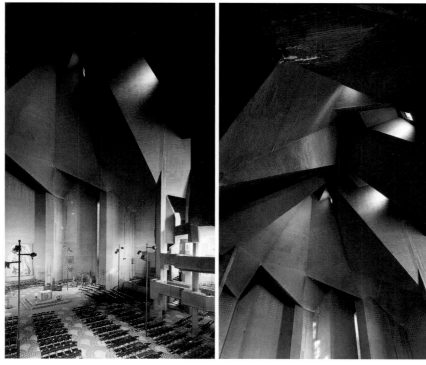

Interior of the pilgrimage church

View of the concrete folds of the cupola

Opera House The 2000 Summer Olympics in Sydney were the first major appearance of the country "down under" in the arena of global publicity. In the media's perception of this successful event, the distinctive and dynamic white concrete sails of the Opera House at the tip of the tongue of land called Bennelong Point made a particularly strong impression as a symbol of the awareness of life in sunny Sydney. It was not until 2003 that the architect of the Opera House, the Dane Jørn Utzon, born in 1918, received the Pritzker Prize for his life's work, but above all for this one building, which had opened to the public thirty years earlier. The bestowal of this most important architectural prize in the world can be considered belated satisfaction for an unfortunate building history.

This now undisputed city landmark at first met with violent opposition. The architecturally daring concrete shells, originally envisaged as somewhat flatter, had originated in a 1956 competition. In his design work, the unknown Dane had to struggle from 1956 to 1965 against a resistance so stubborn that he left the country in 1966. The continuation of construction up to 1973 considerably altered the original plans, particularly in the interior. Not until 2003 was a rebuilding programme decided upon in the spirit of the 1956 plans.

With this decision, a milestone and masterpiece of sculptural building from the transitional phase of the 1950s was able to unfold its full power. The Dane, significantly influenced by the Finnish architect Alvar Aalto, was at that time among the young revivers of postwar modernism. As already prepared by Aalto, the sensuality, emotion and playfulness of a sculptural architecture as a resource of the Modern were finally freed once more from the rigid rationalism of technocratic building. Sydney became a pioneering project of the "sculptural age", in the words of Carola Giedion-Welcker in 1955. The visual fascination of the building emanates above all from the

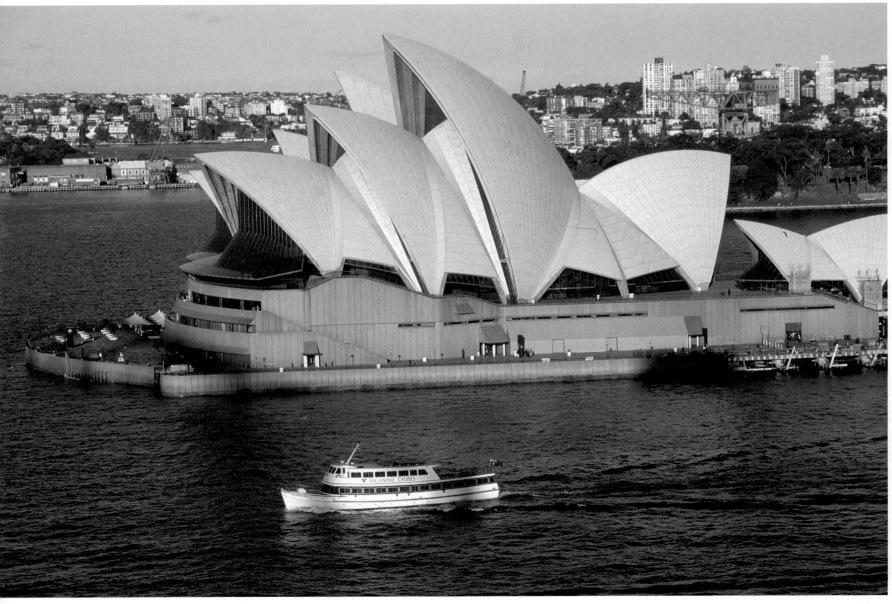

View of the Opera House with its characteristic white roofs

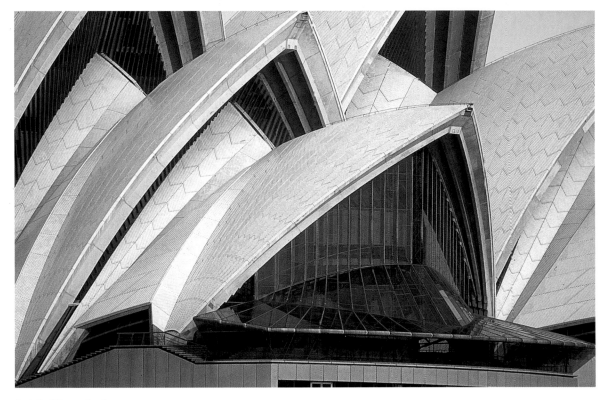

Detail of the roof sails

Sketches by Jørn Utzon of the roof shells

All the roof shells of the Opera House are derived from a single spherical upper surface

sculptural intensification of the sail motif. The presence of sailboats in the many bays of the city with its orientation towards the water is playfully appropriated in the free form of the roof. The concrete sails arch over two masses, each in three unfolding shell-like shapes. These present – up to now, unfortunately, only in Utzon's design – the auditoria as independent organic sculptures, whose roofs form a dynamic counter-movement to the swelling sails of the exterior concrete shell. A third, considerably smaller shell houses a restaurant. The sculptures rest on a platform, which includes an experimental stage and the side rooms. In contrast to the luxuriant green of the peninsula, the flat platform at its tip forms a hard edge of concrete. Analogous to the rising rows of auditorium seats in the concert halls, the platform rises to the tip of Bennelong Point and thus styl-ises the shells that open like blossoms towards the water. These free forms, reminiscent of the early expressionism of, for example, Bruno Taut, are placed by Utzon explicitly in the tradition of Gothic cathedrals. As in the Philharmonic Hall in Berlin by his contemporary Hans Scharoun, which demonstrates an elective affinity, Utzon presents the experience of music as a festive community experience, entirely without emotionalism.

The skyline of downtown Sydney that has grown up since the 1960s today forms the homogeneous backdrop for the eccentrically positioned architectural sculpture, which has now, together with the distinctive harbour bridge, become the symbol of modern Australia. The spirit of the "sculptural age" appears, half a century later, as a time-less expression of the modern awareness of life.

Detail of the service façade

Centre Pompidou The Centre Pompidou is a radical implant in the heart of old Paris. As a cultural centre, it has proven itself an urban pacemaker since 1977. At 42 metres high, it towers over the dense city area west of the Rue de Renard, not far from the town hall and the Seine. The massive steel structure – with its installations and steps set sculpturally in front of the outer walls, the technological roof structure, visible from afar, and above all, everything decorated in the powerful colours of pop culture – at first met with disapproval as an affront to the beauty of the *Gesamtkunstwerk* that was Paris, and then became very quickly accepted, even loved. But it remained the last monument of a radical technoid modernity in the historic city. The district of Beaubourg, cleared since the 1930s, was in 1969 made the site of an international competition by the newly elected President Pompidou. A concept of a modern, popular mu-

seum for contemporary art, a cultural centre, a library, and a media centre, was to once again bring Paris to the forefront over and against the art metropolis New York, and at the same time place culture without arrogance at the service of the city's population. Among the conditions for the competition were conformity to the urban planning context as well as the potential for a flexible use of space.

The competition winners decided in favour of flexibility rather than conformity. In an unprecedented move for Paris, two foreigners were entrusted with the commission: the Italian Renzo Piano and the Italian-born Englishman Richard Rogers, both architects who were still young and who were strongly influenced by the cultural mood of innovation of the 1960s. Their provocative design was a technoid-ironic pop architecture, a colourful culture machine, an "activity centre" (according to the architects) as profane as it was joyful, or "an

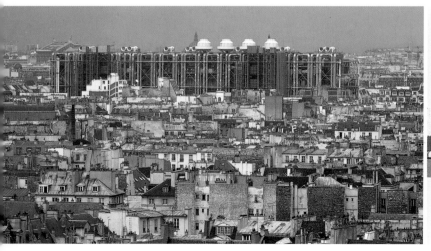

The Centre Pompidou in its urban context

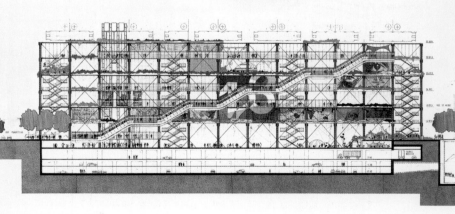

Longitudinal section through the building

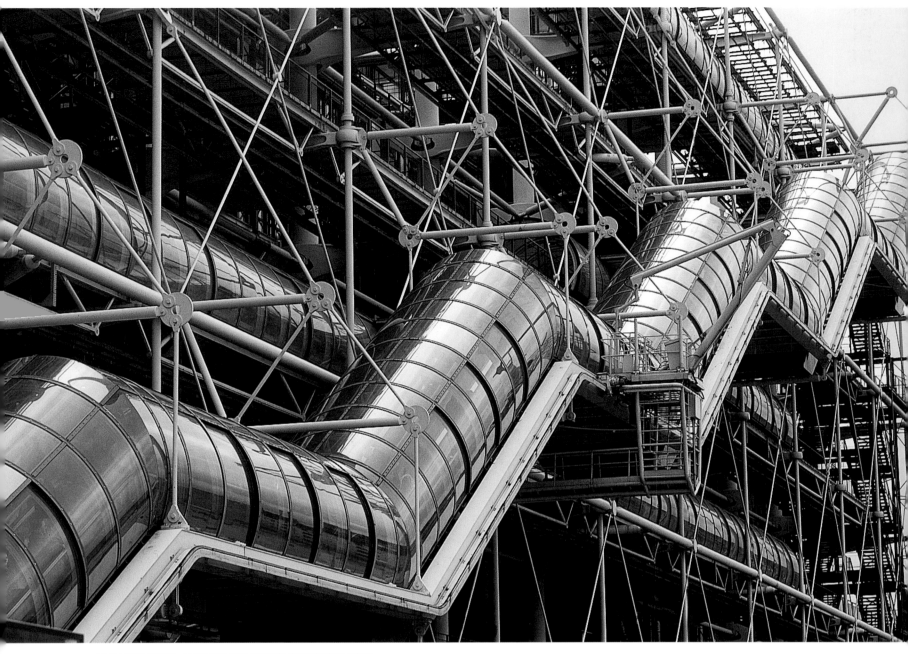

On the west façade, escalators lead upwards through glass tubes

anarchic 'happening' arena", according to one critic. In 1961 Cedric Price had already envisaged a Fun Palace for popular culture in London, a "laboratory of fun"; this vision of a flexible large space in a steel framework became the model for Piano and Rogers. Thus their *leitmotiv* was unpretentious: their theme was not the aura of old Paris, but maximum flexibility in the interior rooms, which were to be freely interpreted. Not least with the help of the great building engineer Peter Rice, they created, on five floors 166 metres in length and 60 metres in depth, a total of 110,000 square metres of usable floor space, freed from all disturbing functions. Thirteen gigantic steel frames shift the load to an exterior structure, strengthened by additional, almost sculptural steel struts. The east façade, facing the narrow Rue de Renard, accommodates all the installations and development systems. The street is almost brutally besieged by the brightly coloured entrails of the building – one critic was reminded of the back of a refrigerator. The west side of the building, the main façade with the entrance, opens onto a square laid out on a grand

scale, slightly sloping down to the building, an urban stage. The massiveness of this technological sculpture is thus explained by the architects' intention of giving air and social space to the inner city of Paris, an aim in which they succeeded. A further attraction of the building is formed by the escalators within glass tubes on the west façade, achieving an elegant effect of height, the so-called *chenilles* or caterpillars. For visitors who rise above the roofs of Paris only because of this mobile viewing platform, the "city culture" is thus revealed to them in passing.

The aesthetic provocation of the Centre Pompidou can still be felt today. Piano and Rogers, who were later to become, and remain, along with Norman Foster, the protagonists of a high-tech architecture laden with symbolism, succeeded in promoting the development of pop architecture. Particularly today, when pop in the form of retro is once more in fashion, the timeless power and vitality of this technoid sculpture is again in evidence. The question of "old Europe", of whether it is really "beautiful", becomes superfluous.

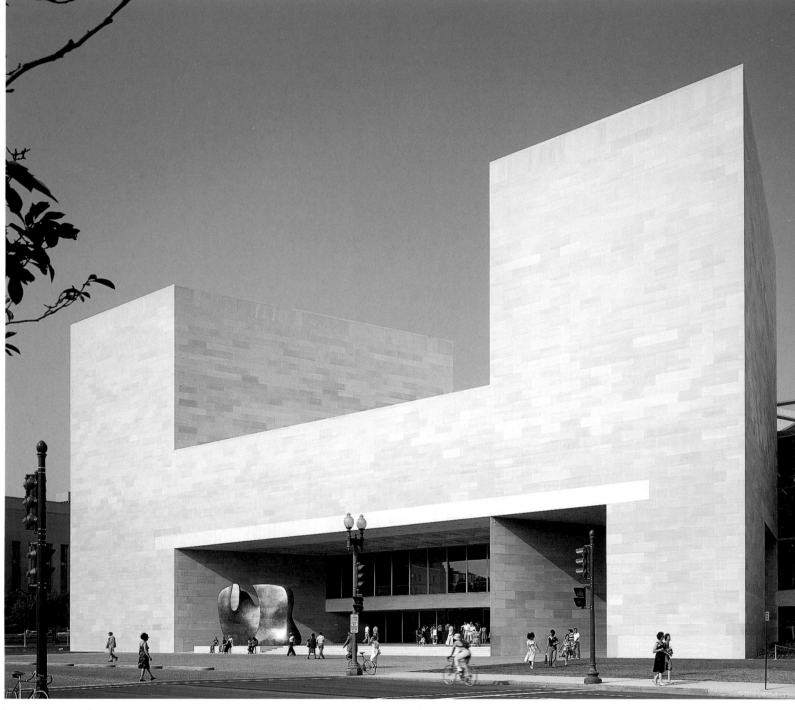

The entrance area of the museum

Design sketch by I. M. Pei

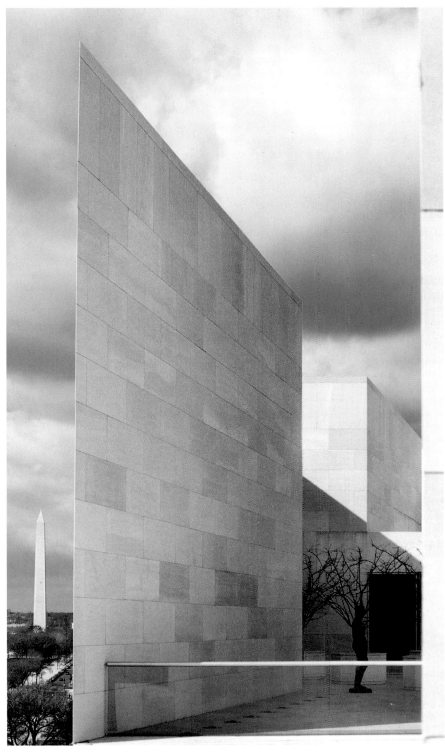

The sharp corners, a striking element of the marble-clad building

National Gallery of Art, East Building The overwhelming public success of the extension to the National Gallery of Art in Washington has made a significant contribution to the world-wide museum boom from the final decades of the twentieth century up to today. It was to bring its creator further important commissions such as the spectacular rebuilding of the Louvre in Paris from 1983 to 1993. I. M. Pei, who studied under Walter Gropius at Harvard, had become prominent since the 1950s as a representative of moderate modernism, which rehabilitated monumentality as a legitimate theme of public architecture once again. Museum building was receptive to these demands, and as a result, with several museums in the provinces, among them the sculptural-cubist Everson Museum of Art in Syracuse, New York (1961–1968), Pei was able early in his career to at-

tract attention as an architect who commanded a sculptural language of form which lent a new power of expression to the minimalism of the modern.

At the triangular site on the monumental axis of the Mall in Washington, this "magical modernism" proved itself to be an appropriate response to an urban context, shaped within sight of the neoclassical, somewhat cool magnificence of the ministries of the Federal Triangle built in the 1930s. Hemmed in between Constitution Avenue, which runs alongside the Mall, and the diagonal connecting axis between the White House and Capitol Hill, Pennsylvania Avenue, the new East Building of the National Galley was to take up the axis of the main building. Pei responds to the neo-classicism of John Russell Pope's main building, built as late as 1941, with a sculp-

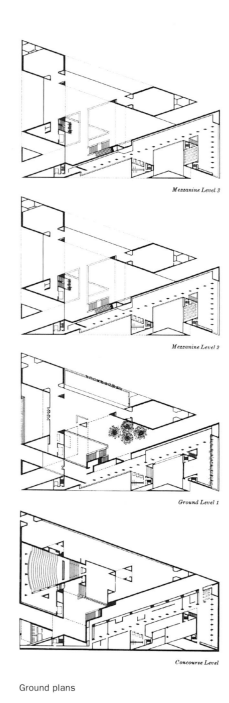

Mezzanine Level 3

Mezzanine Level 2

Ground Level 1

Concourse Level

Ground plans

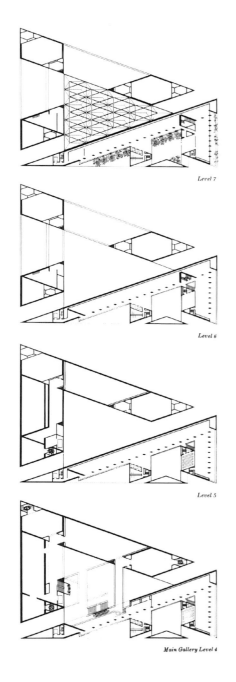

Level 7

Level 6

Level 5

Main Gallery Level 4

tural building as expressive as it is coolly controlled. He makes no formal concessions. The west front of the east wing does indeed respond, though asymmetrically, to the axis of the original building, but the structure is oriented according to its own logic. Pei develops it out of the not quite perfect, trapezoidally abbreviated triangle of the site, by dividing the surface into two triangular structures. The more northerly and larger of the two is based on an isosceles triangle, whose corners are accentuated by tall acute-angled towers that double its height. Here can be found the exhibition rooms, which are gathered around a central, also triangular, glass-covered atrium. This light-filled, inviting public space, furnished in festive fashion with bridges and staircases, is also accessible from the southern structure. This, a slender, acute-angled, wedge-shaped structure rising to the height of the towers of the gallery building, forms a striking front towards the Mall. It houses the Center for Advanced Study in the Visual Arts, accessible only to researchers.

The combination of the two triangles results in a complex spatial structure of intersecting perspectives, which, particularly when seen from below, evokes the sublimity of a mountain landscape, though severely geometricised in the basic module of the triangle. Pei's sculpture conforms to the original building in the dimensions of its height and also adopts its material, a reddish marble from Tennessee. In other respects however it transforms the latter's axial severity into a free modern composition, whose sculptural complexity can only be experienced through movement, from different perspectives and viewpoints. The insular situation of the site, which at first appeared to present a problem, has been used by I. M. Pei as a chance to visually intensify the structure's solitary power.

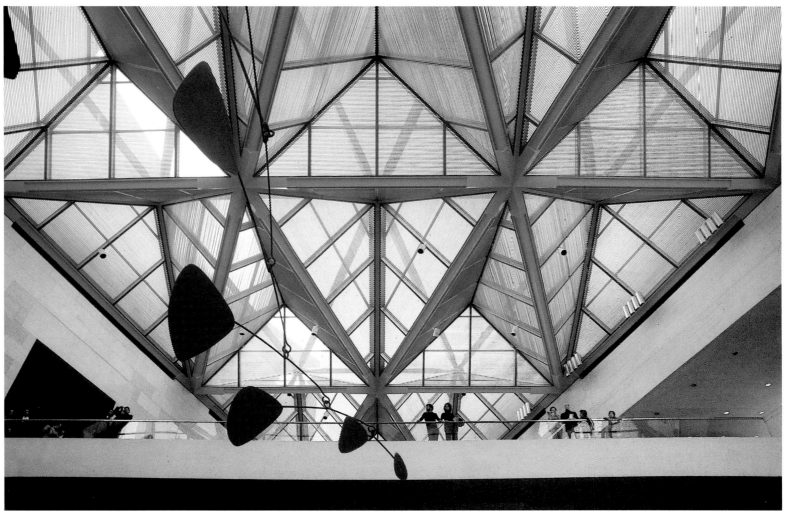

Glass ceiling above the central area of the extension building

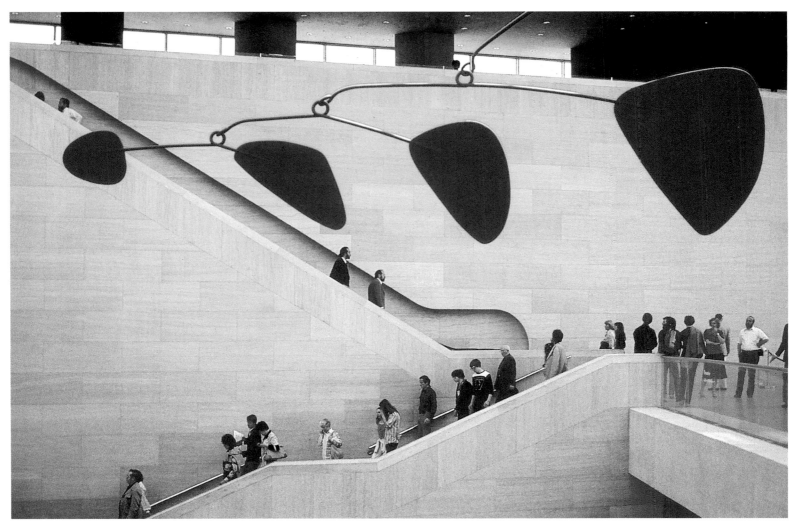

Interior with a mobile by Alexander Calder

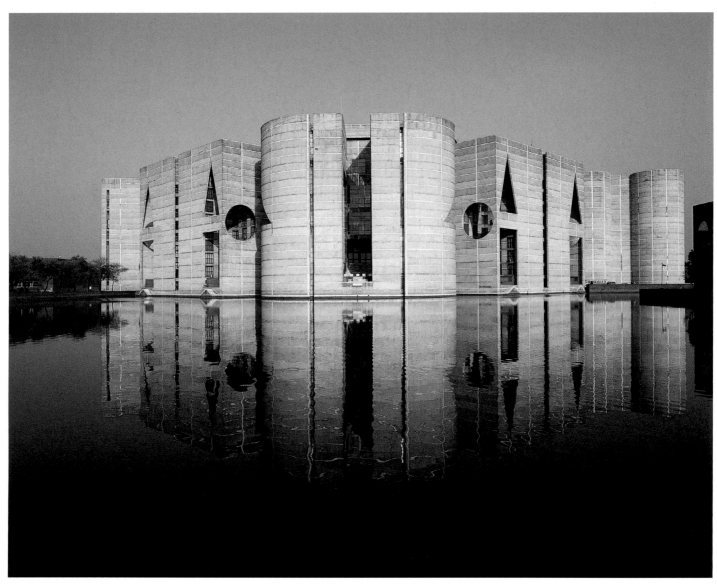

The Parliament complex, lying by a lake, composed of various individual geometrical structures

National Assembly For a long time, political prestige has not been among the main concerns of modern architecture. Thus it was seldom possible in the twentieth century to create state architecture without recourse to emotional historical formulas such as those of Neo-classicism. All the more surprising, therefore, is the impression created by the archaising, massive concrete fortress at Sher-e-Bangla Naga, the "city of the Bengal tiger", the governmental quarter of Bangladesh situated on the outskirts of Dacca. The National Assembly building of the new state, first used in 1982, has its origins in a design of 1963 by the American architect Louis I. Kahn of Philadelphia, who had already died in 1974. An architect of the

modernist movement with an admittedly conventional education in the Beaux Arts tradition, Kahn, after a detour through a technoid hypermodernism, finally in the 1960s brought about a surprising change in the International Style of post-war architecture in the USA. The new monumentality was to give a new meeting-place and identity to the community feeling that had been disappearing in the wake of "mass society". To the architect, only a return to eternally valid geometrical primary forms and archetypes seemed suited to accomplish this political task of architecture. It was not glass and transparency, as in the contemporary Federal Republic of Germany, but an auratic monumentality and physicality of the building, that Kahn expected to

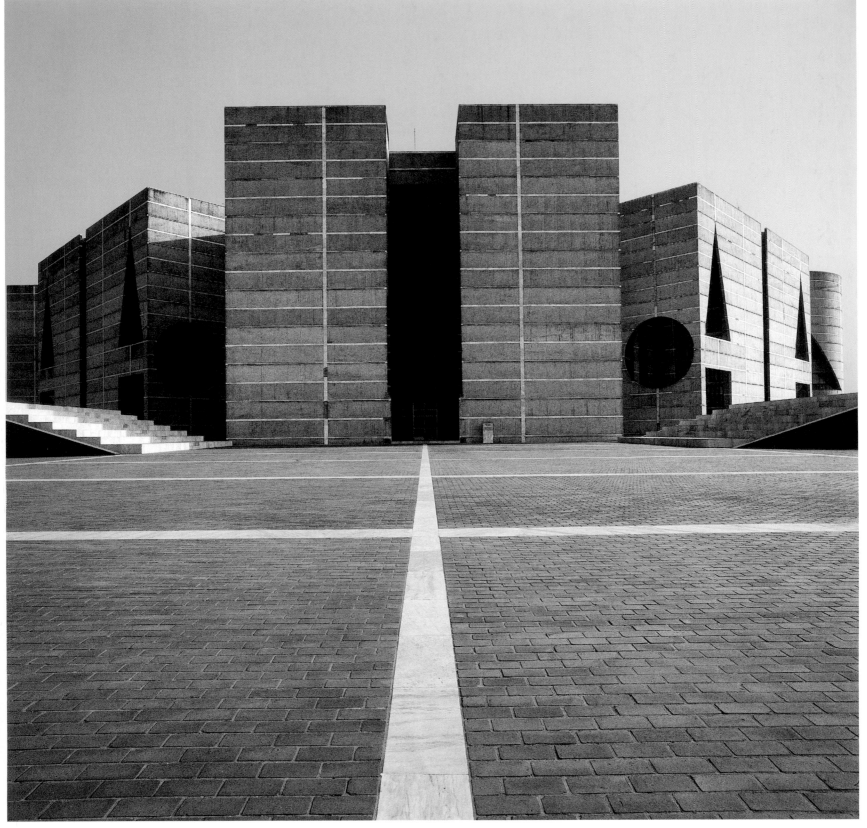

Exterior view from President's Square

be the appropriate expression for the "majesty of a government of the people, working for the common good". Without ceremony, he transplanted this American theme onto the Indian subcontinent.

The basic form of the conference hall in Dacca represents the circle as primary transcendent space for democratic assembly; around it are grouped ancillary spaces such as lobbies and offices in separate buildings. The octagonal central Parliament building distances itself from the city with a base accessible by a 200-meter-wide flight of steps, an expanse of water and a wide area of lawn; it seals itself off from the outside world with massive concrete walls with joins filled with marble, and has the appearance of a gigantically height-

ened fortress. Extending over several storeys, openings in the form of circles, acute-angled triangles and squares create an intermediate, shady zone before the interior of the building, but also, through the distortion of scale, create an additional monumentalisation. In the geometrical reduction and heightening, historical models such as those of late Roman architecture, Palladio and the Renaissance, the architecture of the French Revolution, but also of the Taj Mahal, are not merged in an eclectic blend, but preserved in a mystical idea of space outside time. Thus, without direct historical quotation, Kahn opens up a space for dignity, for sublimity, for an authority actually appropriate only to the classic tradition. The rapid weathering

The ceiling of the Assembly Hall

Drawing of the overall plan of the site by Louis I. Kahn

Design sketch by Louis I. Kahn

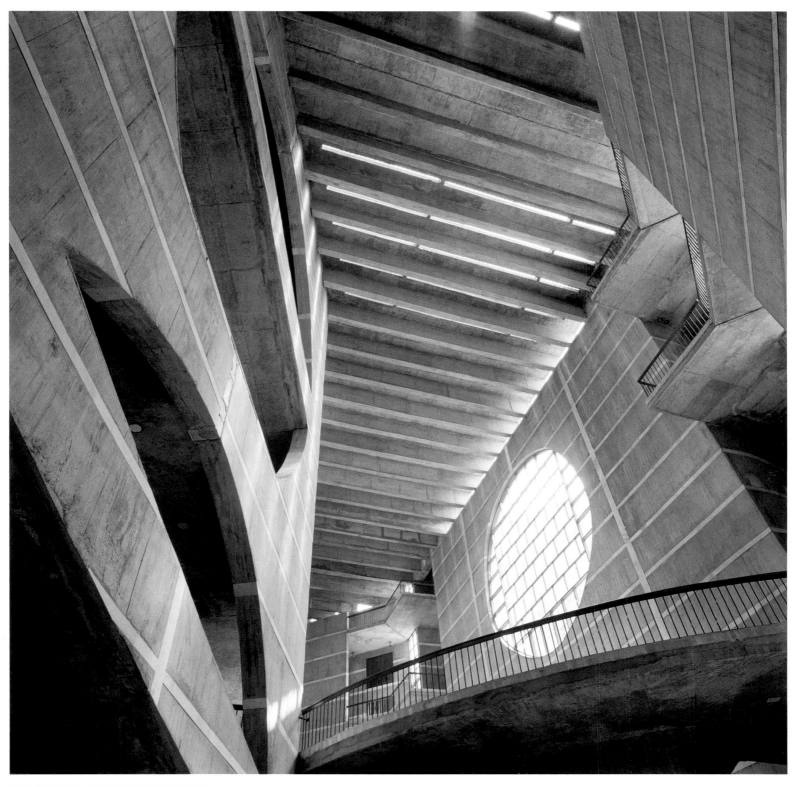

In the interior, too, geometric forms predominate

of the materials only enhances this impression of the aura of the ancient.

The inner rooms of this extensive complex include a lobby of the same height as the building, dominated by the dramatic perspectives of the staircases, and also a mosque. Their deployment of light and space contribute to the religious enhancement of the space: the National Assembly as a compressed public area, as the heart of the political system expressed as space.

Unintentionally, however, the fortress-like character of the Parliament building refers to the disparity between the architect's American ideals and the reality of the impoverished country controlled by the military. Designated as early as 1962 as the seat of government of East Pakistan, its realisation delayed by the civil war in the early 1970s, this building, otherwise infrequently used, first saw the celebration of a democratically legitimised change of government in 1991.

Together with Oscar Niemeyer's Brasilia and Le Corbusier's Chandigarh in the Indian Punjab, Dacca thus represents one of the few modern models of political architecture – and its influence extends as far as the new Chancellery in Berlin.

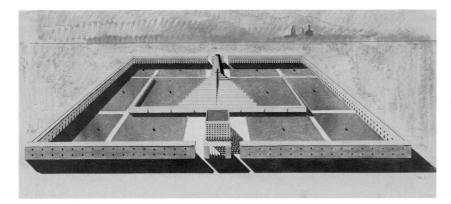

Perspective view from above, drawing by Aldo Rossi, 1971

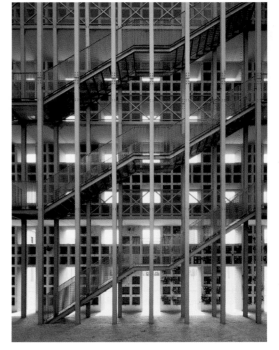

The shelf-like structure of the interior of the charnel-house

Cemetery of San Cataldo With his design for the cemetery of San Cataldo, the man who was the guiding intellectual force of rationalistic architecture in Italy made the necropolis into a monument to his urban concept. As editor of the architectural magazine *Casabella-Continuitá* and as a theoretician in his book *The Architecture of the City* of 1966, Aldo Rossi introduced the repossession of the historic European city. The reconstruction of the European city, which with its ground-plan and its central monuments came to be perceived as the bearer of collective memory, developed with Rossi into the guiding image of European postmodernism: the city as artwork, as form, as symbol of beauty. A typology of basic forms, which guarantees their autonomy, became characteristic of Rossi's architecture. The laws of beauty regained their rightful place against modernism's idea of functional building. In this way a cemetery became a model of the city. The severely orthogonal and axial plan of 1971 formed a connection with the logic of the old neo-classical cemetery's courtyard layout. Rossi's new, larger space includes the outer walls of the courtyard, but establishes an independent order with its dominant central axis. The axis finds its sculptural, abstract-geometrical vanishing points in two monumental structures of geometrical primary forms, a truncated cone and a cube at each end. The southern, red-painted, free-standing concrete cube represents the type of the primary form of the house. As a charnel-house, it symbolises death; as an abandoned, incomplete house without a roof or an upper storey, it is a mere empty shell with a monotonous arrangement of holes for windows. In the interior, the urns are gathered around the empty courtyard in an austere, shelf-like metal structure. At the opposite end of the axis, the cone, reminiscent of a chimney, houses a mass grave. Parallel, conically converging rows of bone graves, branching off in close succession from the central axis, create the impression of a skeleton in the ground plan. The rows of graves also form a triangle in their ascending height. The outer row of graves surrounds this area in the form of an extensive U-shaped enclosure wall. The passages between the enclosing walls and the line of columns added in 1978 complete the "street system" of this city of the dead. In its handling of space by means of structures and monumental geometrical objects, the severe rationalism of the site appears like a metaphysical and poetic staging of the eternity of the city as pure form. The atmospheric intensification of a transcendental concept of space reminiscent of the *pittura metafisica* of a Giorgio de Chirico or a Mario Sironi achieves a physical intensity that for a moment visibly expresses Rossi's thesis that it is the place and not the event that is the essence of the city.

The use of elementary forms such as the cube, cone and pyramid evokes the permanence of the symbolic form. Here in Modena, however, the tragic subtext of the typology is also perceptible. The *rappel à l'ordre* announced by Rossi in allusion to the French Revolution architecture of his model Boullée, the return to the order of geometry and form, seems to be possible only at the price of a rejection of life. Sculpturality for Rossi arises not from the impulse of a vital shaping of free form, but is the result of a melancholy surrender to the eternity of archetypes. In his later buildings, Rossi attempted to escape from this effect of his early purism by means of inclination towards historical allusion and a forced use of colour.

The red cube of the charnel-house

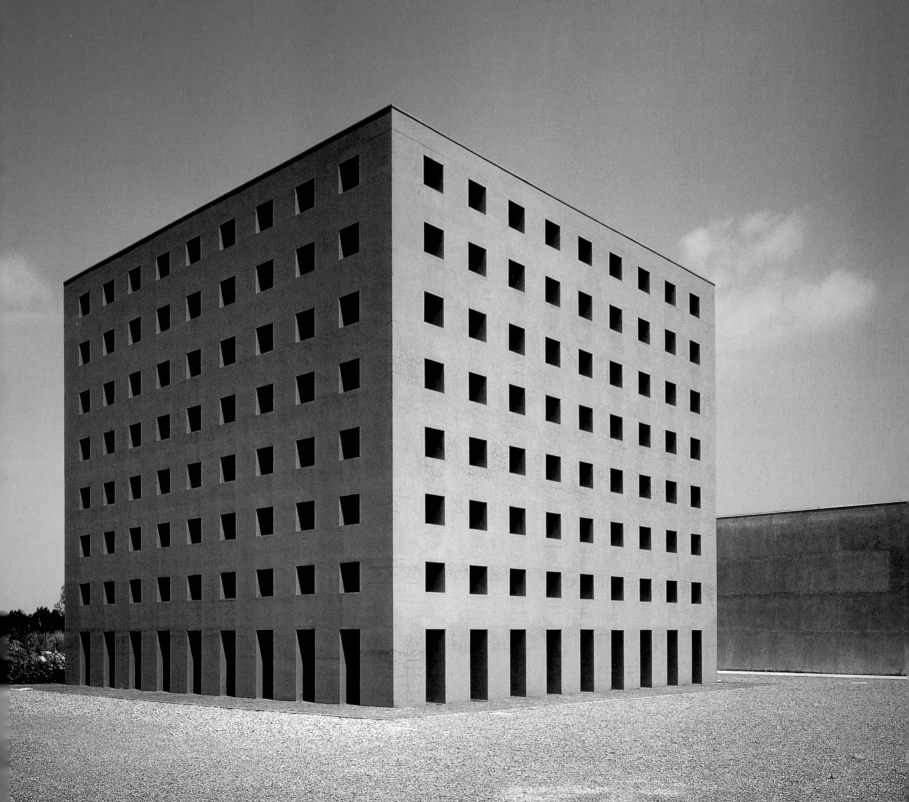

Diagrammatic drawing of the building

Wexner Center for the Visual Arts Can a building that was described by its architect specifically as a "non-building" be an example of sculptural architecture? Peter Eisenman is the guiding force in a rigorous deconstruction of the classical principles of order in architecture, those based on the human body. The Wexner Center for the Visual Arts represents an intellectual architecture that translates this anti-classical, anti-humanistic feeling into an autonomous a-classical concept of space, a concept that also transforms the existing neo-classical context.

The museum, whose design emerged victorious in 1983 from a competition by invitation, lies on the edge of the oval campus of Ohio State University in Columbus. The axial order of the campus – designed in 1880 by Frederick Law Olmstedt, the famous creator of New York's Central Park – is surrounded by a wreath of neo-classical monumental buildings and embodies in an ideal manner those very humanistic concepts long since overcome by Eisenman.

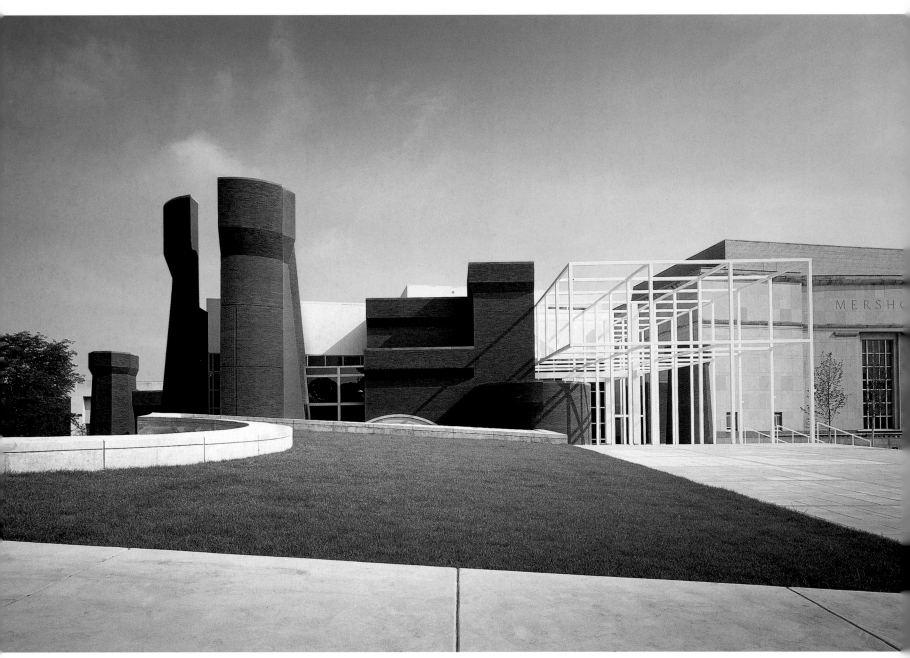

The entrance area of the museum

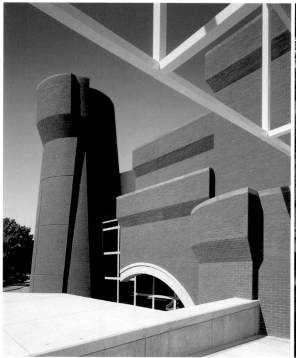

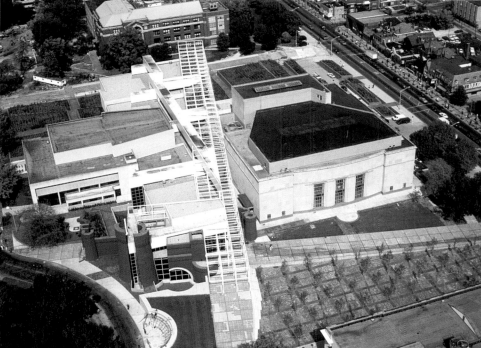

Façade with the brick towers

Aerial photograph of the overall plan

The Wexner Center lies on the south-eastern edge, on the city side of the campus, and forms a long-drawn-out, wedge-like structure of white steel half-timbering; it runs diagonally between the existing monumental buildings and draws a new axis into the campus, which, turned by 12.5 degrees out of the axis, leads to the oval inner path. Here, in a large square, the diagonal – recognisable at first only as a path, then as a free framework – crosses at a right angle a path directed out of the orthagonal road network of Columbus. The overlapping of city and campus creates a new spatial complexity and thus relativises the fictive rationality of the "grid" that is omnipresent in the USA. The long, pointed triangle of the exhibition space is only part of the 157-metre-long grid construction. Dominated by the crossing of paths, with which it is linked by a transparent glass wall, the exhibition space is experienced both as an interior space and also as part of the space outside; it does not assume the protective function of a house. As a spatially diffuse intermediate world, the imaginary mass of the grid seems to undermine the massive tectonics of the surrounding old buildings.

To the west, the building, here only a white grid, pushes into a free space, a square designed by Laurie Olin as landscape architecture.

Just as in the raised flowerbeds in sandstone at the east end of the passage, "an abstract representation of the prairie" (Eisenman), the square created a symbolic connection between landscape and culture. The white grid here alludes to a sculpture by Sol LeWitt. The sculptural dimension of this collage of fragments appears not to be a mass, but a mere indication of structure under the wide heavens of Ohio.

To the north of this interface, fragmentary brick towers and an artificial suggestion of a fortress wall with a large truncated arch confront the white grid and create, in the direction of the oval historic park, a collage of almost romanticising allusions to ruins. They represent the memory of the historic armoury that once stood on this site. The composition of fragments with its faintly post-modern effect, in combination with the various viewing axes and the "non-building" experienced only through the grid and a few white walls, subtly undermines and alienates the orderly arrangement of the campus. Less a place of storage for art than an open, new communication space for city and campus, in architectural terms this place of experimental art develops a rather ephemeral and fragile network of allusions and refractions: architecture as text.

T-House The villa landscape of the Renaissance that came into be-ing in the course of the fifteenth and sixteenth centuries around Rome, Venice and Florence experienced perhaps its most successful reinterpretation on American soil. Thomas Jefferson – humanist, ar-chitect and third President of the USA – began it with his legendary country estate, Monticello. Situated on a mountain spur, the house commands a view of the landscape. An indispensable part of the vil-la is the library, in accordance with Jefferson's ideal of the cultured American country resident.

Thanks to its more liberal building legislation and a clientele to match, such a concept of the villa and of country life still exists to-day in the USA, although, naturally, in a form adapted to contempo-rary ways. An outstanding example of this in the architecture of re-cent years is the sculptural T-House by Simon Ungers and Tom Kinslow at Wilton in New York state, a good three-hour drive from the metropolis. Here too the client, the writer Lawrence Marcelle, wanted a house entirely befitting his personality, and here too his library, comprising 10,000 volumes, was to play an important role in the organisation of the building. This turning towards country life and

culture is not the only analogy to the Renaissance. A first glance at the house, with its upper part projecting like a letter T, makes it clear that extravagance was entirely intentional here. But a second look at the proportions of the building parts and the arrangement of the windows makes it clear that a cleverly devised system of archi-tectural order holds the building together, and makes it appear by no means to be a mere gimmick. The lower part of the building with its high-set windows responds to the upper part whose windows are placed lower, and the whole design revolves around the central part with the largest opening: the entrance door.

This arrangement results from the client's wish for a strict separa-tion between working and living areas. Ungers interpreted this by placing bedrooms, living and eating areas as well as the kitchen in a transom that is pushed to the back on the mountain slope. Upon this is placed the connecting section with the entrance door, which is reached by way of the roof, and on the very top is enthroned the library, turned towards the base in the right corner. Here the 2.4-metre-high and 60-cm-wide windows reach down to the floor. From this elevated position, they allow a view of the forest landscape of

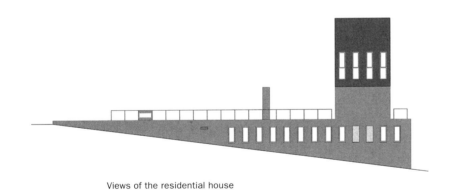

Views of the residential house

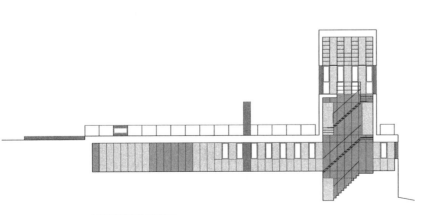

Longitudinal section

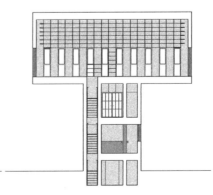

Cross-section

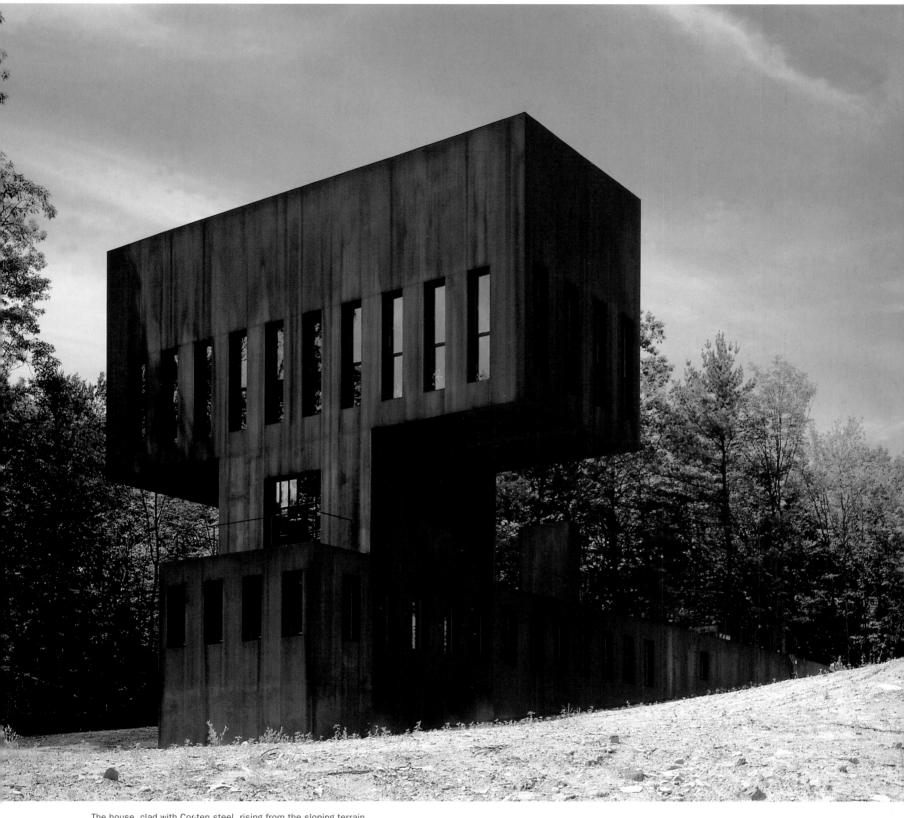

The house, clad with Cor-ten steel, rising from the sloping terrain

the Berkshire mountains and let daylight pour into the workspace. Protected from direct light, the books themselves are stored in the topmost section of the library block's considerable area, measuring 13 metres long, 4 metres wide and 4.8 metres high.

From the outside, the appearance of the building is as elegant as it is unwelcoming: 6-millimetre-thick, rust-covered Cor-ten steel panels – prefabricated, delivered and mounted on the concrete base in only six parts altogether – form a totally smooth hermetic seal enclosing a warm interior, furnished with teak flooring and mahogany panelling. In the living area, as in the library, the windows can be closed from the inside with wooden blinds, thus transforming the wall into a smooth surface. This stringency of lines and materials is continued throughout the strictly symmetrical disposition of the ground plan, extending to details such as the furnishing of the bathroom and kitchen: stainless steel, like that in the large-scale professional kitchen or even in prison sanitation, was used exclusively here. E. W.

Situation sketches Sketches of the exterior view Interior sketches

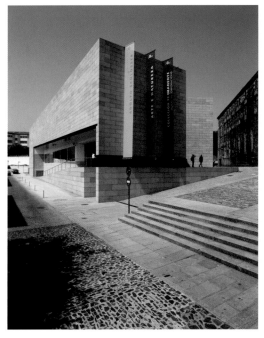

Exterior view of the entrance area

CGAC, Galician Centre for Contemporary Art On a slight elevation above the roofs of the old city of Santiago de Compostela, a place of pilgrimage, the extensive and massive complex of the baroque monastery site of Santo Domingo de Bonaval with its church dominates the transition from the city to the hilly surrounding area. The monastery is both a religious building and a museum; it houses the historic museum of the north-western Spanish province of Galicia. Álvaro Siza's distinctive, resolutely modern new building, the Centro Gallego de Arte Contemporáneo, strengthens the claim of this province, autonomous since the end of the Franco regime, not only to its collective memory but also to cultural contemporaneity. At the time of the competition of 1988, from which Siza emerged victorious, there was as yet no collection of present-day art; the programme for the space was still undetermined.

This museum, finally opened in 1993, occupies a complicated, triangular, downward-sloping site between the west portals of monastery and church and the somewhat lower-lying old city. In the interior of a courtyard protected by walls, however, lies the main portal of the monastery. With its east wing the new museum presses up against the historic monastery wall, together with which it forms a square widening to the north. This square leads up into the adjacent historic monastery garden, also reshaped by Siza. Rising eastward following the slope, his terraces with their brickwork form a natural continuation of the triangular, monolithic museum building.

Álvaro Siza, the architect from Porto known equally for his defiant minimalism and his sensitive treatment of the historic context, received the Pritzker Prize shortly before the opening of the CGAC. In Santiago too the paradox of a contextual architectural sculpture is a success. The uncompromisingly severe, sharp-edged block is composed of three largely windowless structures, which form a triangular

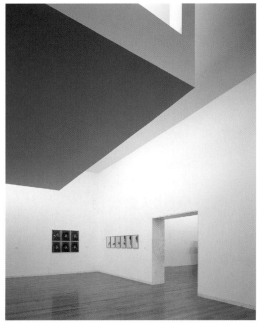

View of one of the exhibition rooms

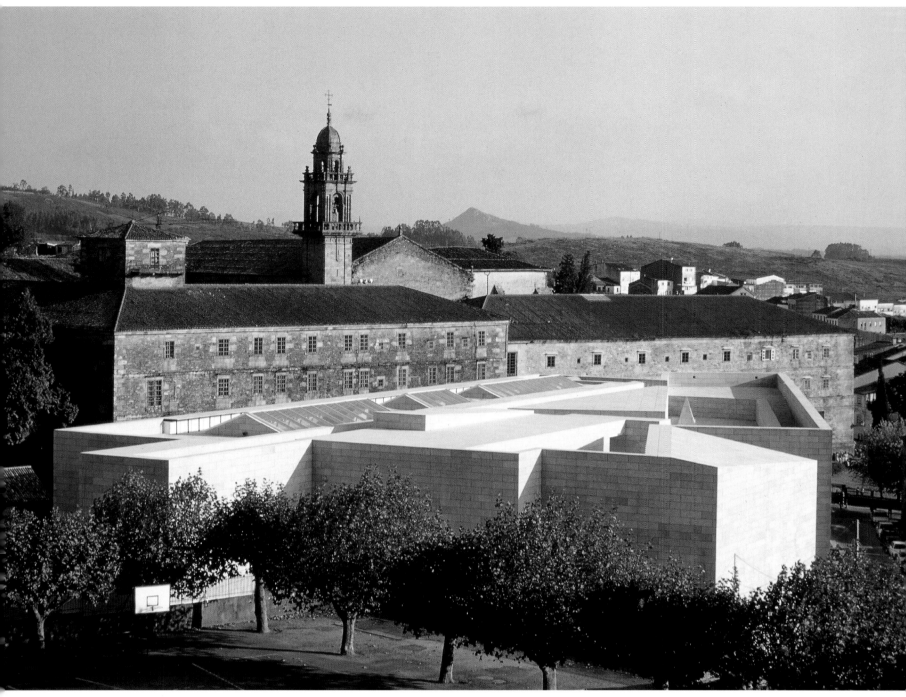

Aerial photograph of the building

ground plan around an atrium courtyard. The almost hermetic sealing off from the exterior, which however is prevented from having a discouraging effect by the light-coloured granite of the façades, is counteracted in the interior by a light-filled sequence of exhibition rooms. Two prisms arranged at acute angles border a triangular atrium with a glass roof in the centre. A long staircase, also glass-covered, parallel to the halls connects the building from the entrance hall to the south up to a roof terrace, which, like a part of the garden, also serves as an exhibition space.

In the entrance area, the two structures form a diamond-shaped point, not harmonised by the collision of the cubes. The spatially almost rigid entrance situation, together with the somewhat higher-lying portals of convent and church that stand close together in the

right-hand corner, form a forecourt which slopes slightly down westward to the street. This is flanked and monumentally dominated by the structure of the museum. A ramp included in the wall and an extended, storey-high glass façade here present a careful opening to the city, but without breaking the hermetic seal of the unwelcoming wall. The continuous eaves on all three sides of the museum when seen from a distance conceal the leap in the terrain, protrude massively in front of the monastery and at the same time remain at a suitably respectful distance far below the height of the monastery complex. In this way the museum, for all its sculptural presence and with its purist-modernistic aesthetic, expresses reverence for the historic aura of the place of pilgrimage at the end of the path to Santiago.

Design drawings by Zaha Hadid

Vitra Fire Station Visionary architecture needs both visionary architects and visionary clients. As such, Rolf Fehlbaum, co-owner and managing director of the Vitra furniture manufacturing company, has made a name for himself and his firm. Since the early 1980s the factory at Weil am Rhein, near the Swiss and French borders, has developed into a conglomerate of unusual architecture. But it is not a museum of architecture that has come into being here, but an innovative, well-functioning furniture company.

This was indeed the intention, for Fehlbaum's decision arose from his pleasure in art as much as from simple necessity. A fire had destroyed a large part of the works in 1980. A weakness for artistic creativity had characterised the Vitra firm for some time before the new building work was undertaken. Since 1957 it has been the sole distributor in Europe of the furniture of Charles and Ray Eames and has worked with noted designers. Thus in a sense, one can see Vitra chairs as models for the architectural patronage that interpreted the disaster of the fire as an opportunity. A beginning was made in 1981 with Nicholas Grimshaw's workshops. In 1989 there followed the spectacular Design Museum by Frank O. Gehry, who was immediately asked to contribute a new furniture production hall as well. The fact that a fire station, of all things, should arise out of the ashes as Zaha Hadid's first building – at the same time as a conference pavilion by Tadao Ando – makes one believe more in the legend of the phoenix than in a coincidence.

The Iraqi architect Hadid, known until then primarily for her paintings of architectural fantasies, was at first only supposed to design a chair. But she did not restrict herself to this small format, and was fascinated by the landscape around the factory: the structure of the fields divided according to South German succession, of the factory and the railway tracks running at an acute angle to it. The fire

The entrance side of the building with its expressive canopy

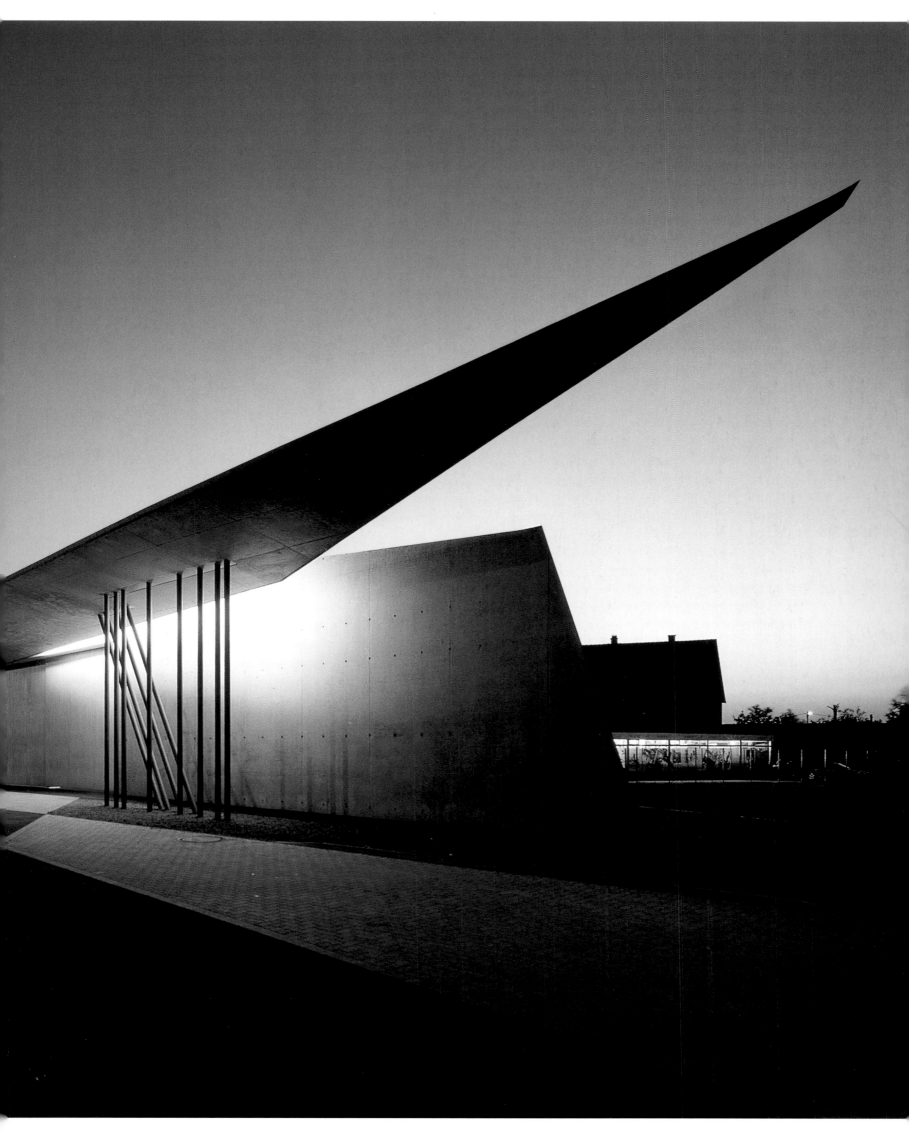

Interior of the fire station building

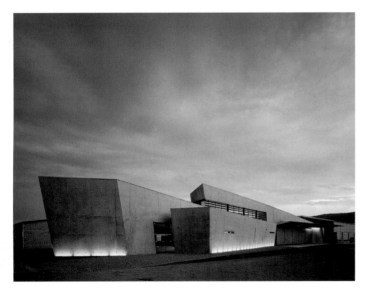

The building consisting of the garage as well as the three long beams

Ground plan and view

station emerged out of a planning and bird's-eye view analysis of the surrounding area. The project drawings show it as a provisionally functionless structure, a sort of focus of the lines found in the landscape.

This sort of design process may remain cryptic for outsiders. But the building is not as complicated as it may seem at first. Basically it consists of three pairs of lines called "beams" by the designers. These were divided in order to do justice to functional needs. The broader part accommodates the five fire engines, one narrower part contains the staircase and behind it a fitness room, and the other narrow part contains the sanitary installations. The serrated structures that communicate between the narrow elements at the point

where they coincide are cloakroom cupboards in stainless steel. Both in its outward reserve and in the construction of its smooth but tapering walls of local concrete, the building gives a distinct sense of its geological affinity. In its interior one is reminded of tectonic plates driven into one another. This individual tectonics permits, among other things, the effortless spanning of the 32-metre-wide entrance gate – which is itself a plate that is pushed to one side. By means of such aesthetic and architecturally constructive qualities the Fire Station has proven that even today it is possible to assume the sort of radically artistic design position in which postmodernism no longer wished to have faith, and which looks with optimism into a future of quite different architectural categories. E.W.

View of the cloakroom area

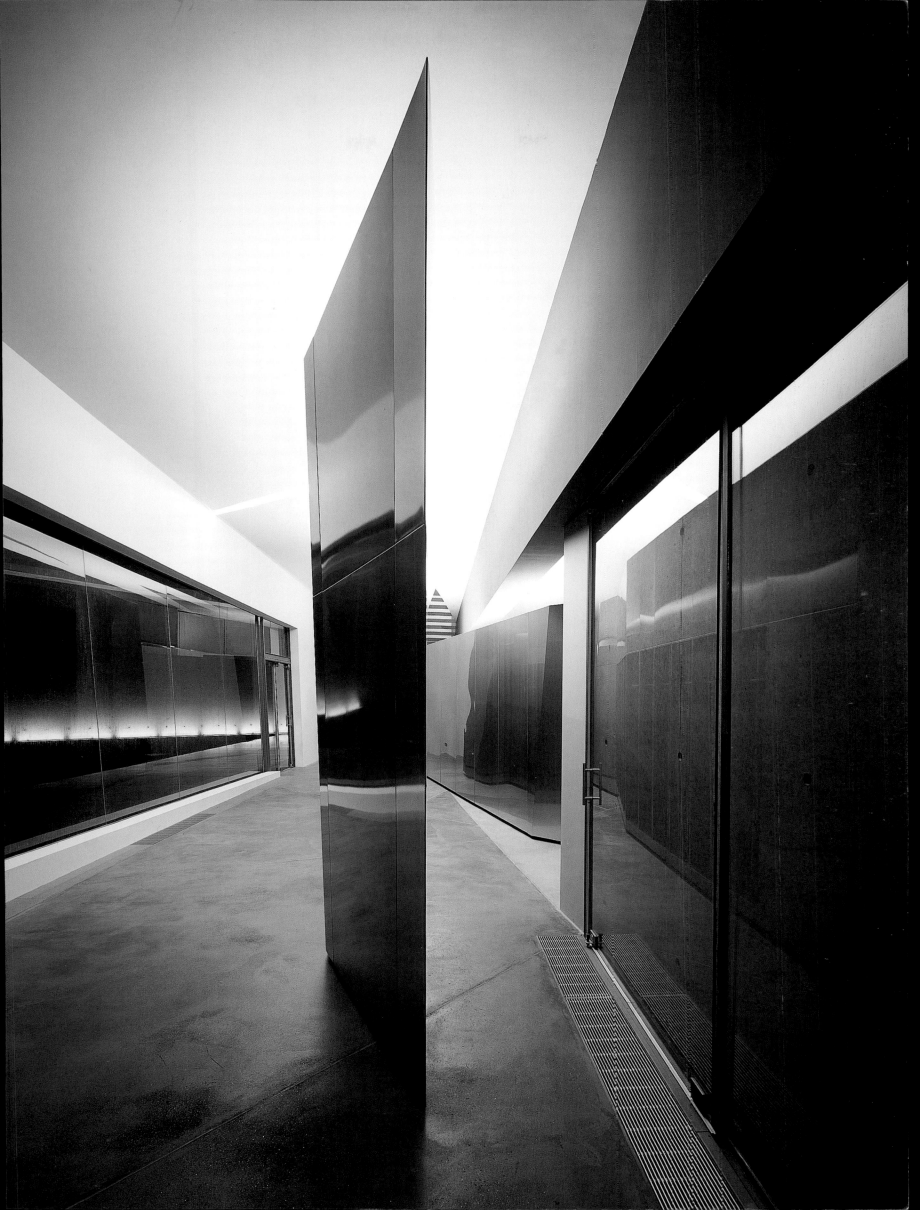

Museum of Wood Tadeo Ando's Museum of Wood in the middle of the forests of the central Japanese province of Hyogo resembles a hollowed-out tree stump: the ring-shaped, wood-clad structure rises upwards slightly conically and the circular inner courtyard is filled with a pond. But the visitor who approaches the museum by way of the gently rising ramp is offered an impression which no longer has anything in common with such associations. This is due not least to the considerable dimensions of this monolith, the effect of which is further strengthened by its isolated position. With its height of 18 metres and a diameter of 46 metres on the outside and 22 metres on the inside, the building no longer appears to be an imitation of nature. The self-confident proportions and smooth edges allow it rather to be a geometric entity that can be experienced but is still abstract. This includes the ramp of reinforced concrete, which cuts through the ring and abandons it on the other side, in order to lead more than 200 metres further straight through the wood, up to an observation point and guesthouse.

With the Museum of Wood in the richly forested hinterland around Mikata-gun, Japan celebrates a material which still characterises its landscape today and which is employed by traditional Japanese architecture in its quite individual perfection. The museum was opened on the 45th National Day of the Tree, introduced by the Emperor of Japan in the 1950s in response to the destruction of the forests through the war. The museum is meant to sensitise the visitor to this interweaving of nature and culture. Ando accomplishes this by means of a series of spatial presentations, and at the same time sets the example of a continuous tradition in his use of material and construction.

The structure, however, is not entirely of wood, but first and foremost a skeleton of reinforced concrete, which is clad on the outside with a horizontal, overlapping wooden shell; here Ando alludes to the method of construction of his pavilion for EXPO 1992 in Seville. For the Museum of Wood he exclusively used indigenous Hyogo cedar. If the building looks from the outside like a gigantic pile of wood, inside it becomes a forest tamed by architecture: thick planks form the floor, from which rise pillars up to 16 metres high in groups of four; the pillars are of the same material, this time laminated wood in layers of boards. They branch out at the tops into horizontal layers of board, taking up the theme of traditional Japanese architecture in wood. Through this interwoven wood the light penetrates into the dramatically vertical space, which consists essentially of a ramp surrounding the ring and falling away gently on which the exhibits are placed.

With the path through the museum, inner courtyard and finally through the forest, Tadeo Ando has created an architectural series that demonstrates all the material's aspects to the visitor. The dead straight path through the trees enables an unfamiliar and close impression of wood in its natural condition, which however immediately acquires the character of an exhibit through this presentation. In the

Design sketch by Tadao Ando

The long path leading through the museum to a guesthouse

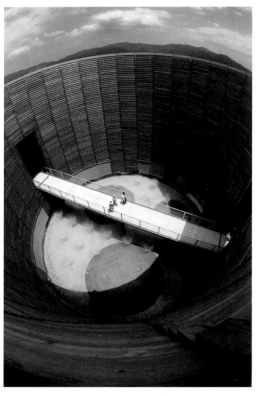

View of the circular inner courtyard

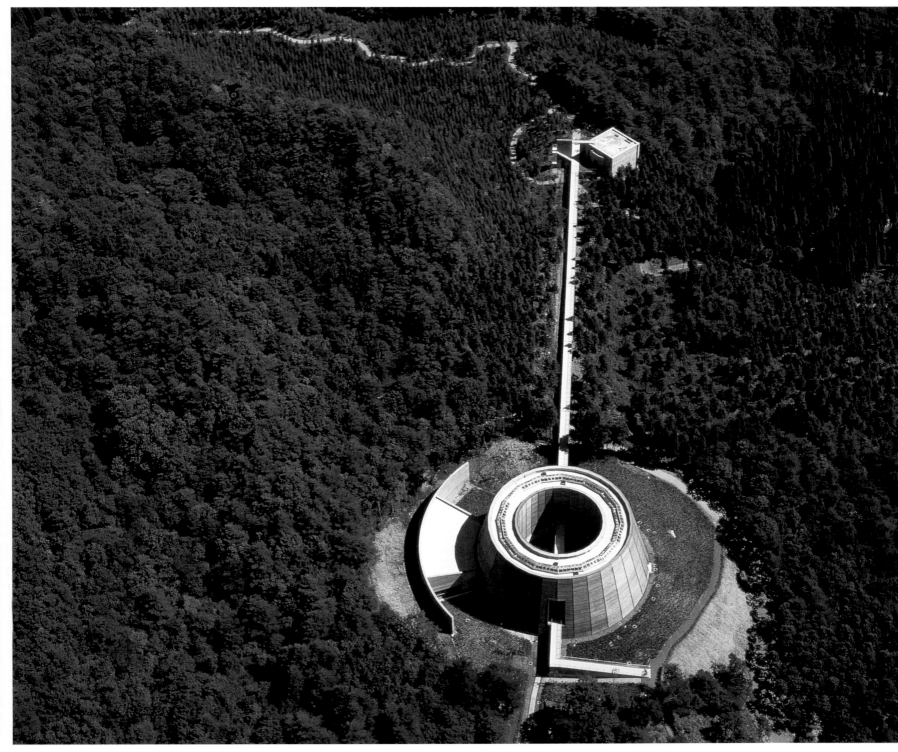

The museum, embedded in a wooded landscape

Site plan

museum space itself, this forest has experienced its (architectural) cultural interpretation, and the mystical atmosphere of the forest is heightened to an architectural one. Finally a third, again totally different experience, is offered by the path into the inner courtyard. The endless rows of slats which frame the water below and the sky above, allow the elements of wood, water and air to appear almost as abstractions, an effect to which the distinctive geometry contributes. Thus the high point of architecture is reached, which for Tadeo Ando consists in the harmony of precisely these elements: authentic materials, pure geometry and domesticated nature. E.W.

Design sketches by Eric Owen Moss

The Box Culver City is one of the places in the Los Angeles area that recall the industrial basis of the southern Californian boom that has taken place since the 1940s, beyond Hollywood and Venice Beach. Along a traffic corridor euphemistically called National Boulevard, in this non-place, a number of unpretentious relics from this period – somewhat shed-like warehouses and workshops – have for some time now been converted by the architect Eric Owen Moss into laboratories of a deconstructive architecture. Like the early Frank O. Gehry, Moss transforms banal functional architecture into emblems, even icons, of the shock of a "new" geometry and materiality.

With inexpensive materials and radical incisions into the building fabric, this "jeweller of junk", as Philip Johnson called him, also tackled this warehouse on the corner of National Boulevard. Whereas the larger part of the extensive low-rise building was only renovated a radical surgical intervention robbed the corner of its roof and a cylinder was inserted which was envisaged as the reception area and bar of a restaurant. With steel supports and new glazing, the area cut away between the implanted new circular form and the rectangular roof was subtly used to bring light to the lower hall. From the cylinder a staircase leads upward, partly on the interior and partly on the exterior. From this, a second staircase – a closed tunnel-like element – leads above the roof out of the closed circular form and then thrusts into an upturned box, which seems to float above the circle on sloping supports in a crooked position as dramatic as it is grotesque. This irregularly cut container with two expressively inserted corner windows is the actual "Box". A black monster, it towers above the surrounding low-rise development. On one side it opens onto a view of Culver City, while the opposite corner window offers a spectacular view of Beverly Hills. The Box has never served its original purpose as an exclusive restaurant space. Rather, its quality consists precisely in the programmatic openness of its almost filmic spatial arrangements. An atmospherically dense and disturbing stratification of different layers, levels and geometries, it creates an aura of creativity and experimentalism. This is what every conceivable innovative branch of industry would want as a stimulating backdrop for its new world of work.

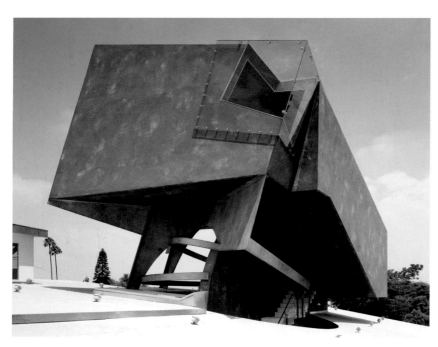

The Box on its tilted supports seeming to float above the building

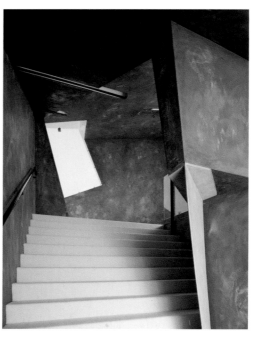

Steps ascending to the building

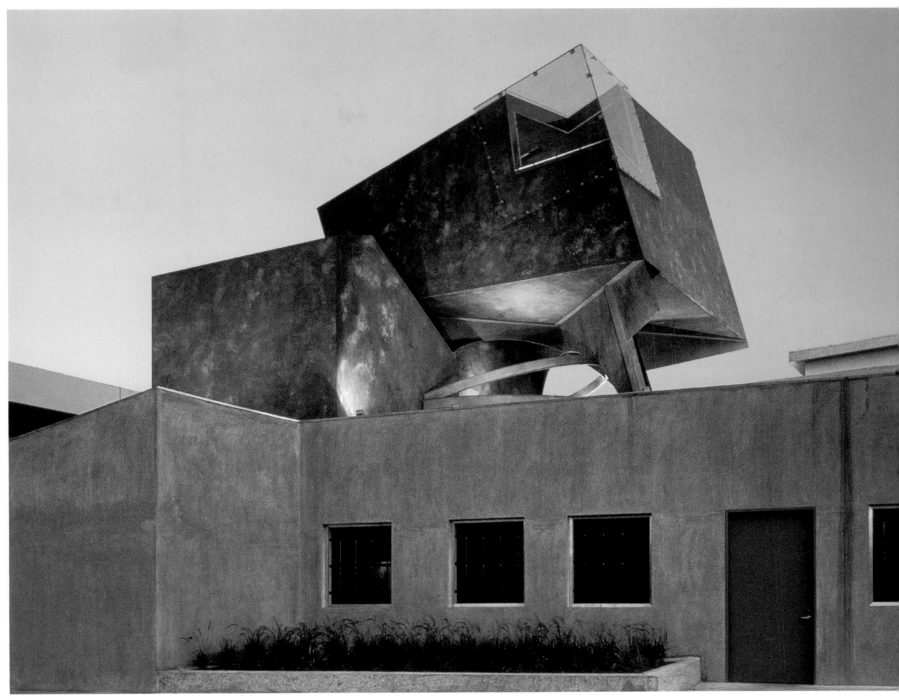

View of the Box from the street

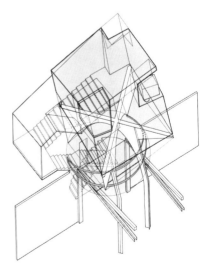

Axonometric drawing of the building

In fact, however, Moss does not build for clients, but for the self-justification of a philosophical architecture, which long ago freed itself from the accepted norms of the classical order and the tectonic security of the eternal theme of support and load. To him, as a deconstructionist in no way inferior to the radicality of Coop Himmelb(l)au, the ripped-up fabrics of old industrial architecture are only the guinea-pigs in an architectural laboratory. Eric Owen Moss does not follow Frank O. Gehry in his turning towards the conciliatory curves of biomorphous or even baroque forms. The splintering and overturning of masses and surfaces stand for the search for meaning in a time in which this can become a theme only in its dissection, that is, analysis. If Moss's clients were to share his sensitivity, or rather intellectuality, then perhaps the separation of form and function achieved by him could be revoked after all: deconstruction as the intelligent aesthetics of the IT generation in LA?

Museum Groningen, East Pavilion If sculptural architecture sets free emotional energies, then an architecture which "must burn" (according to Coop Himmelb(l)au in 1980) is certainly also sculptural. Or is it rather anti-architecture? As the only office still operating from the radical Pop avant-garde of the late 1960s, Wolf Prix and Helmut Swiczinsky are today still challenging the conventions of building. Probably the most aggressive protagonists of MoMA's deconstructivist exhibition in 1988, with their built rhetoric they hold fast to the promise of freedom of the 1968 movement. But whether a position that proclaims "There is no truth. And no beauty in architecture" is appropriate for the building of a museum for Old Masters remains questionable. "The harder the times, the harder the architecture": this slogan of Coop Himmelb(l)au of 1980 nevertheless remains the watchword for the east wing of the Groningen Museum 14 years later, adding the built postscript "and the more colourful". After the sculptor Frank Stella had failed to get his chance with a biomorphic project of 1992, Coop Himmelb(l)au took over this part of the master-plan by Alessandro and Francesco Mendini from Milan, a plan that encompassed a total of four complexes.

On the banks of a canal rises the pavilion by Coop Himmelb(l)au, like an object welded together of heterogeneous and mutually opposed surfaces that seem to break, or even to plunge, out of it. The great wall panels of the upper storeys with their roof surfaces expressively shoving themselves upward, are of aggressive colourfulness, red, white and black, and are crowned by the 61-metre-high golden yellow tower of the depot in the Mendini brothers' nearby complex. Aesthetically reminiscent of Robert Venturi, the base leading to the water is patterned throughout in a detailed design, offering a calming basis to the explosion of colour on the wall. The 300-tonne heavy, double-shelled steel panels were manufactured in a shipyard

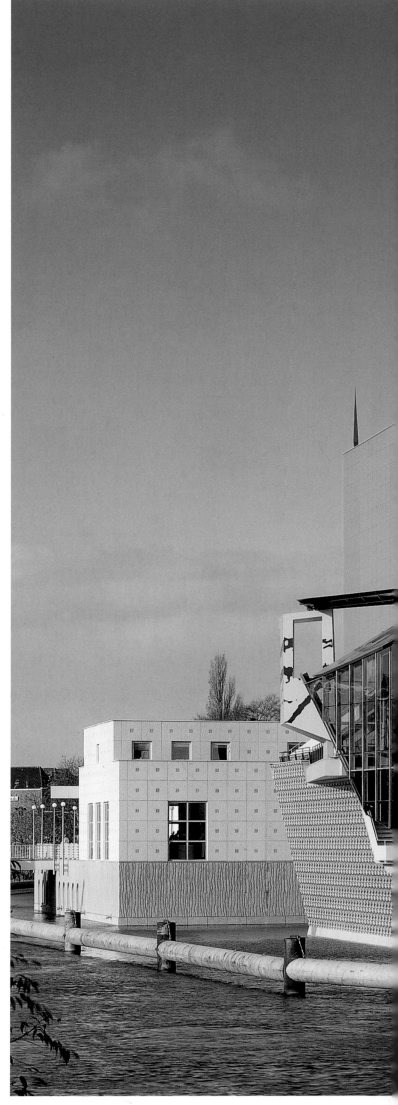

The Groningen museum complex, planned by several architects and designers

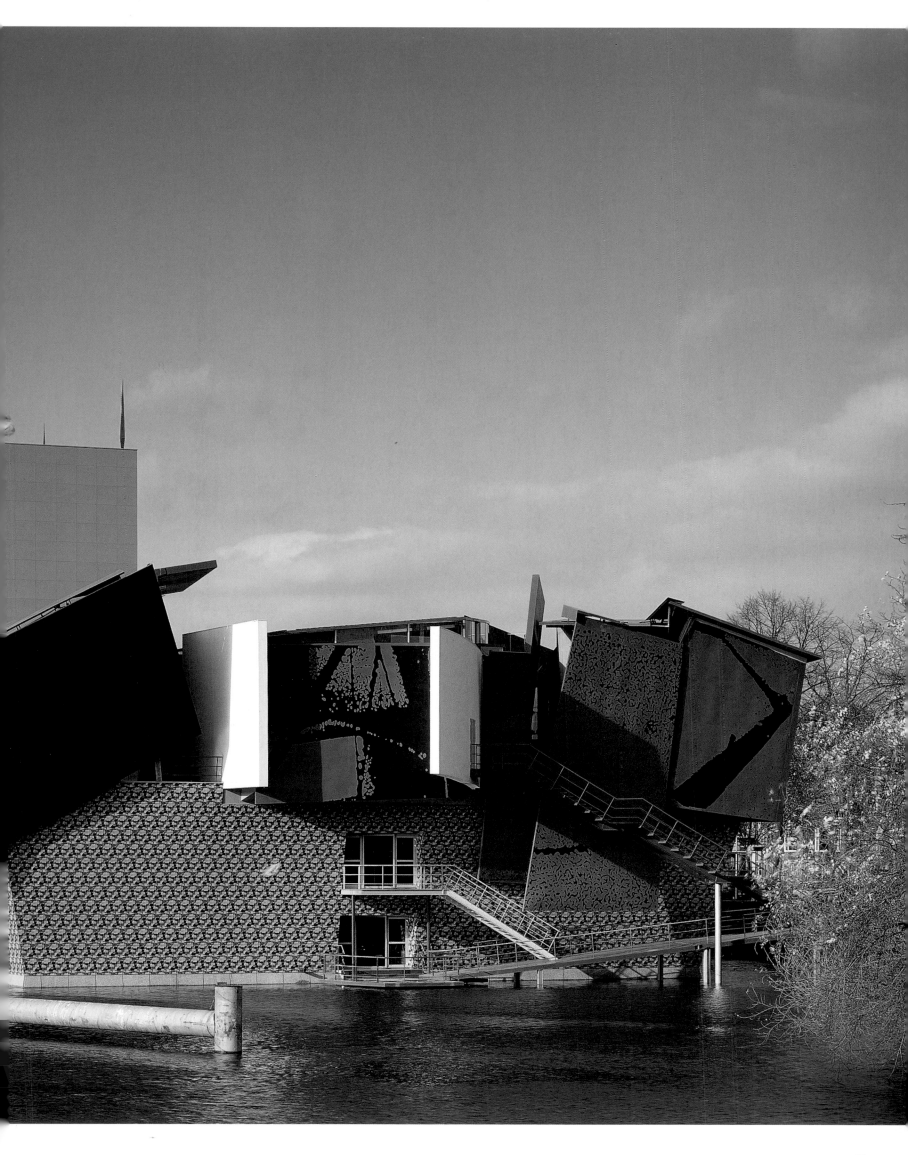

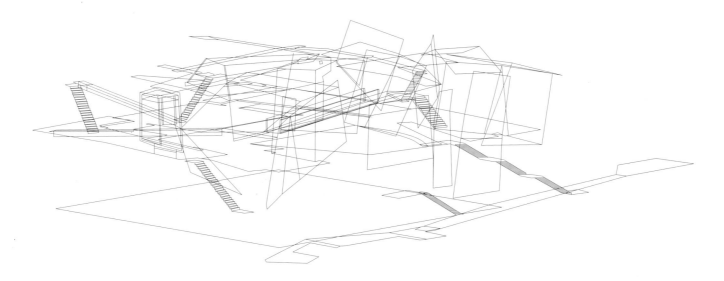

Drawing of the superstructure of the building by Coop Himmelb(l)au

The museum's continually offered views of the city

Interior of the east pavilion

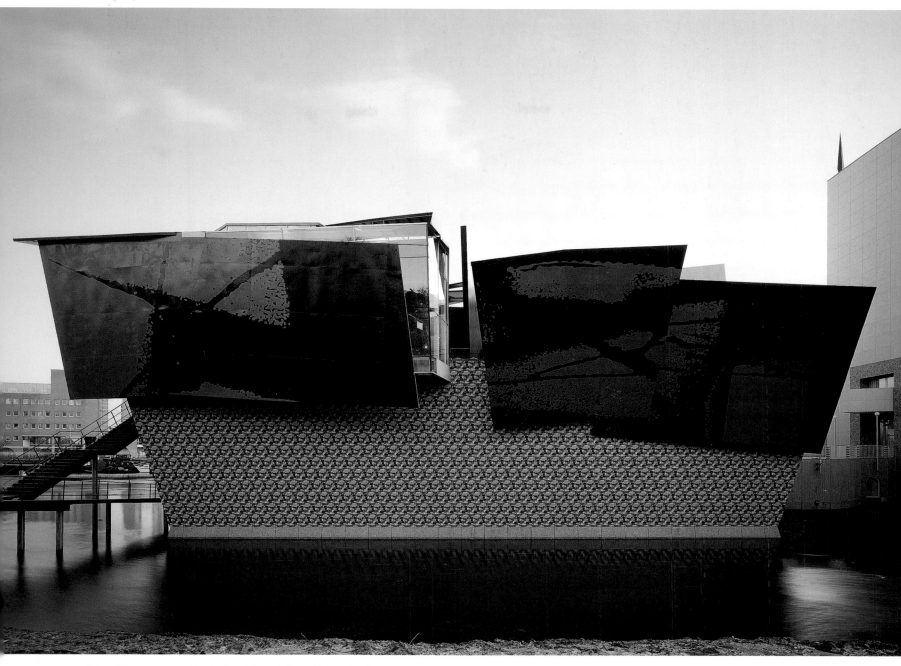

View of the museum pavilion by Coop Himmelb(l)au with its colourful wall panels

and could be quickly welded and assembled on site. The ship metaphor of classical modernism is quoted and at the same time deconstructed: the monster would probably not have been equal to the unbearable lightness of swimming.

The inner space is intersected by a multiplicity of staircases, ramps, paths and galleries. In this restless area of motion, the objects lose their static aura, and are visible from many levels and points of view. This modern, nervous sensitivity, derived from the unrest of modern urban life, certainly collides with the calm of older art, but perhaps takes it more seriously as a partner at eye-level than do the classical painting-graves of the temples of art. The freeing of the observer's gaze by movement makes it possible, says Wolfgang Prix, "to free art from the museum". And indeed, the Old Masters did not

paint for the museum. Nevertheless the crude interior design seems to be committed to the brutalism of the 1960s which constitutes a challenge for any curator.

The spaces allow daylight to enter through double-shelled glass surfaces and movable sun blinds from all imaginable angles of incidence; views are offered of the sky, over the city and downwards to the water surface of the canal. Seen from across the canal, the building looks light and playful, variously fortress and storehouse. In this pop collage of colourful containers, the Old Masters become contemporaries in the everyday of the post-postmodern event society. Coop Himmelb(l)au has succeeded in giving a familiar Swinging Sixties packaging to the disturbing deconstruction of the familiar without trivialising the former as an ornament of retro-kitsch.

Tour Crédit Lyonnais Euralille, where Christian de Portzamparc's high-rise building for the French bank Crédit Lyonnais towers above its surroundings, is the product of an almost nostalgic enthusiasm for the urban planning of modernism and an example of the good functioning of traditional decision-making and business models. In 1987, thanks to his good contacts with Paris, the former French prime minister and mayor of Lille Pierre Mauroy succeeded in relocating the railway lines; this would bring a lasting change to the face of the northern French city. The high speed connections from London to Paris and Brussels were rerouted through the centre of Lille. Thus Lille became the first railway station for travellers from Great Britain when they emerge onto the continent out of the Channel Tunnel.

Together with his favoured architect, Rem Koolhaas, Mauroy was able to make use of the propitious moment and the infrastructure. Along the railway tracks, right next to Lille, emerged Euralille, in the words of the urban planner Koolhaas, "a centre of gravity in a region of 79 million people". Christian de Portzamparc's office tower is part of this total concept of urban planning. In this, Koolhaas envisages a series of high-rise buildings, each some 70 times 40 metres wide and 100 metres tall, which bridge the high-speed railway tracks and even the new railway station itself, and which are thus in fact threaded into the infrastructure. Between the row of high-rise buildings and the old city, a shopping mall and multipurpose buildings have arisen, including apartments and a university. Rising sculpturally from the low-rise development, the solitaires – of which the Crédit Lyonnais is probably the most prominent – are reminiscent of Rem Koolhaas' enthusiasm for the "culture of congestion" from his major theoretical work *Delirious New York*. At the same time the plan is characterised by an almost romantic confrontation of architecture and movement, from the high speed of the TGV and the reposing masses of the office towers.

This represented a significant challenge to Portzamparc, the solution to which determined the highly individual shape and sculptural form of the building. The client did not want to make full use of the shell of the building, oriented towards the railway tracks from east to west, so as not to overload the "bridge" over the tracks. Portzamparc cut into the building so that a sort of L-shaped structure resulted. This is carried by two support cores, which are situated left and right of Jean-Marie Duthilleul's railway station Lille Europe, which lies below. Above the northern support the building rises to twenty storeys, whereas above the southern one it is only three storeys high, and at the same time the structure becomes wider as it rises. This allows the offices a view of the old city to the south, as Portzamparc makes clear in the design of the façades: whereas the windows on the sides oriented to the exterior seem as though they were stamped out of the metal façades, the façade to the south also appear to be cut out, but from a glass curtain. So sometimes the building looks more like a closed, massive sculpture, and at other times more like a hollow space actually occupied by people. Nevertheless it was important to the architect that the building in a sense have no scale – just as it withdraws itself from its surroundings lifted from the ground. Portzamparc saw exactly this as the unusual aspect of the situation: "This is not a place where one would have to think of any 'context'." E.W.

Aerial view

Longitudinal section of the building

View of the office building

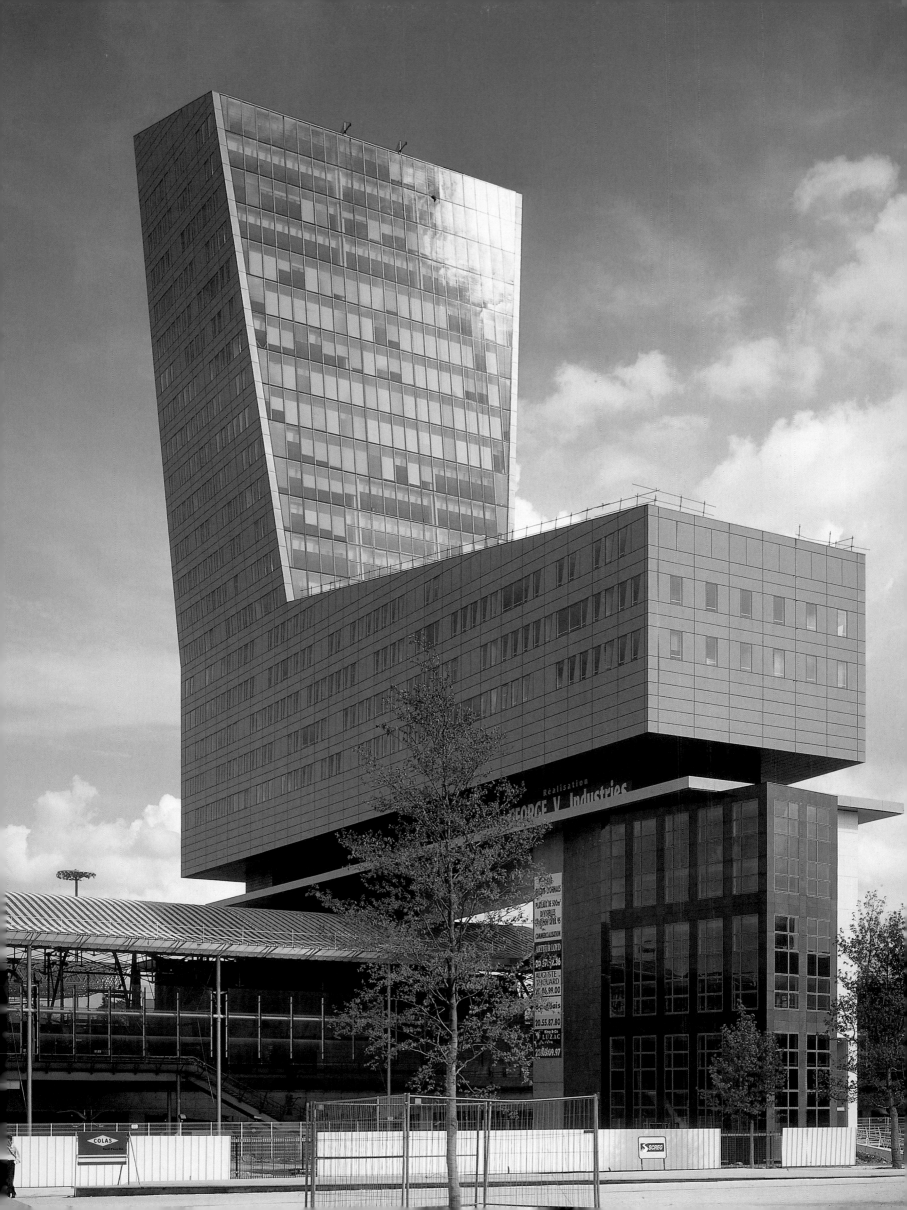

Signal Box, Auf dem Wolf In the digital age, even signal boxes have clearly changed their character. No longer grandiose glass cockpits above the tracks, but hermetically sealed concrete boxes for sensitive electronics: this is the building task today. The medium of monitors has replaced the open view overlooking the railway tracks. A programme thus reduced to a container for electronic instruments seems to give very little scope to architectural imagination. Nevertheless the Basle architects' office of Herzog & de Meuron was able to make an architectural virtue out of this programmatic necessity, when in the late 1980s they were given the commission for a modern signal box in the midst of the extensive track area of Basle's main railway station. The reduction to a box was actually contrary to their design philosophy at the time. As leading representatives of Swiss minimalism the two architects saw architectural potential precisely in the aesthetic of secular, even banal uses: the reduction to essentials, the physicality of pure volume as the elementary form of all building. The concrete box for traffic control instruments, which conveys its function, if at all, through the tall aerial, was heightened by them into a minimalist manifesto. This monolithic block, visible to passing trains only from a great distance, appears monumental in the expanse of the diffuse railway track area. The lack of scale of the concrete hull, which, despite the presence of a few windows, renders the six storeys hidden behind it hardly detectable, is intensified by copper sheathing. The lack of relationship between interior and façade is an important theme for Herzog & de Meuron. They see in it a creative freedom for an ornamental treatment of the curtain-like façade purely as a covering. Appliquéd onto the signal-box, the band of copper, 10 centimetres wide and formed like thin horizontal slats, is a pure staging of reflected light. The reddish-brown copper colouring lends the building a vague impression, constantly changing according to the movement of light.

The translucence suggested by the slats works visually against the forbidding compactness of the concrete cube; they thwart its expression and aim, if not at an aura, at least at optical alienation. This enigmatic quality in an almost archaic building sculpture is paradoxical; for after all here is a prototype of modern information technology transformed into architecture. But it appears in architectural terms almost as a relic, as the gigantic memorial of a long vanquished industrial culture. This erratic monument, with its appearance of symbolism, is thus iconographically rather confusing. Meanwhile, it is regarded, probably not wrongly, as a self-assertive statement on the part of architecture. The virtualisation of the world frees architecture from its programmatic commitment, and gives pure form its due.

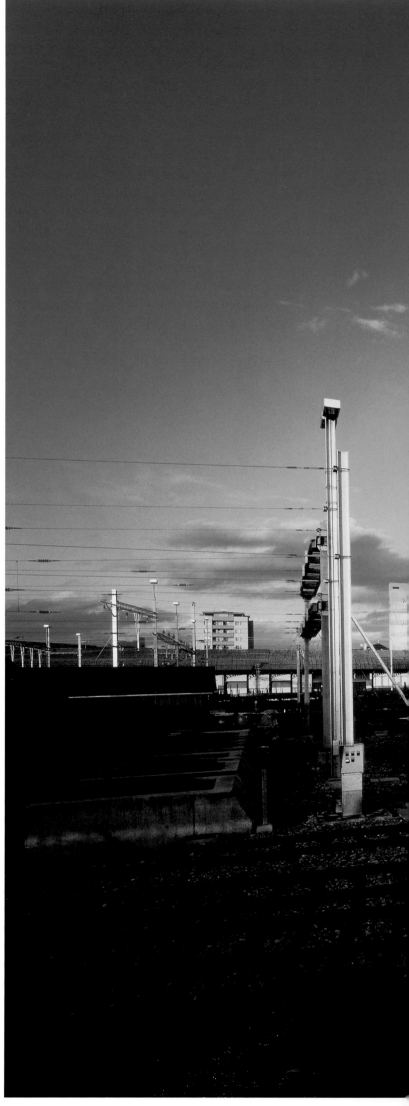

The concrete fabric of the signal box clad with copper bands

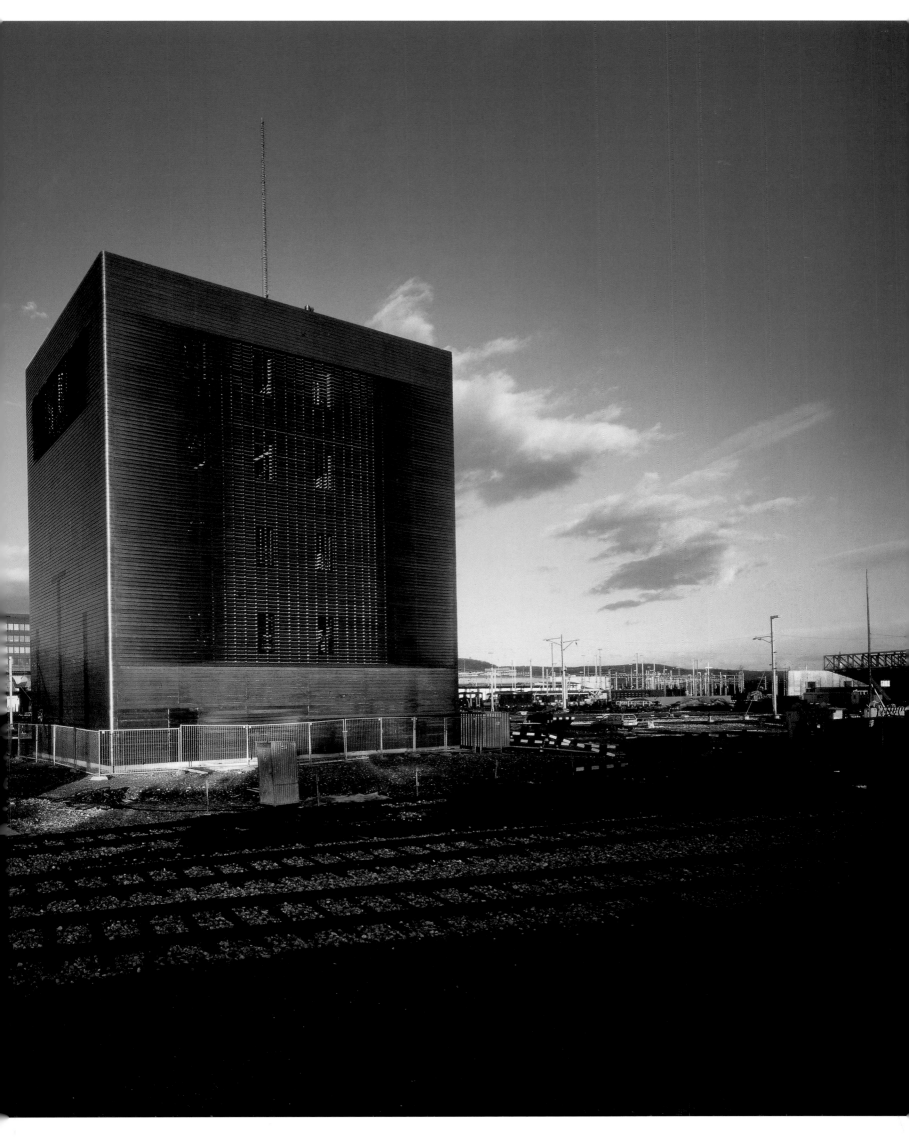

Chapel of Santa Maria degli Angeli Since the 1970s the Swiss canton of Ticino has developed an architectural language of its own, which is related to Italian rationalism rather than to the minimalism of German-speaking Switzerland. The Ticino school, on the model of Aldo Rossi, makes use of geometrical primary forms, which are developed into sculpturally accented, symbolic building structures. Mario Botta from Lugano is probably the most prominent representative of this regional idiom, with which he has come to be identified throughout the world. The cylindrical form is his motif of preference in sacred buildings; he has used it, for example, in the cathedral at Evry near Paris, but in a larger version has also transformed it into a temple of art in the case of the Museum of Modern Art in San Francisco.

The chapel of Santa Maria degli Angeli, designed in 1990 and built between 1992 and 1996 on the 1530-metre-high Monte Tamaro in the Ticino, is incomparably more modest. However, in its heavy, flat positioning on the mountainside it is even more striking. The power of the building is additionally emphasised by the use of rough por-

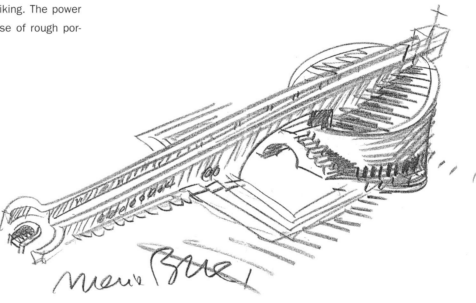

Sketch by Mario Botta

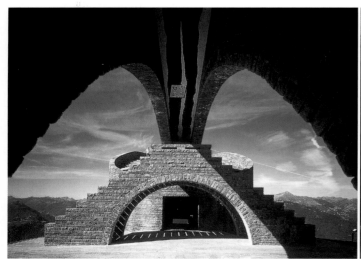

The masonry of roughly hewn porphyry stones

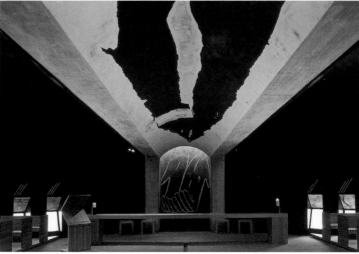

Interior of the chapel

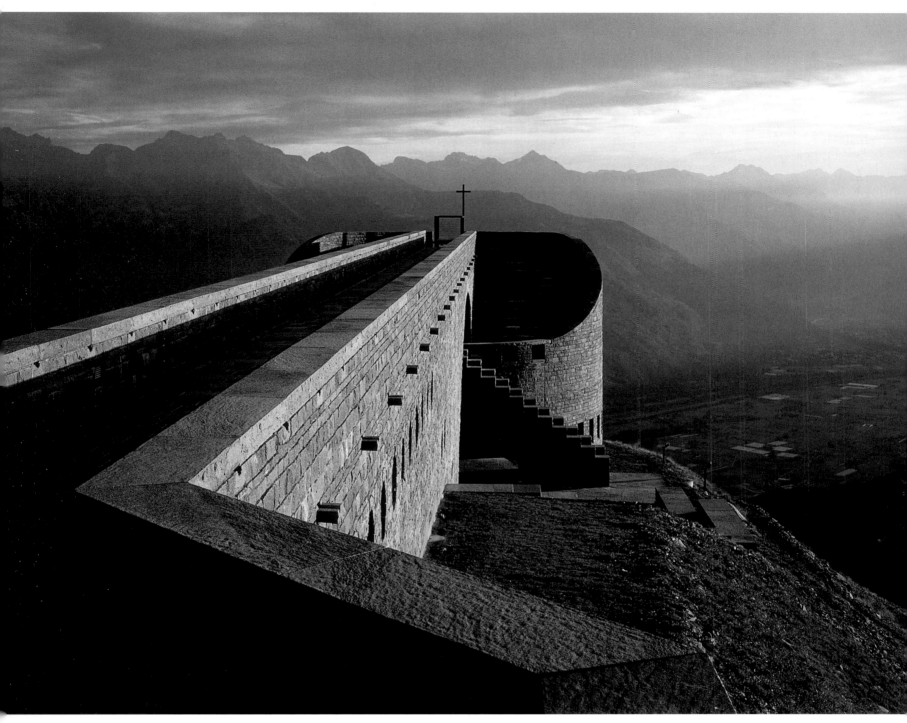

The chapel towering up out of the mountain with a 65-metre-long viaduct

phyry, which binds the chapel firmly into the mountain rock. It emerges close to the edge of the summit, half mountain, half building. The cylindrical volume with a diameter of 15 metres is diagonally sliced off at the roof. The roof, formed as a staircase, is linked to a 65-metre-long viaduct. This, from one point of view, reveals the church as a symbolic pilgrims' path, which leads over the roof and a flight of steps to the forecourt, and from there axially to the central aisle of the church. This axis of the triple-naved, severe structure of the interior opens into an apse rising out of the cylinder, in brilliant blue. The sacred space, lit from above through the roof steps by a glass window in each step, is decorated with frescos, which as a result of their position in the light add additional splendour to the interior of the chapel. The long ramp forms a flat, curving bridge over the forecourt; this curve is taken up by a flight of steps forming a flat bow over the entrance and leading from the roof to the square. This non-functional, purely symbolic path, together with the massive, rough stone surface, create the impression of a fortress of God. The aura of grandeur of the building is obtained from the dramatic nature of the mountain ridge, which is architecturally continued and intensified by graphic, though economical, means. With the link between the viaduct – which, in the light over the peaks of the Ticino Alps, seems to lead into infinity – and the sheltering frame of the community gathering-place, two basic motifs of Christian spirituality are interwoven: life as the path to God, and the experience of God in the community of the faithful. Botta's chapel is thus a significant contribution to the typological enrichment of Christian sacral architecture. But in its archetypal power, the building could nonetheless be seen as having grown together with the mountain for centuries.

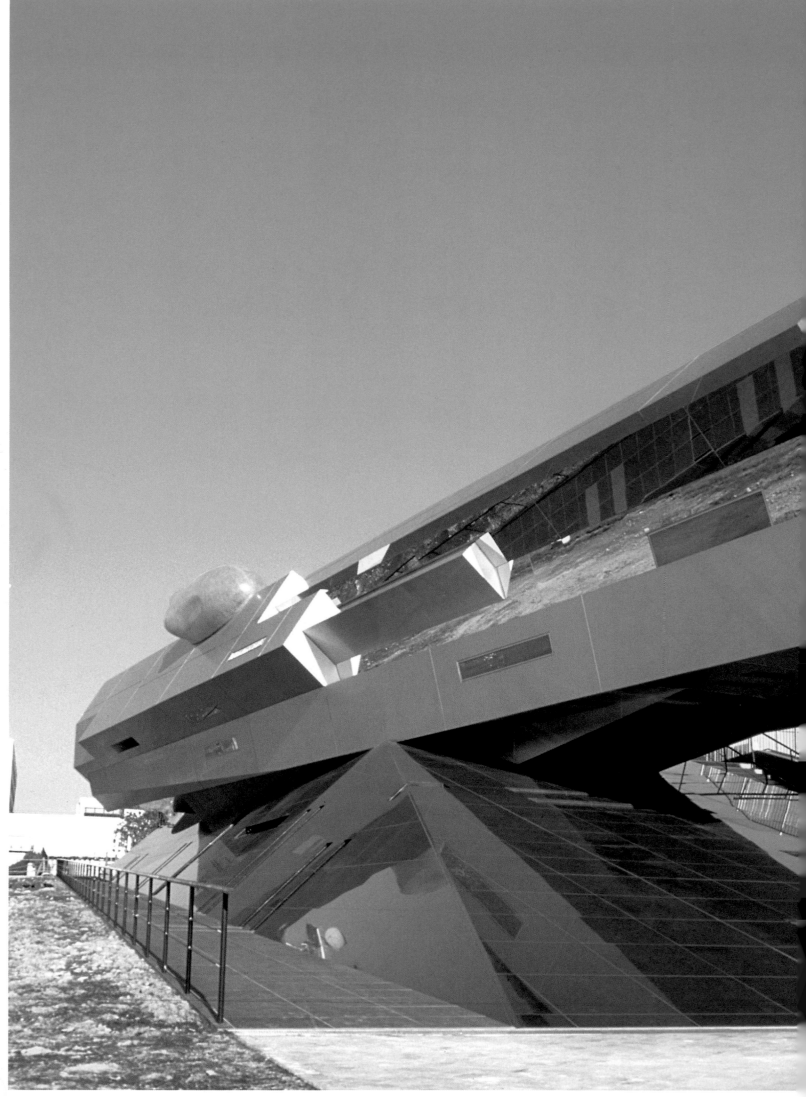

The surroundings mirrored on the façades

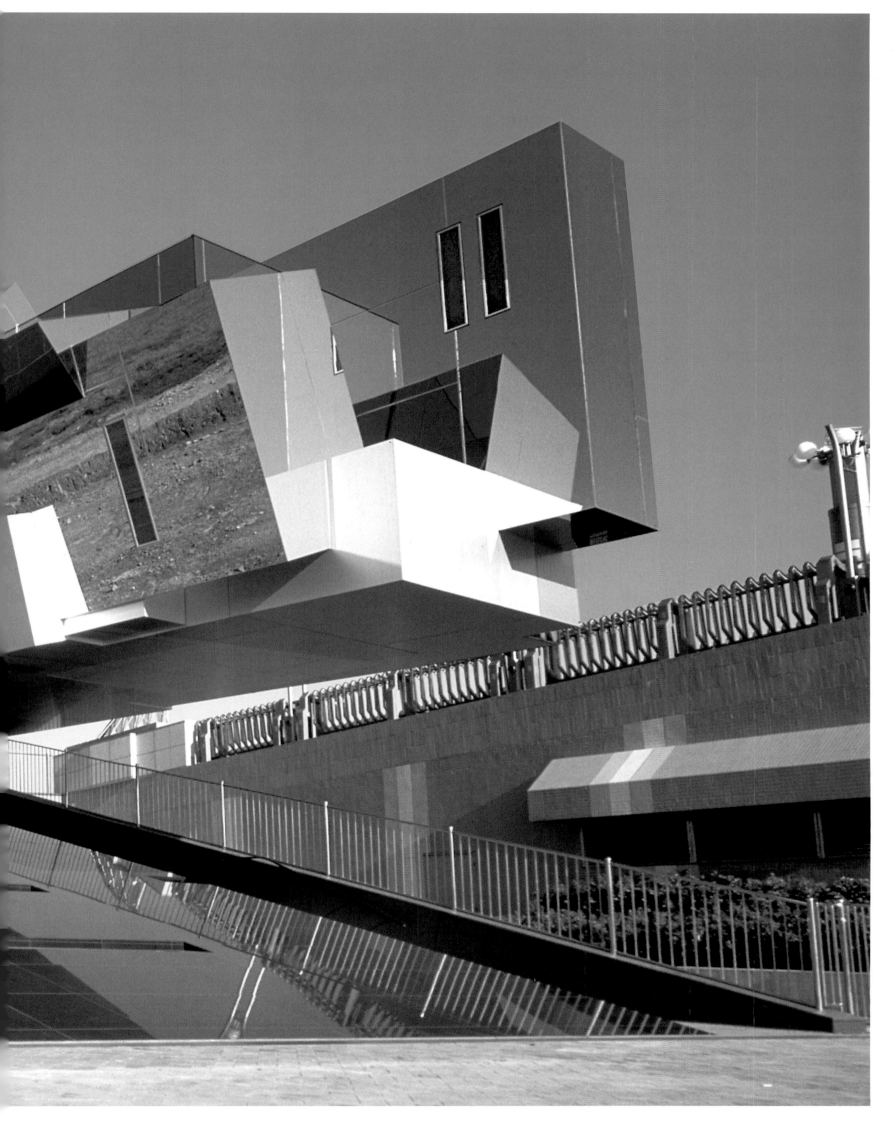

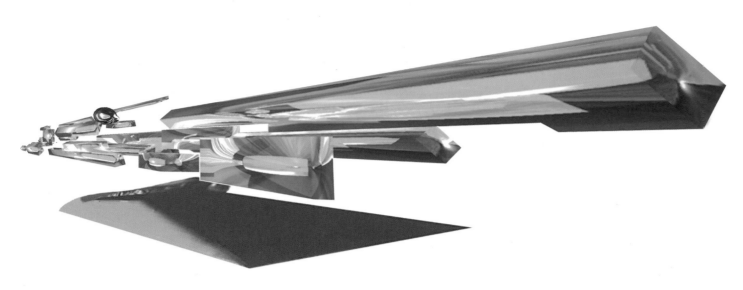

Perspective drawing of the general view

K-Museum Although only a futuristic project, there could hardly be another plan of Japanese metabolism that possesses a presence in the collective memory of architects similar to that of Kenzo Tange's proposal for building over the bay of Tokyo of 1960. Tange's concept included street systems, cables and floating bridges that formed a structure along which the life of the metropolis on the water was to grow.

Thirty years later it looked as though Tange's vision was to become urban planning reality. The industrial boom of the 1980s did indeed inspire an extension of the city into the bay. Toned down by the banality inherent in every realisation of great ideas, part of the bay was filled not with floating structures, but simply with soil. But buried in it was a network of infrastructure, which was certainly capable of accommodating Tange's bold plans. And the common features did not end there. For when the boom collapsed and property prices sank, the expansion of the city too suffered the fate of an abandoned idea. Thus it became Tokyo's best-known wasteland.

No more suitable location could have been found for transforming the infrastructure into a museum, and exactly this was the task of Makoto Sei Watanabe's K-Museum, built in the mid-1990s. The form of the museum seems positively to allude to its bizarre situation. Like a ripped-out piece of pipe and cable the glittering, cubic structure is seated on its black, wavy base – a stranded infrastructure in the flat expanse of land that had once been the bay. Simultaneously homage to and swan song of late modernism's faith in technology – perfect requisites for a science fiction film – Watanabe's glittery structure opens up a multiplicity of associations. The building celebrates the ambiguity of the land between city and nature, lending to it its own nature, as artificial as it is skilful. In its widely extending bridge construction in steel profiles, the upper part of the building encloses the actual museum space, and has been clad with four different metals. The individual structures consist alternately of aluminium, partly untreated and partly fluorine-coated, and stainless steel, partly polished and partly gold-coloured. Each material reflects

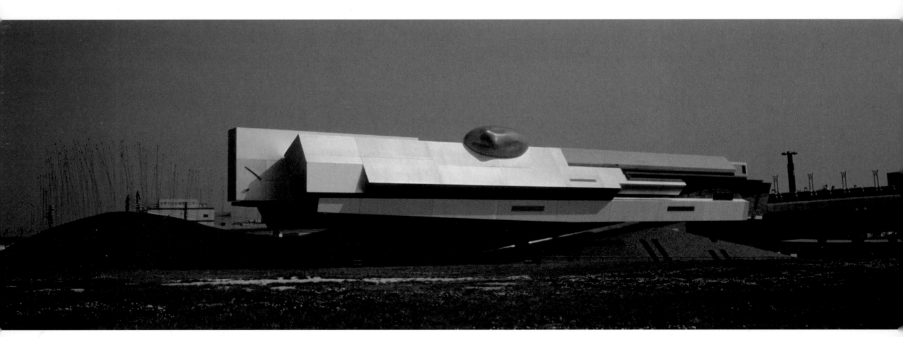

General view of the K-Museum

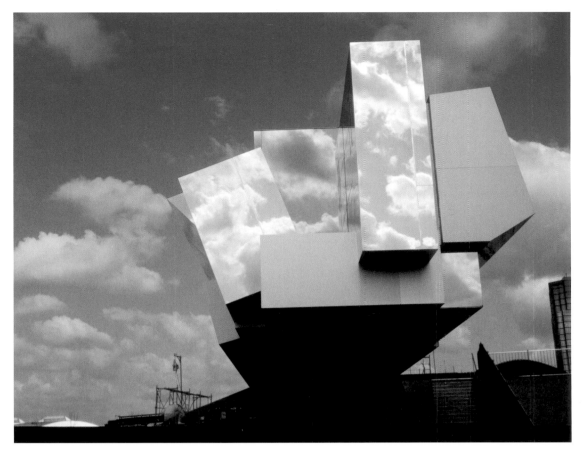

Side view of the building

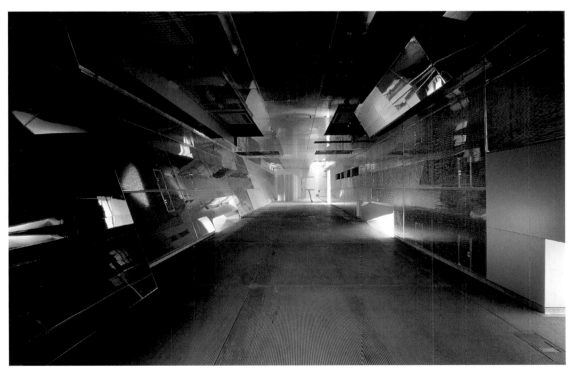

The interior, also clad with metals

the colour and structure of the sky differently, and this creates a fascinating collage of cloud formations. Out of this erupts an amorphous rounded structure of fibreglass. The whole rests upon a landscape of black granite which begins geometrically and dies away in artificial topography, and which conceals a core of concrete. Above the hill of granite, a forest of coal fibre rods gently sways in the wind, their tops forming little diodes of light. Solar energy collected during the day is given off again at night as a bluish shimmer.

The interior of this magical structure is comparatively simple: basically a 28-metre-long and 4-meter-wide rectangle. But the toilet cubes of artificial marble placed in the museum space continue the conversation between artificial nature and infrastructure; and the walls of honeycombed aluminium panels clothed with acrylic glass as well as the floor of steel fused with zinc ensure that the visitor is well entertained, not only by the exhibition. E.W.

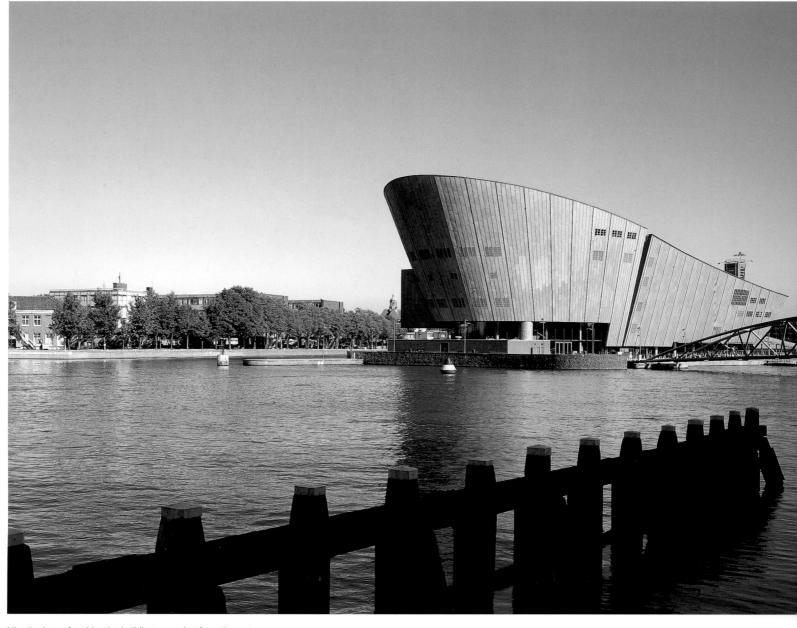

Like the bow of a ship, the building emerging from the water

NEMO, National Centre for Science and Technology A metaphor comes readily to mind: like a stranded ship, the New Metropolis science museum by Renzo Piano lies in the harbour of Amsterdam. But in fact it is stranded the wrong way around: seen from the old city, its bow seems instead to be dynamically moving outwards into the Ijsselmeer. The architect too rejects the association and instead points to a sketch that shows the original concept of the structure in section. Here it is clear: just as the Ij tunnel of the 1960s dives down under the sea, the museum emerges above it. With this image Piano appeared to have found an adequate form for the loveable monster in the midst of Amsterdam, a monster that explodes every standard of the old city and its canals.

One can still however speak of a bow. It is faced with vertically seamed, prepatinated copper sheeting. But it is not only its form and its metal sheeting that lend the structure an almost non-archi-tectural quality; in its relationship to its surroundings, too, it is any-thing but contextual. With only a few windows, or rather portholes, it peers out at the nearby old city and central railway station of Amsterdam; and it seems to be docked at the city rather than inte-grated into it. From the train station, one reaches the museum by means of a long pedestrian walkway, and from the old city too only a narrow path leads to the sloping side of the building. This is not least because the only place in the centre of town which could ac-commodate a building of this size was a leftover area above the en-trance to the Ij tunnel. Piano's design takes up the dynamic curve with which the tunnel road between station and navigation museum puts out to sea, then puts out to sea itself and allows the bow to in-crease to a stately 32 metres. Thus the structure does take the low-

lying development behind it into consideration, and orients itself with its entire physical mass on the water.

Its dark interior houses a significant Dutch institution. The Institute for Industry and Technology, grounded in 1954, grew out of the Museum of Work, in which the painter Herman Hejenbrock had been exhibiting his works with industrial motifs since 1923. This tradition made the museum great. Nevertheless, in the new building the exhibitors – unfortunately, it must be said – have dispensed with almost any traditional exhibits. Thus from the flat south side of the building, the visitor enters an enormous dark area, lit by the glimmer of interactive computer installations and film shows. As a result of the harsh budget and the clients' expectations, the interior had to pay for the strongly expressive exterior. The rhythm of the central staircase, which gives access to the individual exhibition areas from below to above, retains some architectural dynamism. But anyone who knows that the light should be flooding in over the roof with the same power that the bow uses to prevent the sea from doing so, can only be disappointed. One consolation is the high window front on the ground floor, which does let in a little daylight and is a benefit to the building.

But anyone who has made his way through the dark exhibition area receives his reward. At the very top, the restaurant and a second exit open out to the southerly deck, rendered even more magnificent by the missing glass ceiling. From here, there s a fantastic view of the whole of the old city; and this – unique in Amsterdam – from a public place. So there is something of the piazza on this Dutch ship after all. E.W.

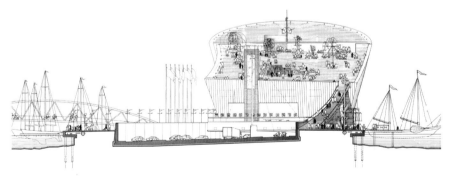

Cross-section of the building

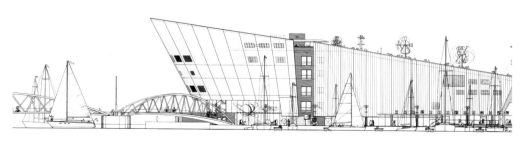

Side view

Site plan

1 crematorium
2 park (Kaze-no-Oka)
3 Kofun (ancient burial mounds)

Site plan

Kaze-No-Oka Crematorium Looking at the buildings in the Kaze-No-Oka park, one would not guess that the brick octagon slanting up-wards, or the rusting Cor-ten steel wall whose flat end extends far into the lawn, are parts of an extended crematorium. That is exactly the intention of the architect Fumihiko Maki. When the town of Nakatsu on the island of Kyushi in southern Japan gave him the com-mission, he was guided by the idea of architecturally endowing death with the place that it has in Japanese culture: at the point of tran-sition from life back to nature. The design was therefore inspired by the ritual of farewell to the deceased, as well as by a life-oriented mood. The "Hill of the Winds" (the translation of the name Kaze-No-Oka), is thus an extensive park, an elliptical hollow, which integrates the crematorium into life and into the landscape. Its sculptural forms of architecture permit no conventional interpretation. Thus the park remains a place actually unburdened by mourning or even resistance, and reciprocally, the crematorium loses something of its stigma.

A mood of reverent concentration remains common to both of them. The mourner experiences it in the succession of rooms attuned to the traditional ceremony of farewell. Correspondingly the building is divided into three parts: the crematorium itself, a common-room and finally a sort of non-denominational hall for administering final bless-ings. The architectural accompaniment of the mourner is the basic motif, and so the building is to be understood only as a path.

On entering the building, one is received first of all in a sort of fore-court, which is bordered on the right by a long brick wall and the hall of last blessings, and which is absorbed from behind by a low-roofed, open reception hall. From here the path continues along a further, this time totally enclosed courtyard, which leads into a small, dark reception room. A single support in a square opening in the ceiling here begins the skilful presentation of the entry of day-light, which constitutes the dramatic effect of the whole building. There follow two small rooms in which visitors see the deceased for the last time in his coffin and then assemble in front of the crema-tion furnace. The hall in front opens into a further courtyard, filled by a low pool. The strong light from the sky and its reflection in the waves, cast upon the surrounding concrete walls, is intended to bring the group of mourners back in touch with life. While the crema-tion, the guests wait in a hall open to the garden and to the sky, until they are able to receive the ashes in a further small room. After a walk in the open air, the procession finds its spatially atmospheric high point in the hall of final blessings, in a tilted octagon, which is sparsely lit by minimal openings cut into the wall and ceiling. From here, the path leads back to the entrance hall: a procession through life and death, architecture and landscape. E.W.

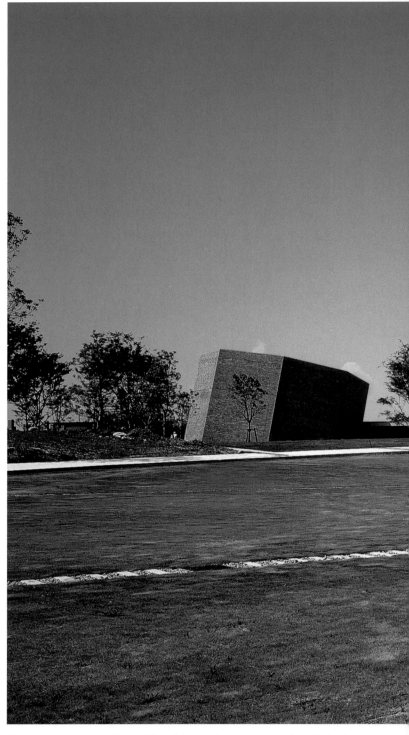

The parts of the crematorium building, rising as abstract elements from the landscape

Design sketch by Fumihiko Maki

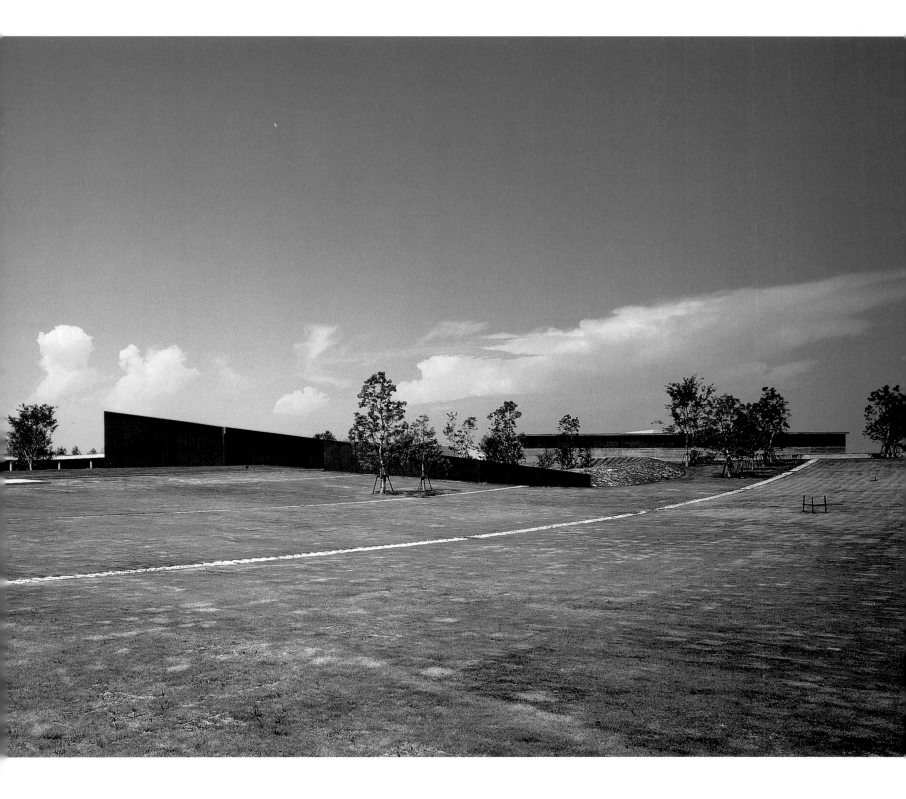

A pool found in the inner courtyard

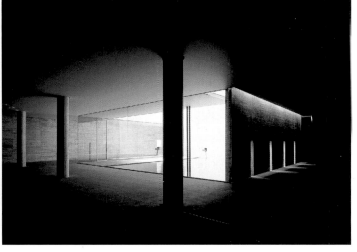

All the spaces in the crematorium radiate dignity and peace

Möbius House A Möbius strip is as fascinating as it is simple. Just take the ends of a strip of paper, twist one of them and join the two ends to form a loop. The result is a one-sided surface, which winds around itself in a sort of figure eight. The continuity of this surface, which at the same time represents a mathematical symbol of infinity, was taken up by the Dutch architects Ben van Berkel and Caroline Bos as the conceptual starting point of their building. They interpreted the figure as the constantly recurring daily routine and the human experiences and encounters it contains: intimate or distant, communal or solitary. Thus they became the winners of a competition by invitation that had been advertised to noted architects by the clients, a young couple who wanted to build a dwelling-house on their secluded piece of land not far from Amsterdam. The building was to allow each of them space for undisturbed work. The concept of van Berkel and Bos thus corresponded exactly to the wish of their clients, who according to their own account feel as much at ease today in their house as though they had designed it themselves.

This may be due not least to the fact that the unusual figure took a form that was by no means subservient to geometry. Rather, the Möbius strip as a diagram allowed an unfamiliar constellation of sleeping, working and living, and, with its distorted surface, a contraction of outside and inside. The result is a form which appears to the visitor like a sculpture lying in the hilly forest landscape.

The Möbius strip is found again in the development of the interior, which broadens out into living areas in the lower part; and it is recognisable in the ground plan of the structure, which continuously winds around itself: meets, broadens, crosses over itself, broadens again and meets again. Below the only freely extending end, one enters the long-drawn-out structure and turns on one's own axis, while moving up a staircase to the first, residential storey. Here one steps onto the route which winds its way through the house only to find its way back to itself again. One ramp leads to the kitchen, living area and veranda, and from here a conically broadening staircase – which of course turns around upon itself again – leads to the upper quarters, where a study to the right and two children's rooms and a bathroom on the left are lined up. Finally, in a twist to the left, one descends again, coming out by the parents' bedroom and the second study, where the access loop was first entered. In the course of this tour, one encircles and moves past the garage situated in the centre of the building.

The architects wanted to avoid any kind of architectural language, but nevertheless there are references that come to the observer's mind: Hans Scharoun's free spatial structures and Frederick Kiesler's endless house come to mind as much as do the buildings of Prague cubism, when the smooth exposed concrete folds into ever newer forms, few of which are rectangular. The well-known modernist trademark of allowing interior and exterior to merge by means of unframed sheets of glass is paraphrased and intensified by these architects in the way that they form both inner and outer walls sometimes of glass, sometimes of concrete; and they play with movement and stasis, even in the creation of fitted furniture out of concrete. E.W.

Diagram of the family's daily routine and movements within the house The Möbius strip, the starting point for the design of the Möbius House

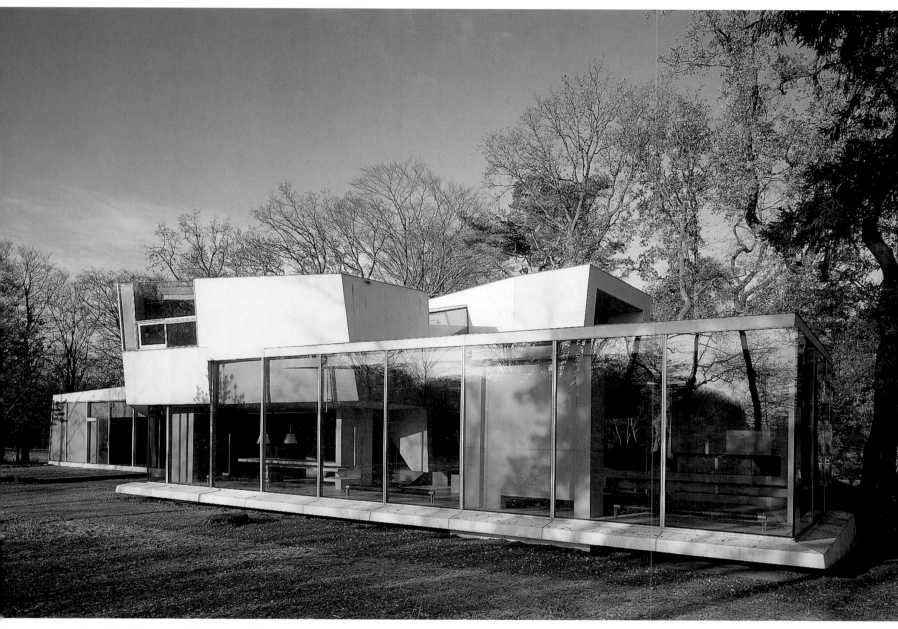

Massive walls in exposed concrete and glazed volumes alternate in this dwelling-house

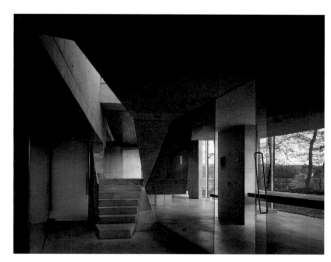

The interior with the different functions of the areas flowing into each other

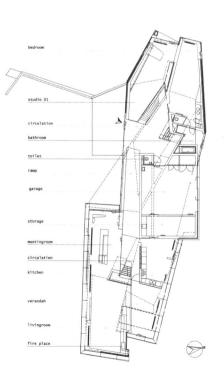

bedroom

studio 01

circulation

bathroom

toilet

ramp

garage

storage

meetingroom

circulation

kitchen

verandah

livingroom

fire place

Ground plan of the house

Oriente Railway Station One of the most important intellectual strategists of the Renaissance, Giorgio Vasari, in a successful polemic, disparaged the Gothic style as the building of Germanic barbarians. But can the French royal architecture of the high Middle Ages on the Île de France seriously be connected to the Goths of the time of the migrations? Nevertheless, the coup has remained successful up to the present day. The bundles of piers extending up to the vault ribbing, typical of Gothic religious buildings, were for Vasari nothing other than the crowns of trees growing together in the mist of northern forests. Architecture in the spirit of classical antiquity meant clear geometric masses in a bright Mediterranean light. Even Le Corbusier still shared this belief.

Santiago Calatrava's Oriente railway station aggressively transforms the tree metaphor. He transports the tree crowns to the South, as sparse architectural sculptures. This Spanish civil engineer and architect working in Zurich is one of many designers who perceive architecture in the tradition of Pier Luigi Nervi as a constructive and aesthetic adventure. In the affinity of his lightweight pier constructions to religiously evocative Gothic forms, he reappropriates an important motif of nineteenth-century civil engineering, as represented for example by Viollet-le-Duc. This makes him a rather distinctive outsider in the architecture of today.

The lightweight roof structures of the Oriente railway station in Lisbon are thus quite explicitly intended to recall "trees on a hill". The eight high-lying railway platforms, 78 metres wide and 238 metres long, with their light roof-skin of steel and glass, become an airy sculpture. This impression of floating is intensified by the fact that the platforms rest on a steel bridge, which is supported by gently rounded, elegant arches. A massive foundation in the form of an organically sculptural "root-base" of powerful, expressive concrete ribs supports this light structure, and draws the passengers into an underground space that recalls the visions of Piranesi. Here there is a station on an intersecting metropolitan line not built by Calatrava. A lengthwise gallery, in part two stories, links the two stations as a distributor of the streams of passengers and at the same time functions as a shopping arcade, a commercial open space.

The station, five kilometres distant from the historic inner city, is the exposed superstructure of a complex traffic junction, which in 1998 opened onto the World Exhibition, Expo '98. Since the railway line separates the city from the banks of the broad river Tagus, the transparency and lightness of the supports also serves to connect the banks with the city by means of a multiple road link. At the two entrances, great floating canopies of glass and steel evoke with their wings the lightness of the high-tech construction.

In the spatially diffuse outskirts of the Portuguese capital the structural sculpture of the station roof contributes a strikingly symbolic reference to place. But this is where the associations with Gothic religious spaces end. A spiritual centre is not to be expected at the junction of the mobile city of modernism. Even if the Expo could not quite fulfil the expectations of a lasting industrial dynamism in Lisbon, the Oriente station is among the lasting architectural achievements of this major event.

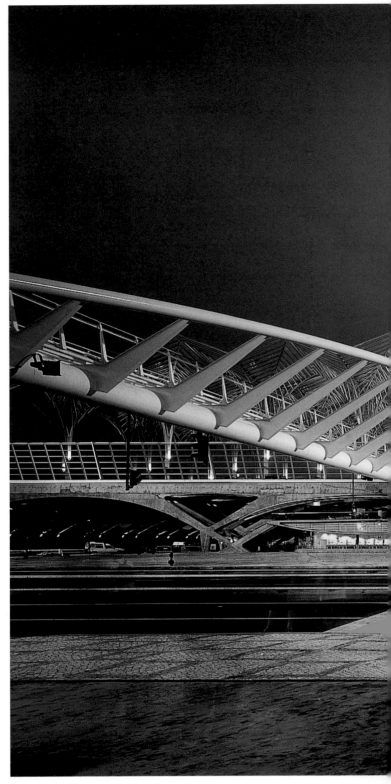

The Oriente railway station, an impressive structure of steel and glass

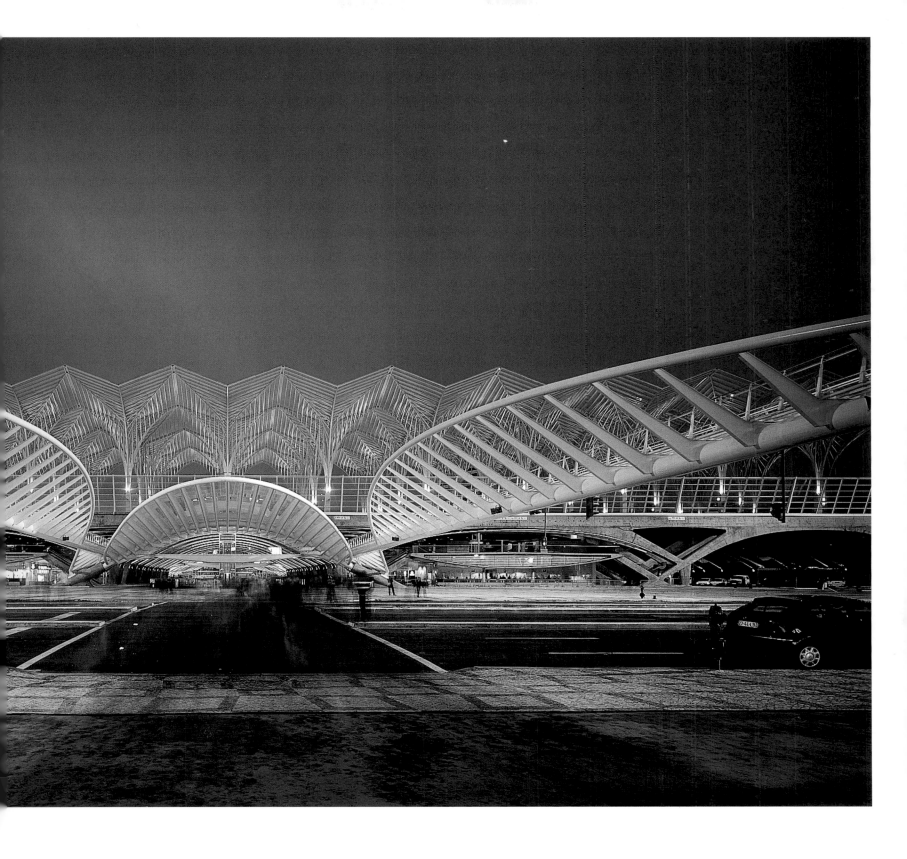

Site plan of the station

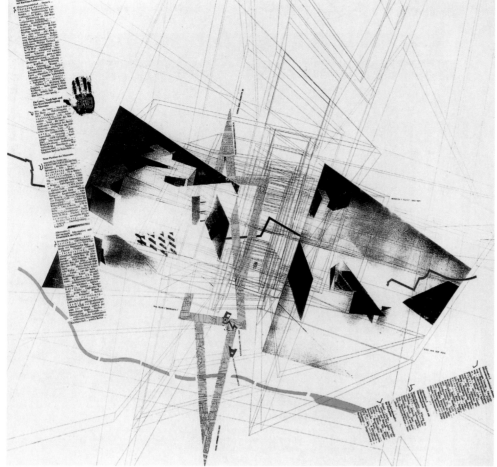

Star matrix in the topography of Berlin

Jewish Museum In a way unmatched by any of the other new museums in Germany, the Jewish Museum in Berlin by Daniel Libeskind embodies an architecture-sculpture whose expressive power and intensity have become the catalyst of a cultural and political controversy. Originally conceived in the invitation to the 1988 competition as simply an extension of the Berlin Museum with only one Jewish section, the building was opened in 1999 as an autonomous museum of national significance, dedicated to the history of the Berlin Jews. For the first two years merely a building without exhibits, it became a magnet for hundreds of thousands of visitors, who preferred to recognise the building form itself as the "actual" Holocaust memorial: sculptural architecture as signifier.

The museum, like an erratic boulder, seems to move ominously close to the baroque edifice of the former Berlin Museum. A coolly zinc-clad mountain, it disregards its urban surroundings. The forbidding sculpture-building has the appearance of an expressive, craggy and sharp-edged zigzag. The collapsing outer walls of the first design would have intensified this impression but were abandoned for reasons of cost.

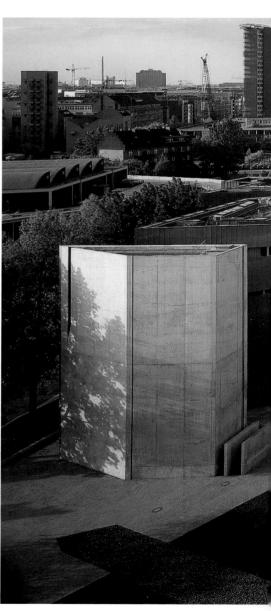

The Jewish Museum in its urban context

The disturbing lack of dimensions of the building, heightened by the lack of entrances and recognisable storey levels, is emblematic. Even if the exhibitors – able to display their collections only since 2001 – attempt to avoid this impression, Libeskind's symbolically charged space for housing the history of the Jews in Berlin and Germany refers quintessentially to the vanishing-point of the breach in civilisation, the Holocaust.

But if anything, the external view hinders the observer's understanding of the radicality of the ground plan, laid out in the dramatic zigzag form of a lightning bolt; and the exterior is at the same time only the reverse side of the central staging area for an inner world rich in allusion and experience. Many observers saw, quite rightly, already in the shell of the building an accessible sculpture, whose subversive spatial effect manifests itself to the visitor only in the movement guided in virtuoso style by the architect. From the foyer of the baroque building the visitor is guided into the lower depths of the new building, towards three "streets" formed as dramatic passageways, crossing and cutting into each other. One of these leads into the exhibition rooms, by way of a narrow cascade of steps serving all the floors and lit from above. The passage to the Holocaust tower proves to be a blind alley. A further passage leads to the stone E. T. A. Hoffmann garden, its floor area slightly tilted, densely lined with 49 pillars. Both places are encamped in front of the mass of the building as solitary pieces, each a sculpture in its own right. They are intended to make the experience of exile and concentration camp comprehensible to all the senses by means of not unproblematic translations into space.

In spite of its definition as a museum, the architect's intention is that, in its symbolic centre, the building remain empty. In the ground plan an imaginary line crosses the lightning bolt, and at these points of intersection the building is broken through at all floor levels by six empty spaces, like light-shafts, the "voids". Only one of these is accessible. Together with the Holocaust tower they represent in architectural form the architect's message about the irreparable absence of murdered human beings and their culture. Thus for all its religious echoes, this disturbing sculpture offers no consolation to its very core.

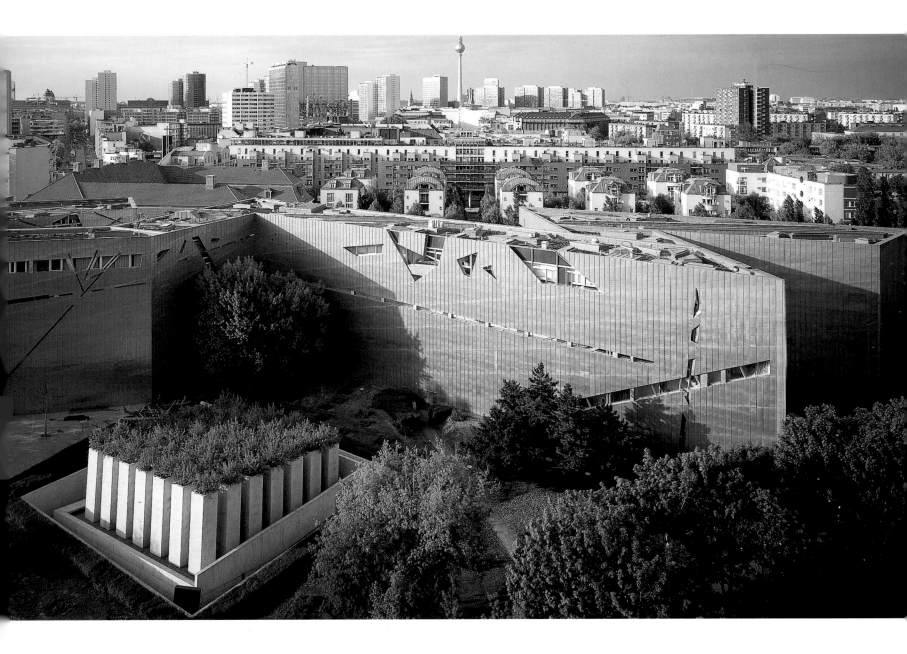

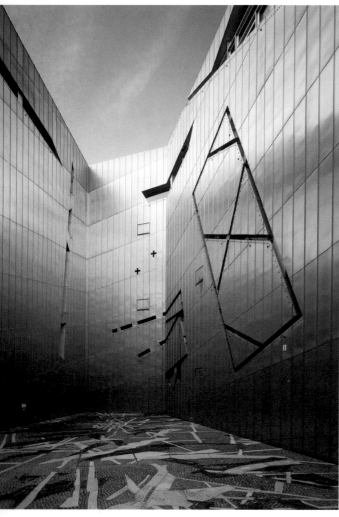

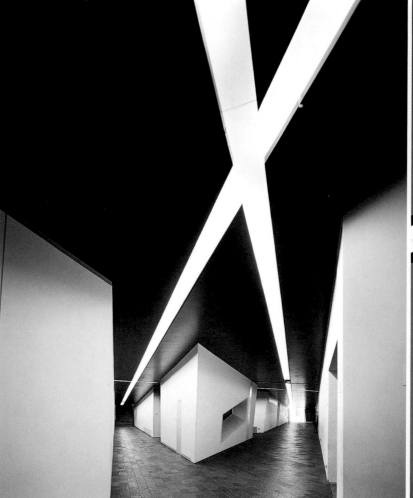

The Paul Celan Courtyard

Crossing of the axial paths in the basement

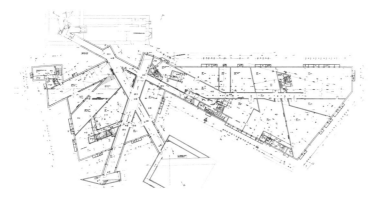

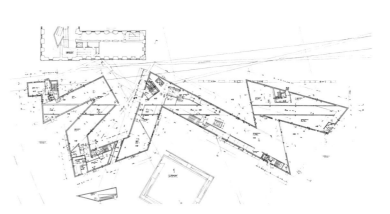

Ground plan: basement

Ground plan: ground floor

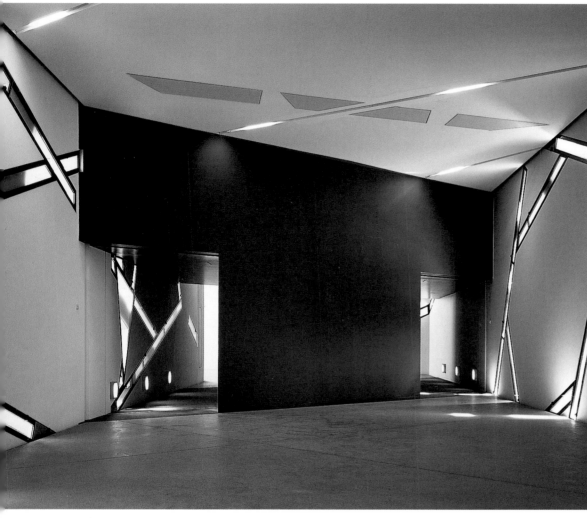

View of one of the exhibition spaces

Only the last of the six "voids" can be entered

Ground plan: first floor

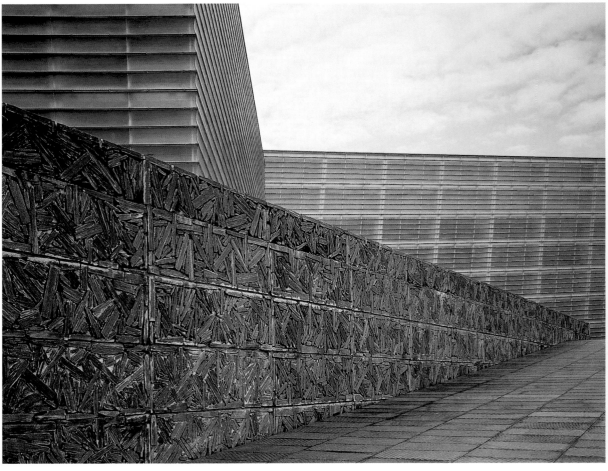

Ramps bordered by stone walls, giving access to the platform on which the buildings stand

Ground plan: second floor

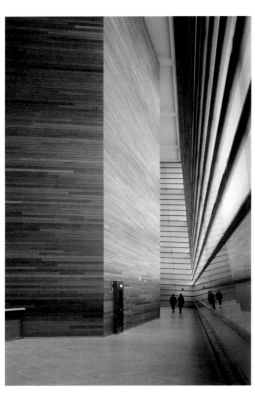

Interior view with the installed hall cube

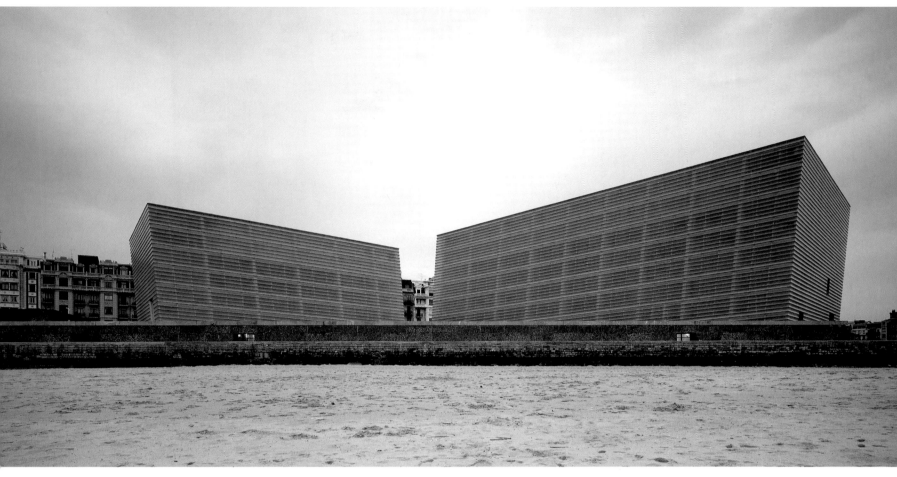

View of the two structures in the Concha bay

Kursaal Auditorium and Congress Centre Committed to a highly reduced modern language of architecture, Rafael Moneo, from Madrid, cannot be considered a representative of an expressionist concept of building. Nevertheless, with his Congress Centre in the Basque capital, San Sebastián, built between 1990 and 1999, he succeeds in an abstract, effectively almost minimalist, interpretation of a classical motif of expressionist architecture: the building as shining crystal, as a solemn intensification of nature. Like "two stranded rocks", the two glass cubes lie on the shore of the Concha bay, as though "they did not belong to the city, but were part of the landscape", as the architect explains it. Its striking position – between the broad coastal road, the Paseo de la Zurriola, behind which a compact city district with eight-storey blocks pushes its way towards the shore, and the pointed tongue of land formed where the river Urumea flows into the bay – makes the crystalline masses appear rather to form an intermediate world, transcending city and nature in equal measure.

The eccentric position of the building units in relation to the city arises from their virtuoso treatment. The outer shells are free-standing, steel skeletons clad on two sides with glass, while the assembly rooms, wood-clad concrete cubes, are placed slightly asymmetrically within these shells. The opaque shells, more or less translucent according to the position of the sun, the time of day and year, incline slightly down to the shore. The steel supports, shining through the glass, take on the distortions of the building fabric and thus inten-

sify its strangeness in comparison with the orthogonal character of the city. In the dark, these crystal forms assume an almost unreal brilliance and seem to float in front of the weightiness of the city's mass.

The two blocks, however, do not lie directly in front of the city, rather they are set apart from the shore by a connecting platform and integrated into the ground plan of the city. The one-storey platform, which contains all the service functions, is slightly terraced opposite the shore, and accessible by means of gently ascending ramps. Opposite the street on the city side, and augmented by a modern, pavilion-like glass structure, it is defined as a traditional urban vanishing-line. The opening between the two solitaires here takes in the axis of the street that leads into the Paseo de la Zurriola, and in this way the grid of the streets becomes a point of reference for the assembly rooms.

The total separation of outer skin and the body of the assembly rooms makes it possible to compose the foyers and staircases as free-standing units in the space, in which the slightly displaced staircases float as independent sculptural structures. This non-tectonic impression is enhanced by the fact that the platforms of the staircases, strengthened by consoles, appear not to touch the glass coverings of the light-filled space. Each building has only one, large, strategically placed window, which dramatically presents the panoramic view of the mountains Ulia and Urgull.

Reichstag Anyone who today experiences Norman Foster's cupola on the Berlin Reichstag may easily forget that it is the product of a tough and protracted struggle. Foster had won the competition in 1993 with a concept that was characterised by the specific rejection of a cupola. Paul Wallot's nineteenth-century building was to be handsomely surmounted by a sort of transparent, horizontal cushion. It became famous, indeed notorious, as the "petrol station roof". In the end Foster had to submit to a decision by the council of elders and, against his will, place a cupola on top of the building. Rising lightly and delicately above the massive base of the old Reichstag, it admittedly has little in common with the original cupola above the rectangular outline. Rather, Foster succeeded in a stroke of genius, a kind of British third way between neo-historical reconstruction and Paul Baumgarten's austere but timid postwar rebuilding of the Reichstag, which managed without a cupola.

In addition, the architect more or less completely rebuilt the interior of the building. All the fittings of the 1960s were removed. One reason for this was that the parliament of the reunified Germany required 270 more seats than Paul Baumgarten's modest chamber. Foster used the demolition of the fittings in order to uncover un-pleasant, previously concealed traces of the chequered history of the building and place them in context, whether these were bullet-holes, graffiti by Russian soldiers or damaged sandstone ornaments of the Wilhelmine building. He enclosed the semi-elliptically arranged rows of seats on the raised ground floor in sheet glass, typical of his architecture and of the perception of democracy in postwar Germany.

But the new Reichstag actually begins on the roof of the old building, where it has freed itself from its historic pedestal and at the same time drawn profit from it. It is more than just a pleasant accident that precisely this part is open to the gaze of the public in its own house. By entering via the west lobby and taking the lift to the top, one can, as it were, walk over the politicians. From here a fantastic panorama opens up, of Berlin, of the other government buildings and not least of the cupola, which rises directly in front of the flat roof terrace. Although statically linked with the foundations, it seems quite independently placed on the building. The glass panels positioned on the steel rings are stacked like shingles, always leaving a gap of air in between, which makes the cupola into a scarcely covered outer space; and a public space, for this is where the flâneurs

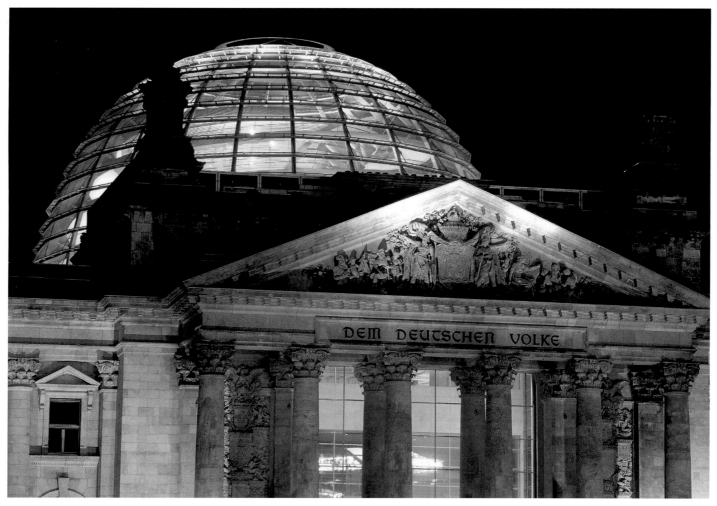

View of the Reichstag with the cupola lit up

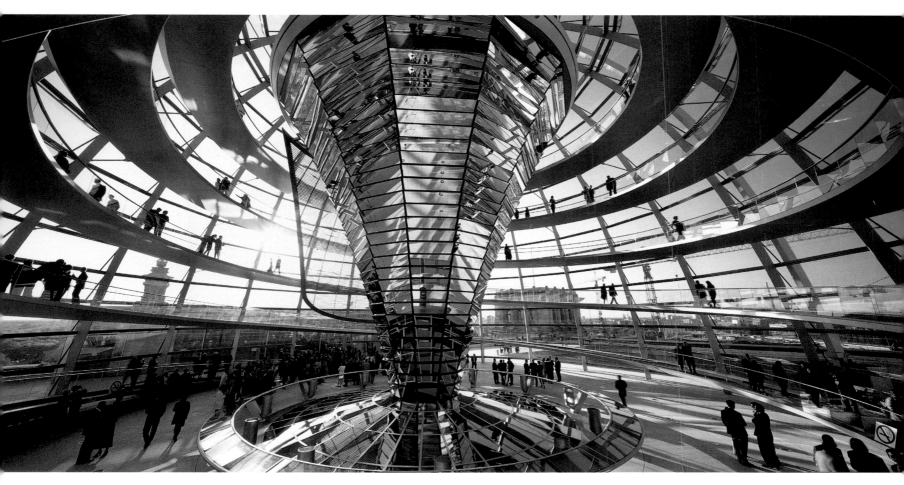

A spiral ramp leading upwards into the cupola

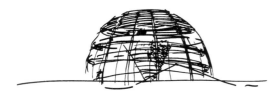

Concept sketch by Norman Foster

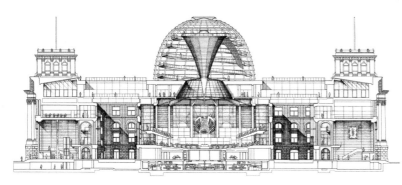

Section of the building and the cupola

make their appearance. Two spiral-shaped and upwards-tapering paths wind around each other, actually allowing the cupola to be experienced spatially. From here it is possible to look down into the chamber as well as outward over the city and park, while one saunters above all this at a comfortable pace. The centre of the tapering, looping path forms a cascade of 360 mirrors, intended to guide the daylight into the plenary chamber, and behind which the exhaust air system of the building is situated. But this building-sculpture has scant need of such ecological-functional justifications, for it has become a telegenic symbol of the seat of government as well as a place for the light-hearted self-presentation of those who ascend here. Everyone who visits the cupola is amazed by the cheerfulness which is transferred from the building to the people: the crowning of the political in architecture. E.W.

New Synogogue The inner city of Dresden, destroyed in 1945, has apparently risen once again as an image. The banks of the Elbe, with the Brühl terrace as stage, gather together the impressive buildings of "Florence on the Elbe", as the city is known, between the Albertinum, Academy of Art, Hofkirche, Opera House by Semper and the Zwinger. The reconstructed Schloss and above all the newly built Frauenkirche with its stone cupola complete the familiar panorama. On the eastern edge of this architectural veduta, separated from the Brühl terrace by a park sloping down to the Elbe, the new synagogue has stood since 2001. Its predecessor had gone up in flames, not of course in 1945, but in November 1938 on the night of the pogrom (known as Kristallnacht), exactly one hundred years after the laying of its foundation stone. No less a person than Gottfried Semper had built it in a green space on the approach up to the Carolabrücke between 1838 and 1840, in the form of a compact neo-Romanesque central building with an octagonal cupola. The new synagogue occupies approximately the same site as the historic building, but is larger, with its massive base of 100 metres in length and 26 metres in width. Between the approach to the bridge to the east and the downward-sloping street leading to the old city, it forms a stone temple complex of two cubes with an inner courtyard. The new synagogue is quite modest at 24 metres in height. Within view of the 95-metre-high Frauenkirche, it stands for a different philosophy in its treatment of history. Not the reconstruction of the old image, but a "nevertheless", a marking of the breach of civilisation in combination with a powerfully erratic architecture, is the aim. The self-assurance of the community is also manifested in the opening of the courtyard towards the city, corresponding socially to a general sense of receptivity.

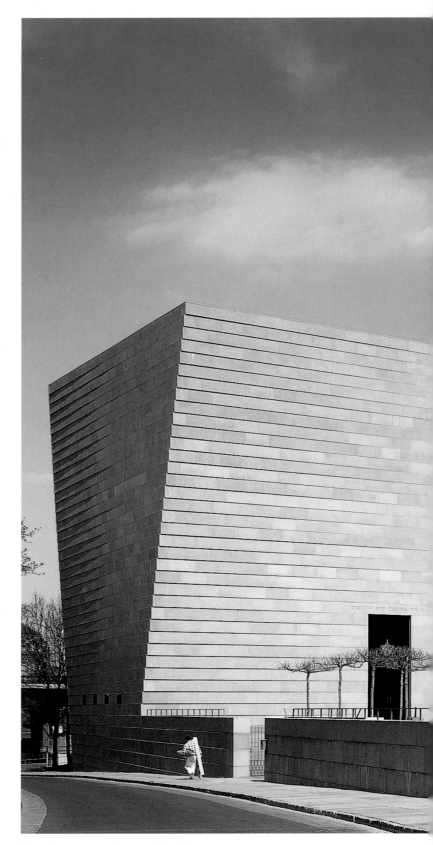

View of synagogue and community centre

Drawing of the construction
kit principle of the synagogue

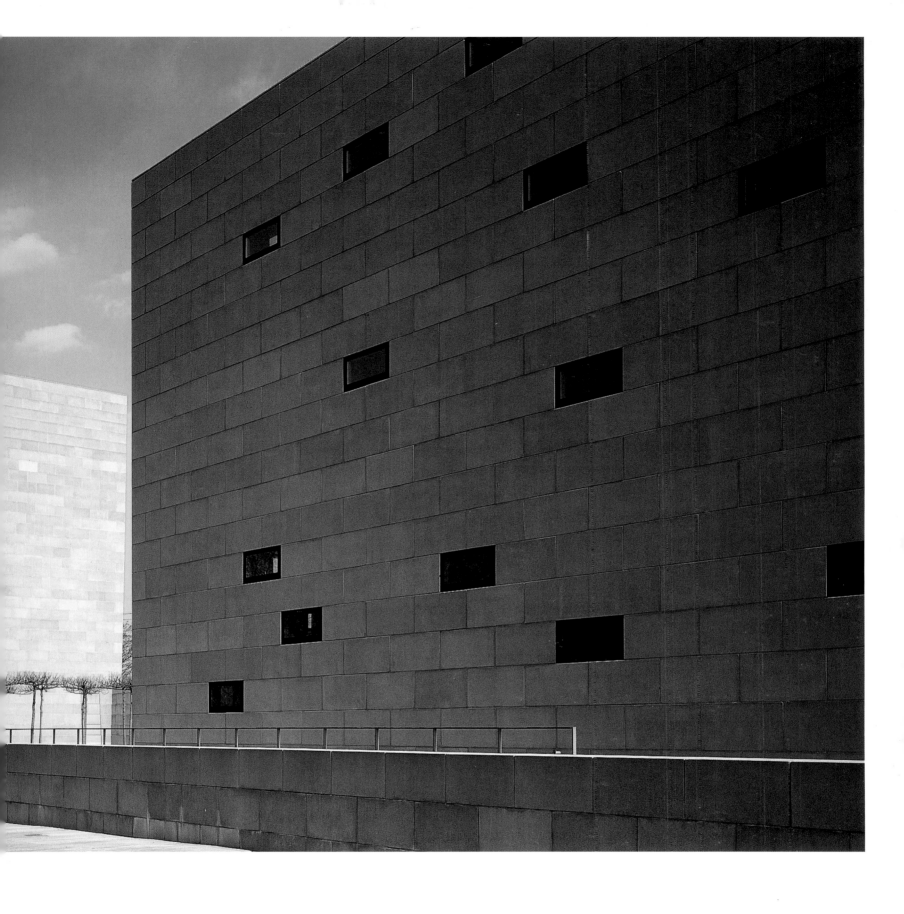

Ground plan of the ground floor

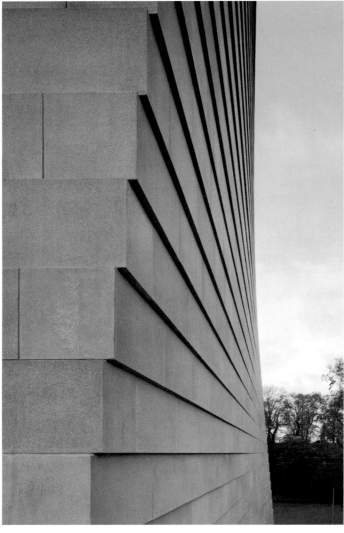

Detail of the twisted façade

Detail of the gold-coloured canopy

The design by the architects Wandel Hoefer Lorch, from Saar-brücken, and Nikolaus Hirsch, from Frankfurt, which emerged in 1997 as third-prize winner in an international competition, defines the space in an entirely new way. Opposite the very wide traffic corridor, with a tram route passing directly alongside the building, the walls of the two structures form a front with a tall wall screening off the courtyard. To the north, the impressively situated synagogue, a hermetically sealed stone cube, occupies a surface of 26 x 23 metres. Similarly closed to the outside, but broken up to the south and west by irregularly placed horizontal window slits, the three-storey community hall opens to the courtyard with a friendly, well-proportioned, modern glass front, given a rhythmic effect by light-coloured wooden shutters. The courtyard responds with a great gesture to the west towards the Brühl terrace, broken up by a row of trees. Despite all its sensitivity to context, the monolithic character of the complex,

minimalistically defined throughout with sandstone-coloured concrete blocks, is sculpturally intensified by the synagogue. In its ground plan the building diverges slightly from an east-west axis; but the turning of the building, achieved by the slight displacement of each stone layer of the façade in relation to the one below, orients the roof exactly to the east. This dynamic and dramatic treatment of the building, achieved by a minimal device, its alienation into a sculpture, is liturgically motivated. The interior contains a canopy of gold-coloured filigree metal, placed like a tent in the very area of the façade that is displaced eastwards in relation to the ground plan. The space within a space is reserved for the ritual with the bima (podium) and Torah shrine symbolically directed towards Jerusalem. Thus the provisional character of the tent motif is placed in a spiritual and spatial tension with the permanence of the temple walls.

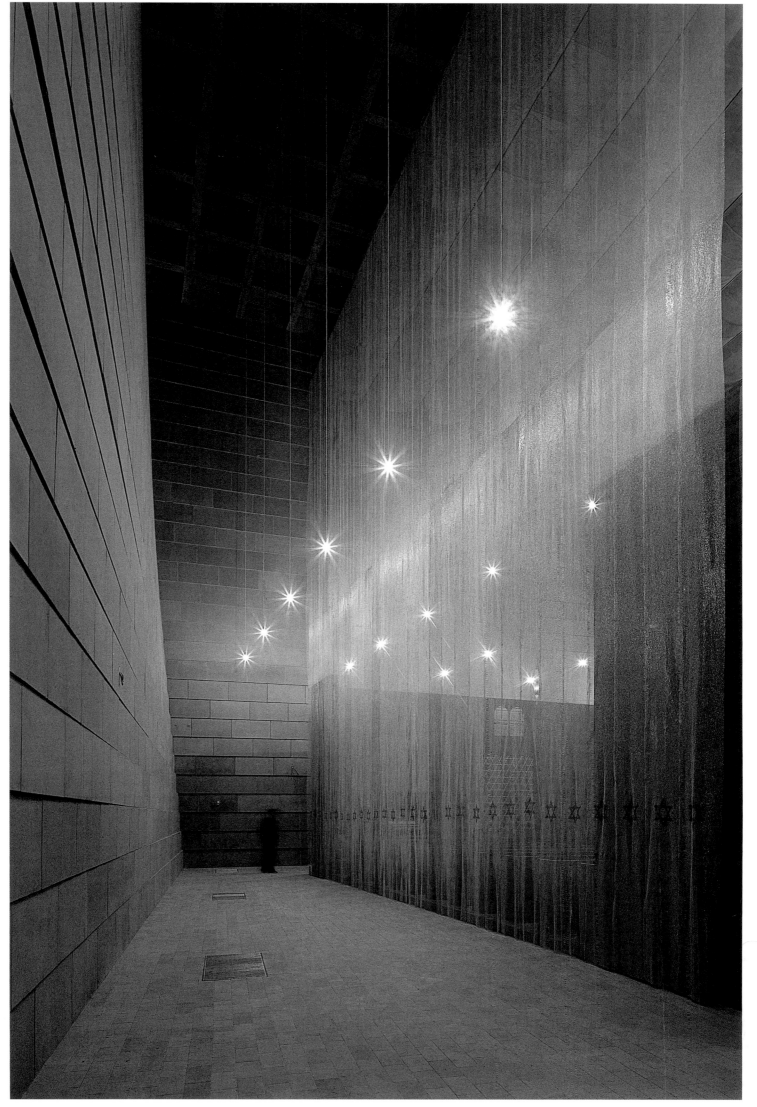

Interior with brass curtain

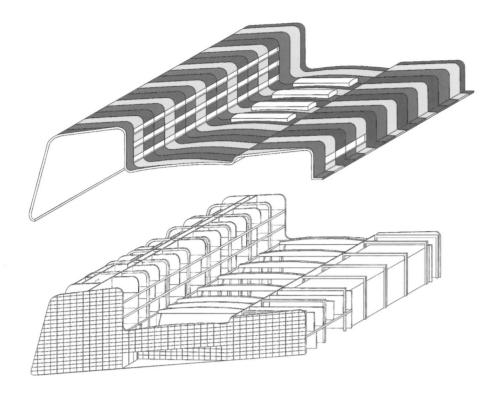

Diagram of the concept of the building

Experimental Factory Magdeburg, once one of the metropolises of the Middle Ages and centre of the Ottonian dynasty, has been since the nineteenth century an industrial city. This character, if anything, was strengthened in the era of the German Democratic Republic and is still retained by Magdeburg today, meanwhile the capital of the new federal state of Saxony-Anhalt. The Otto von Guericke University, newly founded since reunification, is one of the institutions that to-day are coming to grips with Magdeburg's awakening to the new knowledge and information society.

The strikingly colourful and object-like Experimental Factory by Sauerbruch Hutton Architects is part of the new campus of the University, which is screened off from a broad traffic axis on its southeastern edge by the Factory together with other research institutes. Here the building sets a distinctive example in a diffuse urban planning environment, emblematic of a creative research landscape, a signal of hope in a shrinking region. The intense colourfulness of the research factory recalls the 1920s in passing. Summoned from Berlin as architectural consultant, a prominent modern architect had within a few years transformed the city into a centre of the New Building: Bruno Taut. Among other things, he enriched the otherwise rather "white" Modernism with an opulent programme of colour. The two architects of the Experimental Factory made their name not with coloured walls, but with coloured glass façades. The German-English pair of architects Louisa Hutton and Matthias Sauerbruch, with offices in Berlin and London, knew how to combine their light and always playfully colourful glass architectural language with innovative concepts for energy-saving construction. In the meantime, the award-winning design team, both former students and later teachers

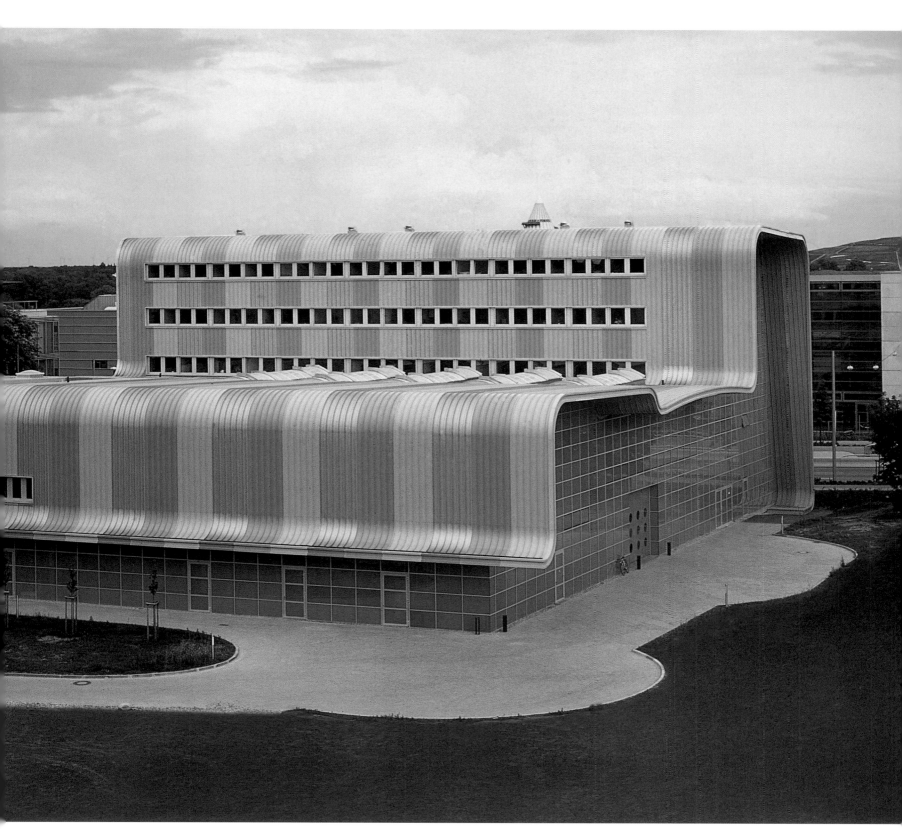

A roof skin in striking colours drawn over the building

Spatial concept of the foyer

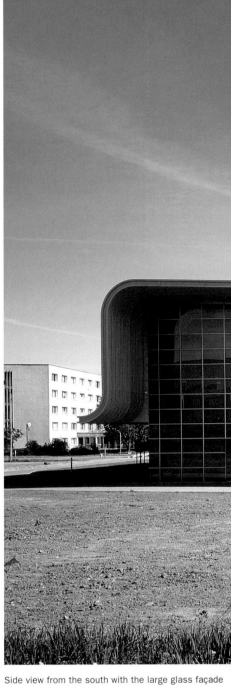

Side view from the south with the large glass façade

A two-storey foyer linking the different parts of the building

The office area in the eastern part of the building

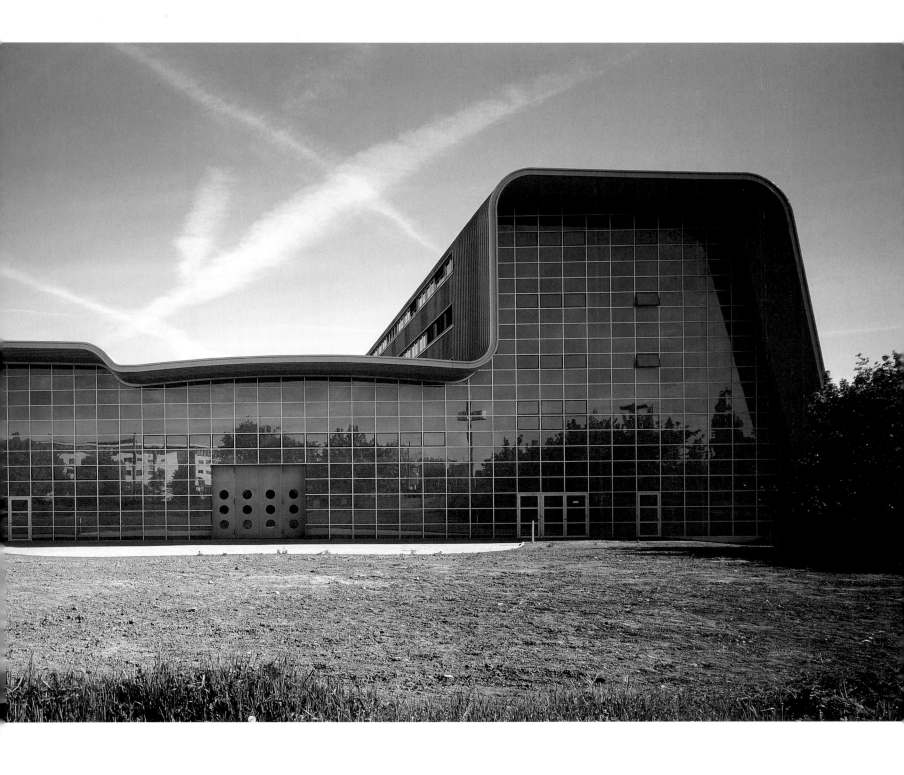

at the avant-garde Architectural Association in London, can also boast many buildings designed for research and industry.

The Magdeburg factory is used for experimental research into electronically driven production processes. As a very compact integration of three structures of different heights, the building achieves its sculptural effect by means of an all-embracing, colourfully glowing roof skin of aluminium sheet metal. As a "cover", according to the architects, this proceeds from the floor of a five-storey office and laboratory building which draws back slightly upwards, over a hall in the centre part right across to the back. Here, likewise, in a separate but connected building, is a large laboratory for electromagnetic testing. Through the pink, orange and silver-grey cover, in which wall and roof become an aesthetic unity in one continuous wavy surface,

the heterogeneous elements of the building programme appear as a sculptural and technoid object of steel, aluminium and glass. The two front sides with their wide covering roof link the three masses of different heights in a large glass façade, which reveals its full luminosity only at night. In Magdeburg, the glass characteristically used by Sauerbruch Hutton Architects is, unusually, white. The different masses are accessible from the interior by means of a two-storey foyer with an impressive staircase, and multiply interlinked, for example by a gallery on the first upper storey. The steel skeleton of the building allows a maximally flexible use of space.

The message from Magdeburg – not overly optimistic, it is hoped – seems to be that in the post-industrial era, even production becomes pop.

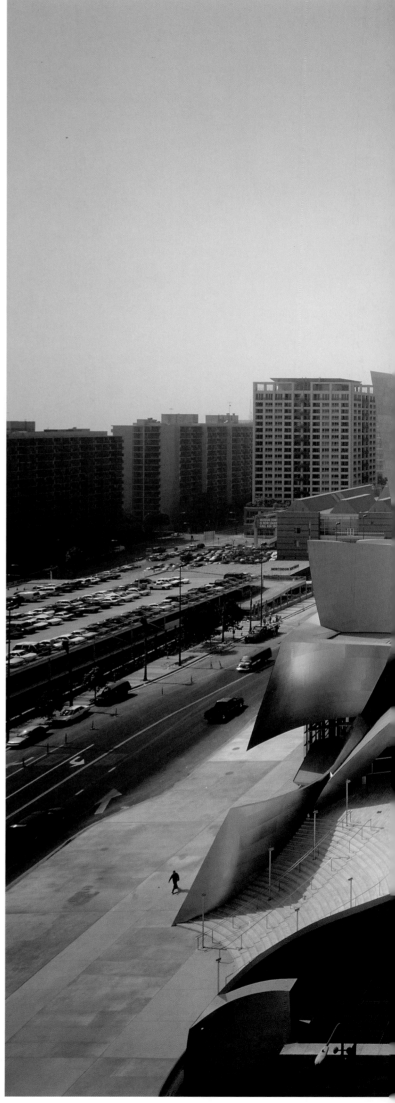

Axonometry of the building

Walt Disney Concert Hall The concert hall of the Los Angeles Philharmonic, ceremonially opened in October 2003 with world-wide resonance in the media, is no mere variation on the Guggenheim Museum in Bilbao, built by Frank Gehry between 1993 and 1998. Rather, his design of 1987 predates the successful Bilbao project by more than five years; in 1988 he won the competition. A new Philharmonic hall was to come into being at Bunker Hill next to Arata Isozaki's postmodern Museum of Contemporary Art. Together these now form an Acropolis of art within view of the new Cathedral by Rafael Moneo. The adjacent historic downtown area, today inhabited by Hispanics, who form the majority of the city's population, is to receive new impulses from the cultural institutions at its edge. The project, initiated with many sponsors, was given a boost in 1992 by an endowment from the widow of Walt Disney, but remained for years stuck in an industrial and political mire, to be finally realised, after considerable reworking, in 1999.

The originally intended stone façade was now replaced by a stainless steel skin, which is closer to the titanium façade of Bilbao. If Gehry's museum in Bilbao had become an example of the almost magical effect of his sculptural, organisational architecture, Bunker Hill now hopes for its own "Bilbao effect": the transformation of a deserted site on the edge of the inner city into a magnet of cultural tourism.

The concert hall makes evident the closeness of Gehry's design approach to the free form design of his sculptor friends Richard Serra and Claes Oldenburg. For Gehry, architecture and sculpture are inseparable. With his Vitra Design Museum of 1989, Gehry had already tried out this organic-dynamic language of forms for the first

The Walt Disney Concert Hall against the Los Angeles skyline

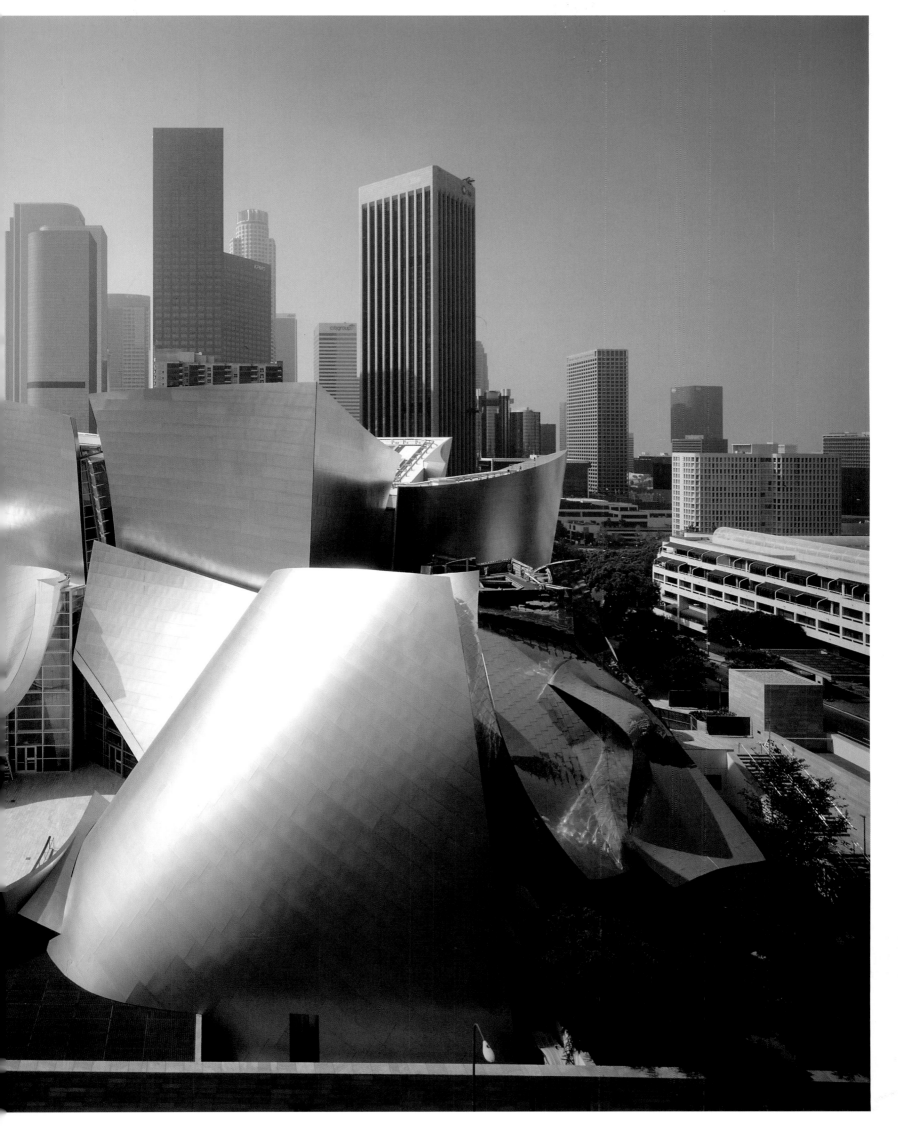

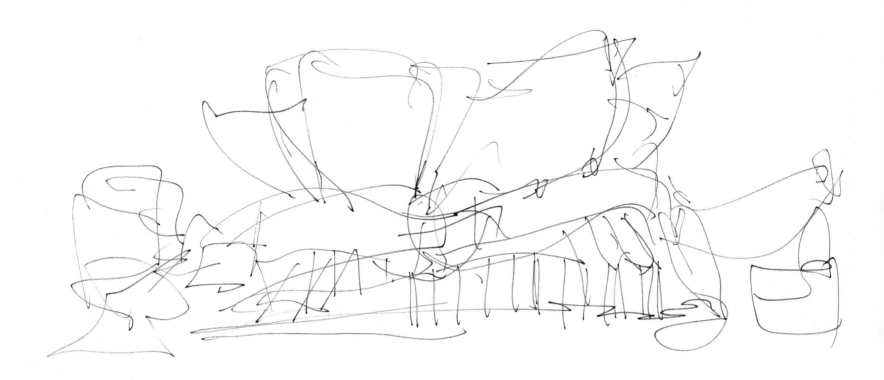

Design sketch by Frank O. Gehry

time. At that time, because of his earlier building collages of fragmented surfaces and collapsing walls, he was publicised as a Deconstructivist in the influential exhibition Deconstructive Architecture of 1988 in New York. Under this misleading label he became known worldwide. But his sculptural dynamism in Los Angeles clearly takes as its measure the older tradition of Hans Scharoun's late expressionistic Philharmonia in Berlin, which was clearly the godfather to Gehry's "vineyards" of terraced auditorium around the centrally placed orchestra. More conventional than Scharoun, he develops the sculptural dynamism differently, not out of the space, but out of the outer wrapping and its folds. This lies like a loose sail of stainless steel, transformed into dramatic curves, around a severe and axially structured concert box with 2,275 seats. The erratic massif made of sails adopts the motifs of Jørn Utzon's Sydney Opera House but curbs its vertical, sharp-edged dynamic into broad horizontally layered folds. The sculpture-building stands on a base which, with an underground car park for 2,000 vehicles, encompasses a whole, sloping block of Bunker Hill. It is surrounded by a public garden and on two sides at the back by extended, low-lying administrative buildings which, fortress-like, screen off the concert-hall from the traffic. The entrance is reached, almost intimately, diagonally from a street corner by means of a set of steps enclosed by curved steel walls and an equally steely-shimmering forecourt. From the foyer, the concert-hall is then reached axially by way of steps on several levels. As an expressionistic crown of the city, the Walt Disney Concert Hall, radiant in the sun of southern California, can also be understood as a baroque response to the puritan coldness of the mirror-glazed office towers of downtown Los Angeles.

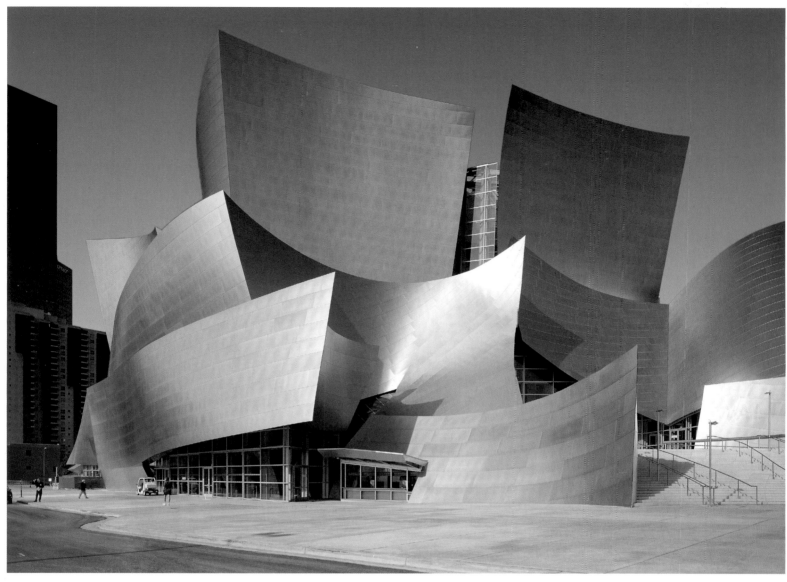

Exterior view of the concert hall with its stainless steel skin

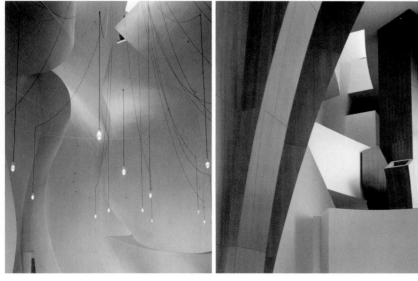

Ceiling detail

Detail in the entrance foyer

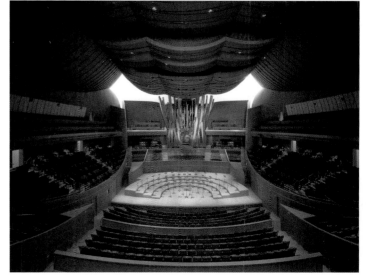

The concert hall with the organ designed by Gehry

View and section

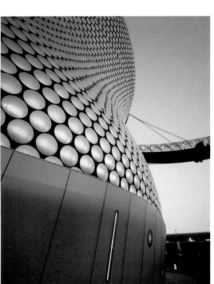

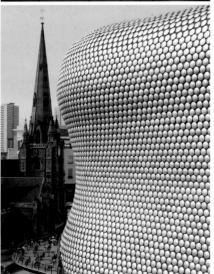

A neo-Gothic church in the vicinity of the curved building

Design sketch

29 – 10 – 99

Selfridges Department Store Of the Bull Ring centre in Birmingham, only the impressive round tower is preserved. Otherwise, this large business district of the 1960s, with its pedestrian levels raised above the street traffic, has been demolished. What was conceived at that time as a public space has now been replaced by a resolutely introverted system of shopping malls. As the first harbinger of the new consumer world in the impoverished industrial metropolis in the Midlands, since September 2003 a hermetic though attractive object has landed almost like a UFO on a section of this area: a branch of the Selfridges department store group. The unloved concrete world thus makes room for a pop architecture derived from the spirit of this very same era and its unbuilt utopias: back to the sixties. The London architects Jan Kaplicky, a Czech exile, and Amanda Levete – who years earlier had been able to realise a biomorphous media centre at Lord's cricket ground in London but otherwise, primarily designs for stores – have here at last brought to life the fantasies of "swinging London" and *Yellow Submarine*.

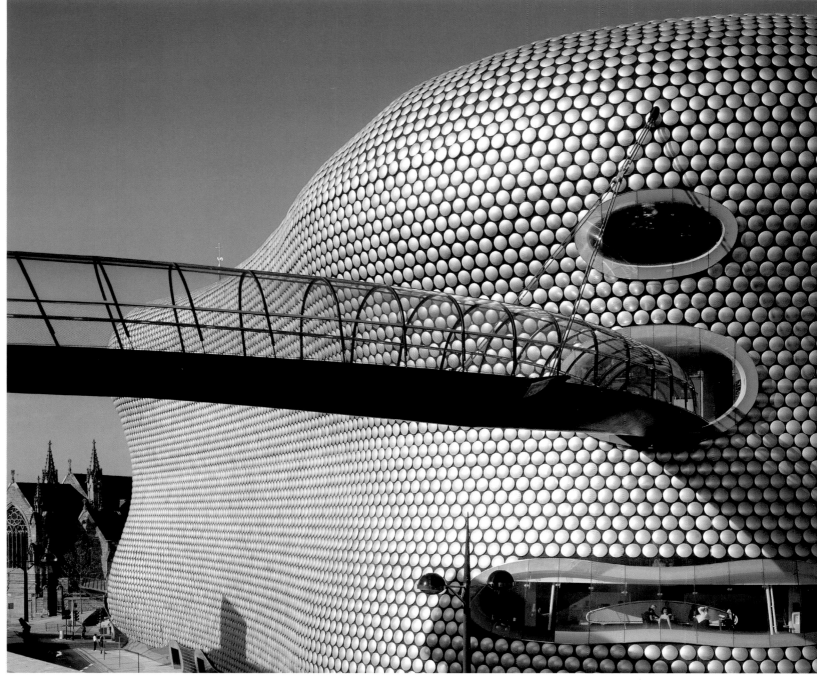

The five-storey department store is set with shimmering aluminium discs

The three-dimensionally curved, amorphous structure, 37 metres high, is nothing but a closed concrete wrapping, painted in the majestic blue of Yves Klein, enclosing five storeys in its interior. Four storeys are occupied by shopping areas, which are sited around two slightly curved atrium courtyards dramatically traversed by escalators. The skin of this urban animal is covered, as though with scales, with 15,000 polished aluminium discs intended to create the shimmering effect of a snake's skin or a dress by the designer Paco Rabanne. This continuous wrapping with its textile quality creates the almost weightless effect of a body in motion – the architecture of illusion. In marked contrast to its lifeless and scarcely attractive surroundings near the railway station, the shimmering nonconformity of the UFO suggests the promise of a mysterious parallel world in its insides. Confronted with the neo-Gothic Victorian St. Martin's Church in the newly created pedestrian precinct of St. Martin's Square, this organic form makes a respectful curve, but at the same time radically alienates the church's architectural context. Like a gigantic beached whale, it threatens to devour the nineteenth century. This object rejects every convention, it is sufficient unto itself, it requires no context of its own and does not really want to be the context for anything else. It reflects its surroundings without communicating with them.

The building is accessed by four entrances and four different levels, one of which leads over a 17-metre-high bridge to a multi-storey car park. In the roof, a glass membrane opens to the light and directs it, in fine gradations, into the atria and the storeys. The department store, for a long time in the tail-wind of cheap mass consumption, is, quite in the spirit of pop, styled once again as a shop window, a theatrical backdrop of lifestyles. Is "cool Britannia" now conquering the Midlands too? The apparent promise of pleasure conveyed by the curved outer skin is fulfilled only in the interior, in the consumer area. Beyond the aesthetics of its façade, the big-bellied monster that is Selfridges thus also stands for the regressive fantasies of the 1960s, the retreat from reality into the area of desires and commodities, a fantasy whose ideal covering this organic sculpture appears to be.

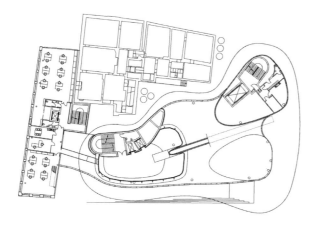

Ground plan

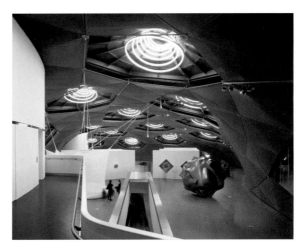

Interior with openings for light

Kunsthaus Graz Perhaps precisely because of the overpowering tradition of an opulent historical architecture of splendour in Austria, young architects in the 1960s there were particularly ready to respond to the joyfully profane message of English pop architecture from "swinging London". Along with Vienna, where Coop Himmelb(l)au transferred the visions, unfortunately never realised, of the Archigram office in London into real architecture and into the later deconstructivism, Graz was a further centre of futuristic building. There was even talk of a Graz School.

In 2003 a small group of arts managers and curators associated themselves with these avant-garde demands. As a European capital of culture, Graz was offered the opportunity to make use of a major event to ignite a new cultural movement. Like other events, this too brought international protagonists into the Styrian capital. Two architects at once built spectacular tokens of the architectural spirit of the age. In the vicinity of corresponding baroque buildings – characteristic of a part of the old city of Graz – were placed blob-like, biomorphic objects. In addition to Vito Acconci's glazed shell in the waters of the Mur, it is the Kunsthaus of Peter Cook and Colin Fournier

which has made blob architecture into a trademark of the new Graz. In the 1960s Peter Cook, along with Ron Herron, was one of the visionary moving forces of the legendary Archigram office, and one of their bubble-like pop monsters on wandering stilts of that era, Ron Herron's Walking City of 1964, has now taken shape on the banks of the Mur. Seen from this point of view, the Kunsthaus is simultaneously a reprise of the sixties and a contribution to the blob architecture of the 1990s.

The bubble, reminiscent of a fish or a zeppelin, floats above a transparent, glazed ground floor. Here can be found the foyer, a lounge, a media laboratory and a café with a view of the river. From here, a gently rising travolator moves upwards, into the cave-like belly of the building. In this steel belly are exhibition areas for contemporary art. In spite of the light-sucking proboscides with which the curved back of the Kunsthaus is studded, the interior gives the impression of a dark, three-storey cavern. A free and unlimited view of the city is provided only by the widely projecting glass catwalk attached to the side of the building, the "Needle". The façade was conceived by the architects as a membrane, as the breathing, osmotic and translucent

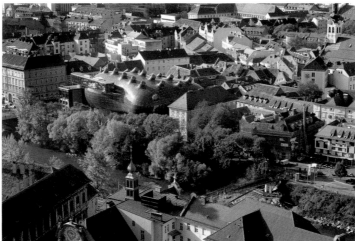

The Kunsthaus in its urban context

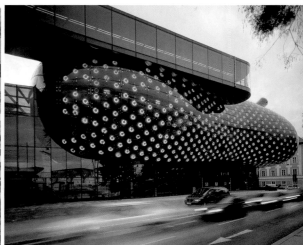

Street view

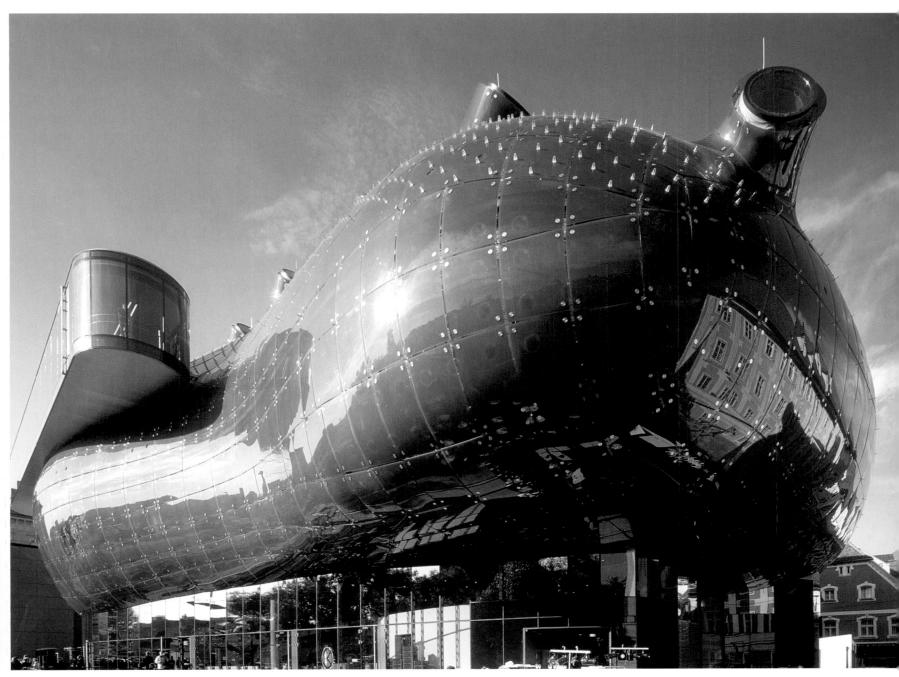

View of the glass Kunsthaus

skin of a structural organism, which would at the same time project and communicate the events n the interior of the Kunsthaus. Instead the skin became a steel armour-plating, as though the Kunsthaus were a U-boat. Almost as an act of reparation to the original concept, the outer wall, shimmering in green and blue, has now been supplemented by the Berlin office "realities united" with an intelligent media layer, which has been fixed behind the Plexiglas façade (originally conceived as transparent), and screened off from the outer wall by a third, water-diverting inner layer. During the day the Plexiglas skin acts as an architectural element, as the "proper" wall, but after dark, by means of specially written software, the 900-square-metre wall fulfils its communicative and artistic mission with countless circular fluorescent tubes. Perhaps it is not at all surprising that this "show" effect conspicuously harmonises architectural pop culture with the partly baroque environment of the old city. The "friendly alien", as the architects call it, this messenger of pop, has for a long time now been granted civic rights in the Styrian capital.

Design drawings by Moshe Safdie

Yad Vashem Holocaust Museum On the Mount of Remembrance above Jerusalem, in an extensive area, lies Yad Vashem, a research and documentation centre, but above all a memorial site for the victims of the Holocaust. Following a decision by the Israeli Parliament, the Knesset, of 1953 this is the place where the state of Israel preserves the Holocaust in the collective memory and at the same time conducts scholarly studies of it. Dignity, mourning and a thirst for knowledge, not emotionalism and false theatricality, are the strengths of this place of concentration. Since the mid-1990s a comprehensive concept for the reorganisation and enlargement of this central site has been developed.

The master plan of 2001 takes account of new media and presentation technology, and creates new spaces for the growing collections, including works of art produced in defiance of the concentration camps and persecution. To the steadily increasing need for research, it offers archives and work rooms, an International Institute for Holocaust Research opened in 2001, and an International School for Holocaust Studies opened in 1999. The growing numbers of visitors as well – two million in the first year of the new millennium alone – required a rebuilding of the museum, which includes a Hall of Names and a new visitor centre, the Mevoah, already open in 2003. Its centrepiece is a nearly 200-metre-long, 18-metre-high monumental mega-structure, a steeply towering closed triangle on a small ground plan projecting southwards over the slope. From the Mevoah the museum is accessible by a long bridge parallel to the mountainside. The powerful form bores into the mountainside like a wedge, where it gives access to the actual historic collection by means of countless underground exhibition rooms lit from above. The Hall of Names, a consecrated space open at the top and containing the names of all known Holocaust victims, is located beside the axis, and towers 10 metres up from the ground like a cone. Its mirror image, a conical space carved from the rock, forms a memorial to the nameless victims.

The prismatic, tall, lengthwise axis, whose width and curvature constantly appear to change, becomes very narrow in the centre of the museum; the axis widens out behind the exhibition spaces at the northern end of the mountain and is finally driven out of the rocks, which here form terraces. With a broad, dramatic movement the tent-like wings of the walls open. Their gesture, recalling wide-opened arms, directs the gaze into the distance, to Jerusalem below, sparkling in the sunshine. At the end of the long, painful path of the people of Israel, condensing symbolically and spatially in the long underground passage and becoming positively oppressive to experience, stand hope and confidence.

The balancing act of all significance-laden architectural sculpture between superficial effect and incomprehensibility has succeeded here with a major structure. Unlike Dani Karavan at the Negev Monument in Beersheba, Safdie at Yad Vashem is able to place the symbolic power of sculpturality in the service of an institution central to the identity of the nation: at the same time monument and museum.

The walls opening at the end of the building with a great movement

General view in the model

The building emerging from the mountain to the north

Detail of the façade structure

Swiss Re London Headquarters In the 1950s the inner city of London was still dominated by the towers of Sir Christopher Wren's seventeenth-century churches. The rise of the city to one of the greatest finance centres of the world has allowed a skyline of glass towers to come into being, in which the majestic dome of St. Paul's can only just manage to assert itself. With the exception of Richard Rogers' high-tech icon, the Lloyds of London insurance building, most of these office buildings are rather banal. For a long time Norman Foster – apart from his former partner Richard Rogers the most important of England's high tech architects and like him a long-established global star architect – had tried in vain to contribute something to this skyline, perhaps a Millennium Tower, which would have become the tallest building in the world. Despite his brilliant Hong Kong and Shanghai Bank in Hong Kong (1979–1986) and, at 300 metres the tallest tower block in Europe, the ecotechnically costly Commerzbank in Frankfurt (1991–1997), it was only now that Foster was able to build a high-rise building of moderate height in the City of London. The new London headquarters of the Swiss Re reinsurance company, with offices on forty floors and a shopping area at the base, is modest by comparison with the Commerzbank building, and attracts attention first of all because of its almost too graphic form. Structured by diagonal window strips, the curved building swells in the centre and is conically rounded off at the top; it has already been labelled "the gherkin" by Londoners. Actually it looks more like a pine-cone.

On the site of the former Baltic Exchange, the bulbous building in St. Mary Axe towers over the old early thirteenth-century church of St. Helen's Bishopsgate and competes with the nearby silver monster of Rogers' Lloyd's building. The eccentric form of the building adds a sculptural solitaire to the somewhat insensitive, hard-edged high-rise landscape of the city; its soft, organic form, quite unexpected in this location, contributes noticeably to the atmospheric brightening of the urban micro-climate. In the skyline it acts as a counterpoint. Its rounded "footprint" leaves enough space at street level for a public square. The façade structure consists of diagonally linked steel elements. Small atria (lightwells) on the exterior spiral upwards along the façade in almost ornamental fashion. Also functioning as balconies, they enable both better lighting for the offices, and most importantly, natural ventilation for them. Thus air-conditioning can be dispensed with for about 40 per cent of the year. The "gherkin", with its aerodynamic shape derived from the procedure known as parametric modelling adopted from the air travel and automotive industry, has also proven its ecological excellence. It directs the up- and down-currents into the circulation of air of the natural ventilation system.

The Swiss Re headquarters is Foster's second organic building in London. Also with his less elegant new building for the Greater London Authority – a tilted egg-shaped solitaire on the South Bank of the Thames west of Tower Bridge – he contributes to the revival of biomorphic-pop architectural sculpture that was introduced by the architectural office Future Systems with the organically shaped media box at Lord's cricket ground. Thanks to new technology, the pop architecture of "swinging London", which existed only on paper more than thirty years ago, has at last found its place in the City.

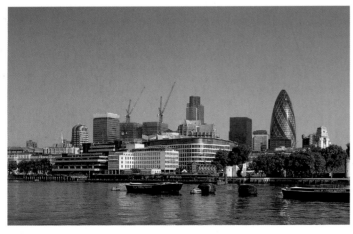

The Swiss Re Headquarters in the London skyline

Sketch by Norman Foster

Exterior view of the high-rise office building

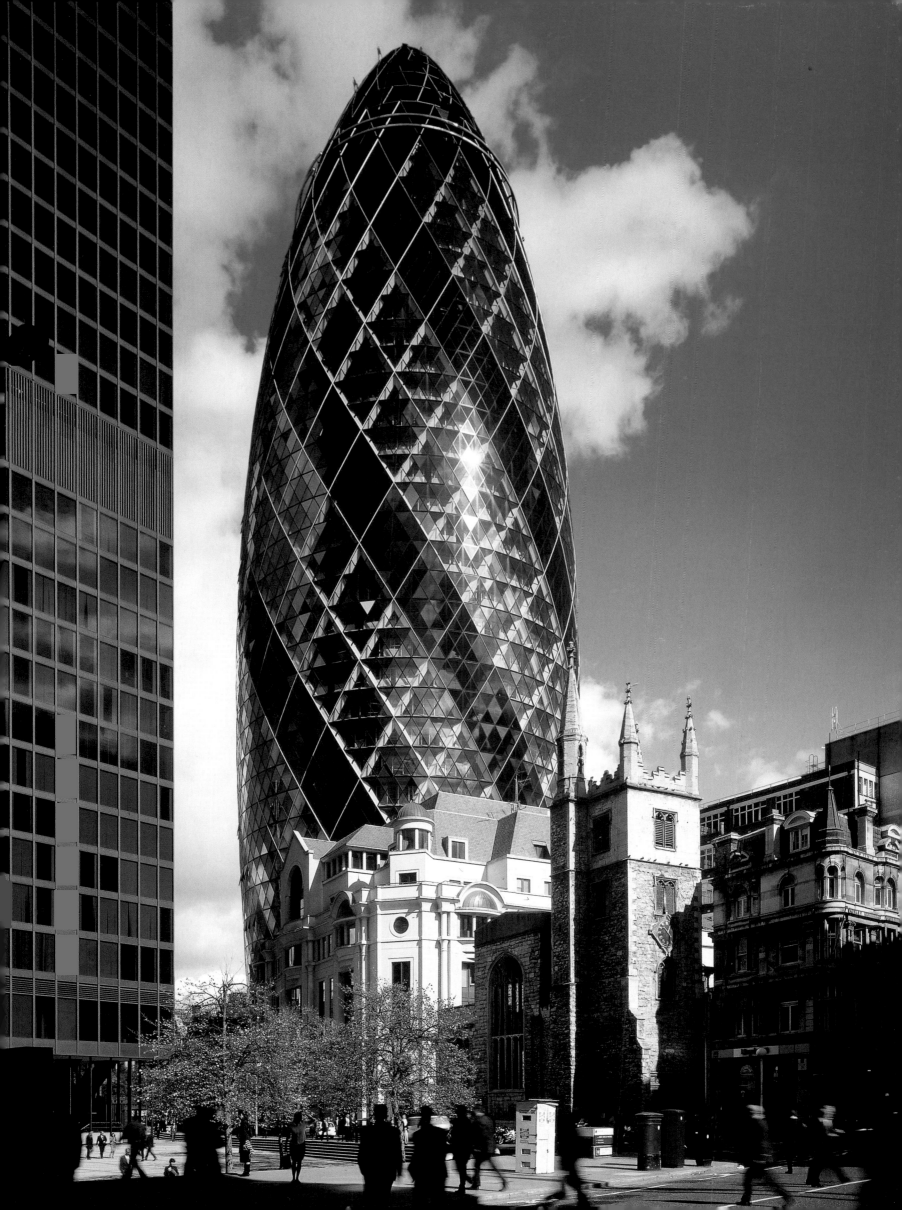

Structural model of the library

Seattle Public Library The inner city of Seattle consists above all of a collection of massive office towers, shoving themselves up a very steep slope in the Waterfront's rectangular network of streets where the arcades of Pike Place Market, piled up one above the other, seem to concentrate the urban life of the city. The new city library occupies a whole downward-sloping block in this office landscape, between Fourth and Fifth Avenue, Spring Street and Madison Avenue. Alongside Frank O. Gehry's Experience Music Project and a museum by Robert Venturi, the Public Library by the star architect Rem Koolhaas now belongs to the few public buildings that oppose the commercial downtown area with urban culture.

A public library, according to the global player Rem Koolhaas from Rotterdam, can play a central role in the information age only if it becomes a multimedia "information department store" and makes all areas of knowledge freely available. The theme of the bizarre crystalline structure – with nevertheless an area of 35,000 square metres – is the presence of the virtual space of electronically transmitted information within actual urban space.

If the Public Library has the effect of a sculpture whose storeys, pushed together, seem to float in the air in violation of all the laws of statics, then this spatial impression is perhaps only a side effect of an idea by Koolhaas according to which we are seeing above all a built diagram. The varying levels, five platforms with transparent distribution levels placed in between, are already encountered by the visitor as he searches the Internet. Here a diagram shows the different media areas with their subdivisions as programme areas, complex networks piled one above the other as clusters. On site this diagram is then encountered as a succession of functional levels bundled into different cubes and transparent areas, which are embedded through impressive staircase structures in a continuous, vertically open space. Public space within a large form as answer to the commercialisation of urban free space: this theme of the architect since the 1970s – which perhaps appears not quite so plausible in the Netherlands – becomes here in downtown Seattle a visible urban intervention.

The diagrammatic legibility of the sculptural city of knowledge comes from its vertical sequence of functions. The base platform, placed on a slope, organises parking on three levels, then service areas and, by now at street level and flooded with light, the children's area. As an entrance area, platform 2 contains the multimedia entertainment, the shops, the administration office, and the lobby as well as the "living room"; platform 3 the electronic area, the recording

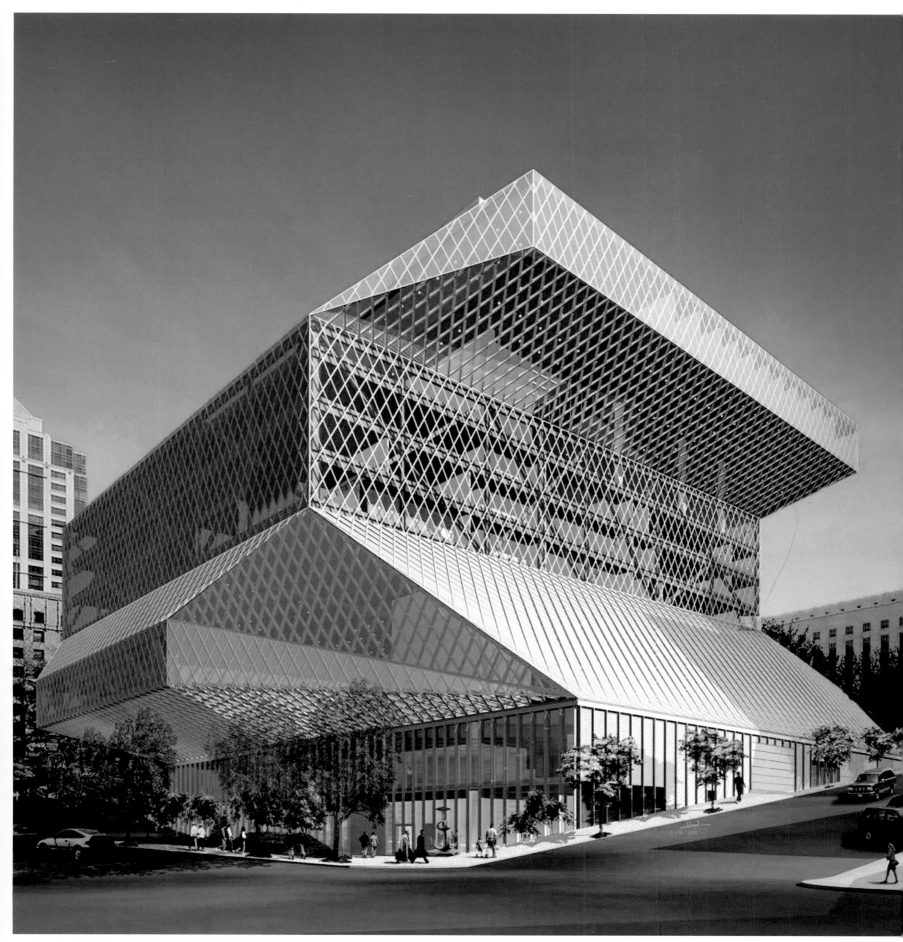

Computer-generated exterior view of the building

Interior views of the library spaces in the model

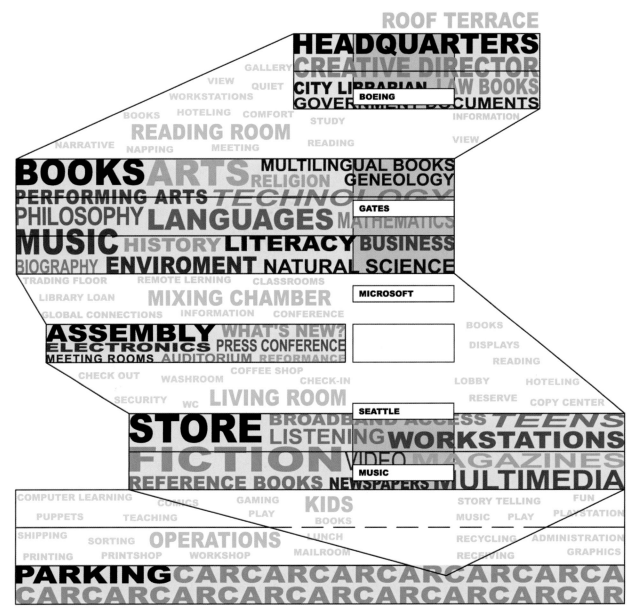

Diagram of the functions of the different areas

studios and the public meeting space. Platform 4 houses the "traditional" realm of books on four levels, and platform 5 contains one level for periodicals, one for staff offices, and is crowned by a dramatically extended roof terrace.

In a masterly achievement by the London engineering studio Ove Arup, the airy intermediate floors as well as the floating platforms of varying size – of which the topmost almost seem to hang in the air – are carried by a few supports and above all by the all-encompassing net of glass and scissors-like interwoven copper rods. The slanted glass fronts give the "urban squares" covering the depth of the building the transparent quality of an exterior space.

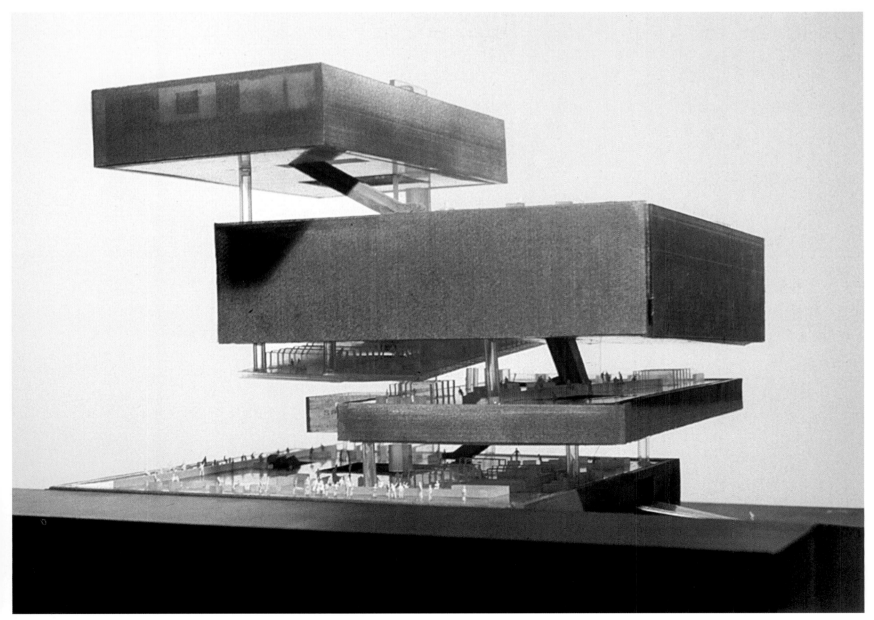

Model with the different platforms and distribution levels

Nelson Atkins Museum of Art, Extension With the Kiasma Museum in Helsinki, opened in 1998, the New York architect Steven Holl was at last able to make his mark in museum architecture. The Museum's strongly sculptural and organic architectural language asserts itself in Helsinki even in its position below the martial neoclassical Parliament building of 1931. The Nelson Atkins Museum in Kansas City, with its three risalite fortified by columns, is another example, if not quite so massive, of traditional monumental architecture. Steven Holl's concept for the new extension, whose opening is planned for 2007, dates from 1999 and building began in 2002. Here too, Holl respects the great gesture of the older building, but in "flattering contrast" (Holl's words) he follows different paths. These lead him into the topography of the large museum garden, a sculpture garden, which he transforms with free forms. Half architecture, half landscape garden, this is a merging of interlinked galleries with the gently downward-sloping lawn surface. Towards the garden, individual tall glass fronts guarantee a transparency almost reminiscent of early modernism. As sculpturally distorted masses of varying height, the underground galleries emerge from the extensive hills in five transparent "lenses". These not only provide lighting for the buried gallery spaces, but also, with their T-shaped construction, supply lasting, energy-saving ventilation and air conditioning. According to Holl, the concept guarantees a "green architecture", not only in the visual sense. At night the lenses, together with the window fronts, transform the sculpture garden into a "meandering light garden" (Holl).

The old main building and the new galleries are reached by way of a three-storey, glazed lobby, the sole occupant of the northern side of the forecourt. The new lobby area directs visitors out of the rigid axiality of the old building into the peripheral new suite of galleries. This

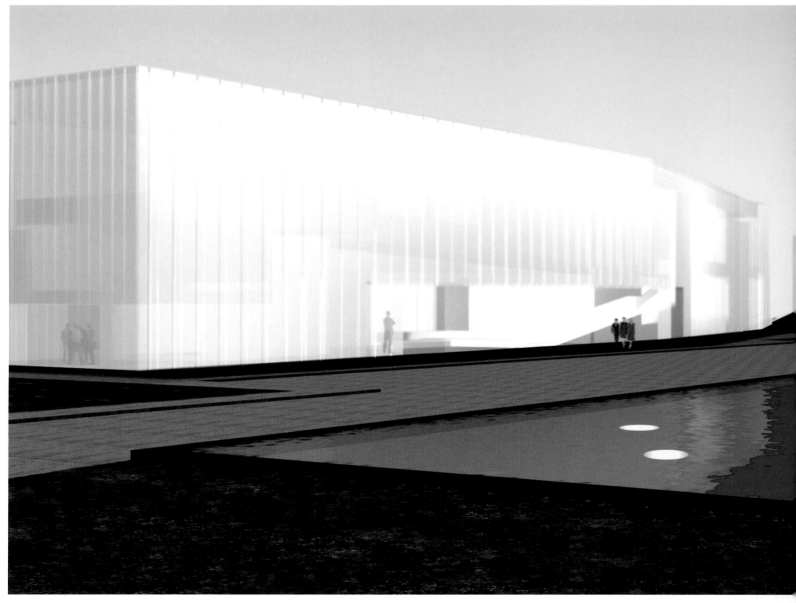

View with the existing museum building and one of the glass "lenses"

Design sketches by Steven Holl

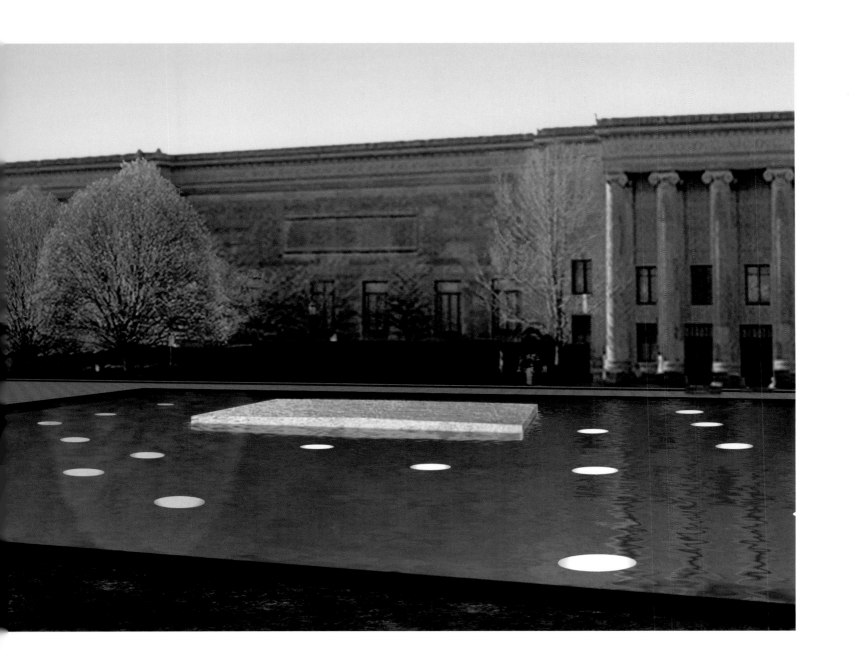

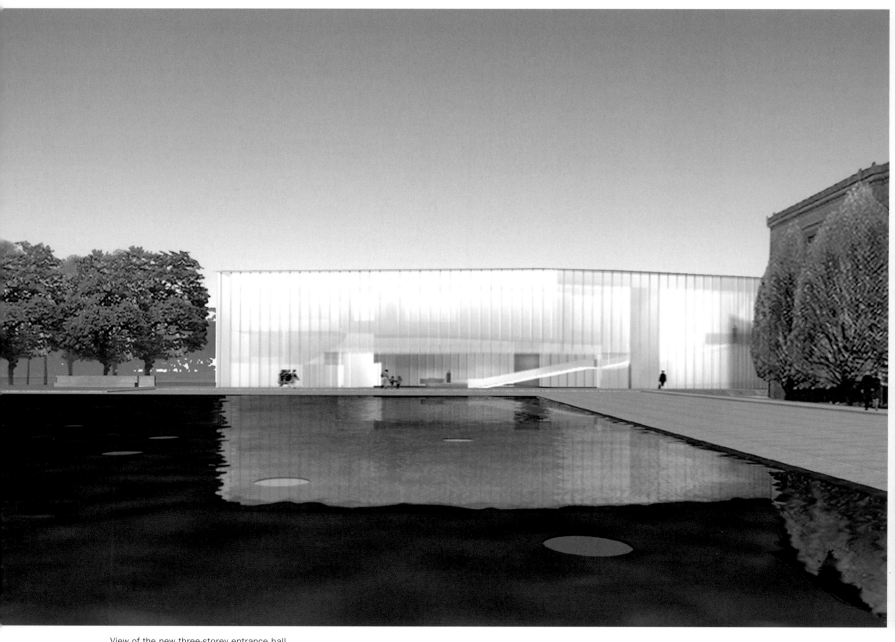

View of the new three-storey entrance hall

entrance hall with its two storeys in fact represents the tallest of the new architectural sculptures, but its height remains lower than the eaves of the neoclassical old building. The forecourt is occupied partly by a rectangular, very shallow water surface, the "reflecting pond". This illusionistic optical strengthening of the new building, slightly shifted out of the axis of the old portal, at the same time forms the ceiling of the underground car park, which is supplied with daylight by special glazing in the floor of the pond.

The glazed lobby building respects the orthogonality of the forecourt, but close to the corner of the main building it is noticeably swung out from the latter's axis, and with its ramp opens up the expressive free sequence of spaces of the extension building. What appears underground to be a space in continuously flowing motion is presented on the above-ground landscape roof as a meandering path into the green. With this totally "non-classical" statement, the design of 1999 takes up an important theme of 1990s architecture: the overcoming of the classical distinction between figure and ground. Architecture becomes an element of topography, of landscape architecture. Unlike many other biomorphic architectures, however, Steven Holl's concept demands no total merging of the two phenomena. His erratic "lenses" further guarantee the continuing sculptural presence of architecture.

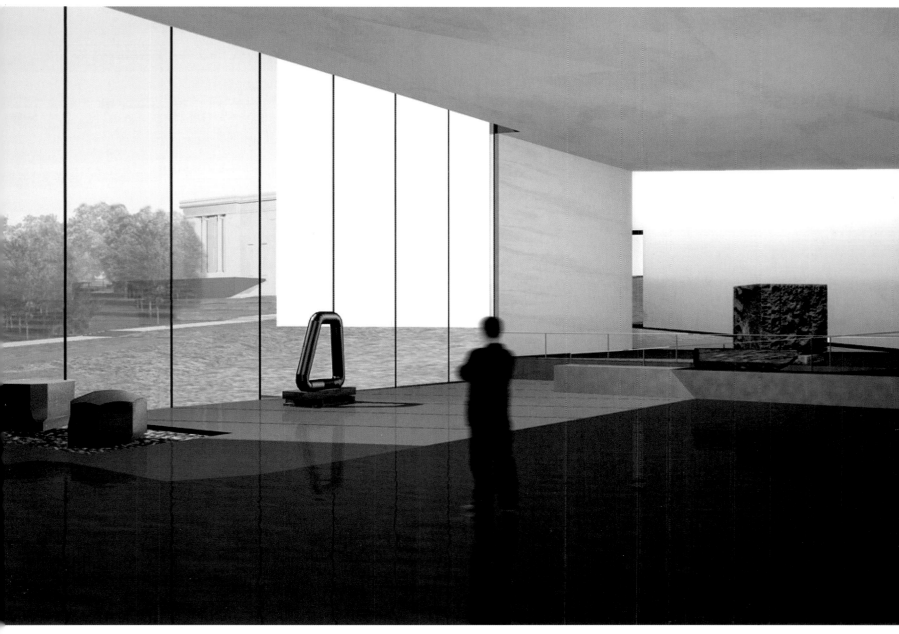

View of the garden from one of the gallery spaces

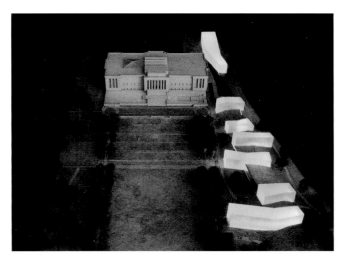

View of the museum extension in the model

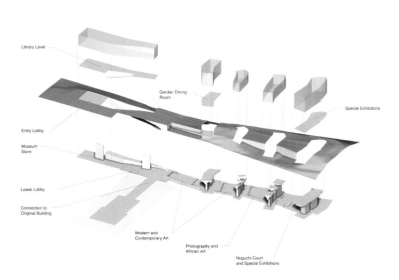

Diagram of the conceptual structure of the new galleries

Appendix

Suggested Reading

General

Aldersey-Williams, Hugh. *Zoomorphic – New Animal Architecture*. London, 2003.

The Changing of the Avant-garde. Visionary Architectural Drawings from the Howard Gilman Collection. Exhibition catalogue, The Museum of Modern Art. New York, 2002.

Dodds, George, and Robert Tavernor, eds. *Body and Building. Essays on the Changing Relationship of Body and Building*. Cambridge, Mass., 2002.

Giedion, Sigfried. *Space, Time and Architecture: The Growth of a New Tradition*. Cambridge, Mass., 1982.

Kostka, Alexandre, and Irving Wohlfarth. *Nietzsche and "An Architecture of Our Minds"*. Los Angeles, 1999.

Machado, Rodolfo, and Rodolphe el-Khoury, eds. *Monolithic Architecture*. Exhibition catalogue, Munich, 1995.

Müller, Ute. *Zwischen Architektur und Skulptur. Eine Untersuchung zur architektonischen Skulptur im 20. Jahrhundert*. Aachen, 1998.

Pehnt, Wolfgang. *Expressionist Architecture*. London, 1973.

Philipp, Klaus Jan. *ArchitekturSkulptur. Die Geschichte einer fruchtbaren Beziehung*. Stuttgart, 2002.

Ragon, Michel. *The Aesthetics of Contemporary Architecture*. Neuchâtel, 1968.

Ruby, Ilka, and Andreas Ruby, Angeli Sachs, Philip Ursprung. *Minimal Architecture*. Munich, 2003.

Schneider, Romana, and Wilfried Wang, eds. *Moderne Architektur in Deutschland 1900–2000. Macht und Monument*. Exhibition catalogue, Deutsches Architektur-Museum, Frankfurt am Main, 1998.

Sonne, Wolfgang. *Representing the State, Capital City Planning in the Early Twentieth Century*. Munich, 2003.

Stock, Wolfgang Jean, ed. *Europäischer Kirchenbau 1950–2000 European Church Architecture*. Munich, 2003.

Utopisches Bauen. Volles Risiko. Architektur als Abenteuer. DU 742 (2003).

Vidler, Anthony. *The Architectural Uncanny. Essays in the Modern Unhomely*. Cambridge, Mass., 1992.

Tadao Ando

Ando, Tadao. *Tadao Ando – Light and Water*. Basel, 2003.

Chow, Phoebe. "Forest Monolith". *Architectural Review* 1199 (1997): 26–30.

Dal Co, Francesco. *Tadao Ando. Complete Works*. London, 1996.

Jodidio, Philip. *Tadao Ando*. Cologne, 1997.

Gottfried Böhm

Gottfried Böhm. a+u 240 (1990).

Pehnt, Wolfgang. *Gottfried Böhm*. Basel, 1999.

Raev, Svetlozar, ed. *Gottfried Böhm: Lectures, Buildings, Projects*. Stuttgart, 1988.

Stock, Wolfgang Jean. *Europäischer Kirchenbau 1950–2000 European Church Architecture*. Munich, 2002.

Mario Botta

Fassoni, Barbara. "La cappella di S. Maria degli Angeli al Monte Tamaro". *Domus* 795 (1997): 14–20.

Jodidio, Philip. *Mario Botta*. Cologne, 1999.

Pizzi, Emilio. *Mario Botta. The Complete Works*. 3 vols. Basel, 1993–1998.

Pozzi, Giovanni. *Mario Botta. Santa Maria degli Angeli sul Monte Tamaro*. Bellinzona, 2001.

Sakellaridou, Irena, ed. *Mario Botta. Architectural Poetics*. London, 2001.

Coop Himmelb(l)au

Newhouse, Victoria. *Towards a New Museum*. New York, 1998.

Vidler, Anthony. *Warped Space. Art, Architecture, and Anxiety in Modern Culture*. Cambridge, Mass., 2000.

Werner, Frank. *Covering and Exposing. The Architecture of Coop Himmelb(l)au*. Basel, 2000.

Santiago Calatrava

Jodidio, Philip. *Santiago Calatrava*. Cologne, 2003.

Seipel, Wilfried. *Santiago Calatrava. Wie ein Vogel/Like a Bird*. Exhibition catalogue, Kunsthistorisches Museum Vienna, Milan, 2003.

Tzonis, Alexander. *Santiago Calatrava. The Poetics of Movement*. London, 1995.

Peter Cook, Colin Fournier

Bogner, Dieter, ed. *Friendly Alien*. Ostfildern-Ruit, 2004.

Feireiss, Kristin, and Hans-Jürgen Commerell, eds. *Curves and Spikes*. Exhibition catalogue, Aedes West Gallery, Berlin, 2003.

Haus der Architektur. *Kunsthaus Graz: Dokumentation eines Wettbewerbs*. Graz, 2003.

Peter Eisenman

Benjamin, Andrew, et al. *Blurred Zones: Investigations of the Interstitial, Eisenman Architects 1988–1998*. New York, 2003.

Newhouse, Victoria. *Towards a New Museum*. New York, 1998.

Tzonis, Alexander, Liane Lefaivre, and Richard Diamond. *Architecture in North America since 1960*. Basel, 1995.

Vidler, Anthony, et al. *Wexner Center for the Visual Arts, Ohio State University: a Building*. New York, 1990.

Wexner Center for the Visual Arts. Architectural Design 11/12 (1989).

Norman Foster

Foster, Norman. *Rebuilding the Reichstag*. London, 2000.

Foster, Norman. *Foster Catalogue 2001*. Munich, 2001.

Glancey, Jonathan. "Space Odyssey". *The Guardian*, 8 December 2003.

Russell, James. "With his sleek, ecological design, Lord Norman Foster imbues the Reichstag with Germany's new self-image". *Architectural Record* 7 (1999) 102–113.

Schulz, Bernhard. *The Reichstag: The Parliament Building by Norman Foster*. Munich, 2000.

Future Systems

"Future Systems. Selfridges Birmingham". *a+u* 9 (2003): 22–27.

Sudjic, Deyan. "Urban Icon". *Domus* 863 (2003): 65–83.

Frank O. Gehry

Filler, Martin. "Gehry's Great Crescendo". *House and Garden* 8 (2003): 217–223, 244.

Filler, Martin. "Victory at Bunker Hill". *New York Review of Books* 16 (2003): 55–60.

Koshalek, Richard, et al. *Symphony: Frank Gehry's Walt Disney Concert Hall*. New York, 2003.

Ragheb, J. Fiona. *Frank Gehry, Architect*. Exhbiton catalogue, Solomon R. Guggenheim Museum, New York, 2001.

Zaha Hadid

Zaha Hadid 1983–1991. El Croquis 52 (1991).

Binet, Hélène, and Zaha Hadid. *Architecture of Zaha Hadid in photographs by Hélène Binet*. Baden, 2000.

Hadid, Zaha, and Aaron Betsky. *The Complete Buildings and Projects*. New York, 1998.

Winter, John. "Provocative Pyrotechnics". *Architectural Review* 1156 (1993): 44–49.

Herzog & de Meuron

Herzog & de Meuron 1998–2002. El Croquis 109/110 (2002).

Machado, Rodolfo, and Rodolphe el-Khoury, eds. *Monolithic Architecture*. Munich, 1995.

Mack, Gerhard. *Herzog & de Meuron, The Complete Works*. 3 vols. Basel, 1996–2000.

Ruby, Ilka, and Andreas Ruby, Angeli Sachs, Philip Ursprung, *Minimal Architecture*. Munich, 2003.

Steven Holl

Architekturzentrum Wien, ed. *Steven Holl: Idea and Phenomena*. Exhibition catalogue, Architekturzentrum Wien, Baden, 2002.

Garofalo, Francesco. *Steven Holl*. London, 2003.

Morris, Alison, and Finlay Lockie. *Next: 8th International Architecture Exhibition 2002*. Exhibition catalogue, Venice, 2002.

Louis I. Kahn

Brownlee, David B., and David G. De Long. *Louis I. Kahn: In the Realm of Architecture*. Exhibition catalogue, Museum of Contemporary Art, Los Angeles, 1991.

Gast, Klaus-Peter. *Louis I. Kahn. Complete Works*. Munich 2001.

Ksiazek, Sarah. "Architectural Culture in the Fifties: Louis I. Kahn and the National Assembly Complex in Dhaka". *Journal of the Society of Architectural Historians* 52 (1993): 416–435.

The Louis I. Kahn Archive. *National Capital of Bangladesh, Dacca*. Vol. 3 of *Personal Drawings*. New York, 1987.

Ronner, Heinz, Sharad Jhaveri, and Alessandro Vasella. *Louis I. Kahn. Complete Works 1935–1974*. Boulder, Colorado, 1977.

Dani Karavan

Restany, Pierre. *Dani Karavan*. Munich, 1992.

Le Corbusier

Boesiger, Willy et al., ed. *The Complete Architectural Works. Le Corbusier and Pierre Jeanneret*. 8 vols. London, 1964–1970.

Nerdinger, Wilfried. "Architecture is Movement. Le Corbusier's Sacred Buildings". In *Europäischer Kirchenbau/European Church Architecture 1950–2000*, edited by Wolfgang Jean Stock. Munich, 2003.

Pauly, Danièle. *Le Corbusier: La Chapelle de Ronchamp/The Chapel at Ronchamp*. Paris, 1997.

Petit, Jean. *Le livre de Ronchamp*. Paris, 1961.

Purdy, Martin. "Le Corbusier and the Theological Program". In *The Open Hand. Essays on Le Corbusier*, edited by Russel Walden. Cambridge, Mass., 1977.

Tzonis, Alexander. *Le Corbusier, The Poetics of Machine and Metaphor*. London, 2001.

Daniel Libeskind

Lampugnani, Vittorio Magnago, and Angeli Sachs, eds. *Museums for a New Millenium*. Munich, 1999.

Libeskind, Daniel. *The Space of Encounter*. New York 2000.

Schneider, Bernhard. *Daniel Libeskind. Jewish Museum Berlin*. Munich, 1999.

Spens, Michael. "Berlin Phoenix. Jewish Museum, Berlin, Germany". *Architectural Review* (April 1999): 40–47.

Fumihiko Maki

Maki, Fumihiko. "Kaze-No-Oka Crematorium". *Architectural Design* 3/4 (1997): 22–25.

Maki, Fumihiko. "Il Crematorio Kaze-No-Oka a Nakatsu. Retour à l'ordre – moderatamente". *Casabella* 658 (1998): 4–11.

Maki, Fumihiko. *Fumihiko Maki: Buildings and Projects*. New York, 1997.

Pollock, Naomi R. "Kaze-No-Oka Crematorium". *Architectural Record* 2 (1998): 92–99.

Taylor, Jennifer, and James Conner, eds. *The Architecture of Fumihiko Maki: Space, City, Order and Making*. Basel, 2003.

José Rafael Moneo

Construction dossier Kursaal. Tectonica 2 (2000).

Rafael Moneo 1995–2000. El Croquis 98 (2000).

Cohn, David. *Moneo's Centro Kursaal. Architectural Record* 188 (2000): 212–223.

Eric Owen Moss

"The Box, Culver City, California 1990–1994". *a+u* 2 (1994): 84–91.

Cohen, Preston Scott, and Brooke Hodge, eds. *Eric Owen Moss. The Box*. Cambridge, Mass., 1995.

Jodidio, Philip. *Contemporary California Architects*. Cologne, 1995.

Moss, Eric Owen. *Eric Owen Moss: Buildings and Projects*. 3 vols. New York, 1991–2002.

Oscar Niemeyer

Evenson, Norma. *Two Brazilian Capitals. Architecture and Urbanism in Rio de Janeiro and Brasília*. New Haven, 1973.

Fils, Alexander, ed. *Brasilia. Moderne Architektur in Brasilien*. Düsseldorf 1988.

Flagge, Ingeborg, ed. *Oscar Niemeyer. A Legend of Modernism*. Exhibition catalogue, Deutsches Architektur-Museum Frankfurt am Main, 2003.

Underwood, David. *Niemeyer and the Architecture of Brazil*. New York, 1994.

OMA Office for Metropolitan Architecture

OMA@work 1972–2000. a+u, 2000

Bush, James. "The Art of Being Rem". *Seattle Weekly*, 20–26 July, 2000.

Koolhaas, Rem. *Content*. Exhibition catalogue, Cologne, 2004.

Koolhaas, Rem. "Transformation into an Information Storehouse, Seattle Public Library". *Archithese* 1/2 (2000): 46–49.

Olson, Sheri. "Rem Koolhaas' Central Library". *Architectural Record* 8 (2000): 120–125.

I. M. Pei
Boehm, Gero von. *Conversations with I.M. Pei*. Munich, 2000.
Fish, Marilyn B. "East Building, National Gallery of Art". In *The Critical Edge,
Controversy in Recent American Architecture*, edited by Tod A. Marder.
Cambridge, Mass., 1985.
Wiseman, Carter. *The Architecture of I.M. Pei*. London, 2001.
Wiseman, Carter. *I.M. Pei: A Profile in American Architecture*. New York, 2001.

Renzo Piano
Buchanan, Peter. *Renzo Piano Building Workshop. Complete Works*. 4 vols.
London, 1993–2000.
Buchanan, Peter. "Titanic Triumph". *Architectural Review* 1210 (1997): 54–58
Tzonis, Alexander, and Liane Lefaivre. *Architecture in Europe since 1968*.
London, 1992.
Pizzi, Emilio. *Renzo Piano*. Basel, 2002.
Silver, Nathan. *The Making of Beaubourg. A Building Biography of the Centre
Pompidou, Paris*. Cambridge, Mass., 1994.

Christian de Portzamparc
Croisé, Espace, ed. *Euralille – the Making of a New City Center*. Basel, 1996.
Jacques, Michel, and Armelle Lavalou. *Christian de Portzamparc*. Bordeaux,
1996.

Richard Rogers
Burdett, Richard, ed. *Richard Rogers Partnership. Works and Projects*. New York,
1996.
Silver, Nathan. *The Making of Beaubourg. A Building Biography of the Centre
Pompidou, Paris*. Cambridge, Mass., 1994.
Tzonis, Alexander, and Liane Lefaivre. *Architecture in Europe since 1968*.
London, 1992.

Aldo Rossi
Braghieri, Gianni. *Aldo Rossi*. Zurich, 1993.
Geisert, Helmut, and Hans G. Hannesen, eds. *Aldo Rossi. Architect*. London,
1994.
Johnson, Eugene J. "What Remains of Man – Aldo Rossi's Modena Cemetery".
Journal of the Society of Architectural Historians 1 (1982): 38–54.
Moneo, Rafael. "Aldo Rossi: The Idea of Architecture and the Modena Cemetery"
Oppositions (Summer 1976): 1–21.
Tzonis, Alexander, and Liane Lefaivre. *Architecture in Europe since 1968*.
London, 1992.

Moshe Safdie
Moshe Safdie: Museum Architecture 1971—1998. Exhibition catalogue, The
Genia Schreiber University Art Gallery, Tel Aviv, 1998.
Kohn, Wendy. *Moshe Safdie*. London, 1996.

Sauerbruch Hutton Architects
Förster, York. "Experimental Factory, Magdeburg". In *DAM Jahrbuch 2002:
Architektur in Deutschland/Architecture in Germany*, edited by Ingeborg Flagge,
Peter Cachola Schmal, Wolfgang Voigt. Munich, 2002.
Mostaedi, Arian. *Factories and Office Buildings*. Barcelona, 2003.
Rappaport, Nina. "Sauerbruch and Hutton rolling out a Bright Wrapper for the
Experimental Factory". *Architectural Record* 6 (2001): 108–113.
Sauerbruch Hutton Architects 1997–2003. El Croquis 114 (2003).
Slessor, Catherine. "Polychrome Experiment". *Architectural Review* 1259 (2002):
60–63.

Hans Scharoun
Bürkle, J. Christoph. *Hans Scharoun*. Zurich, 1993.
Jones, Peter Blundell. *Hans Scharoun*. London, 1995.
Pfankuch, Peter, ed. *Hans Scharoun, Bauten, Entwürfe, Texte*. Schriftenreihe der
Akademie der Künste, vol. 10. Berlin, 1993.
Sasaki, Hiroshi. *Hans Scharoun: The Berlin Philharmonic Concert Hall, Berlin,
West Germany. 1956, 1960–63*. Tokyo, 1973.

Álvaro Siza Vieira
Frampton, Kenneth. *Álvaro Siza. Complete Works*. London, 2000.
Jodido, Philip. *Álvaro Siza*. Cologne, 1999.
Lampugnani, Vittorio Magnago, and Angeli Sachs, eds. *Museums for a New
Millenium*. Munich, 1999.

Kenzo Tange
"Tokyo Duomo". *Architectural Review* 824 (1965): 10f.
Kultermann, Udo, ed. *Kenzo Tange 1946–1969: Architecture and Urban Design*.
Zurich, 1970.
Tange, Kenzo, and Udo Kultermann. *Kenzo Tange: Works and Projects*. Barcelona,
1989.

Simon Ungers, Tom Kinslow
Stein, Karen D. "Suit to a T". *Architectural Record* 4 (1994): 90–95.
Thompson, Jessica Cargill. *40 Architects under 40*. Cologne, 2000.
Ubach, Henry, and Gustau G. Galfetti. *Simon Ungers*. Barcelona, 1998.

UN Studio
Cleef, Connie van. "Radical Domesticity". *Architectural Review* 1231 (1999):
47–51.
Thompson, Jessica Cargill. *40 Architects under 40*. Cologne, 2000.
Wigley, Mark, and Aaron Betsky. *Unfolded*, Rotterdam, 2002.

Jørn Utzon
Drew, Philip. *The Third Generation: Changing Meaning in Architecture*. London,
1972.
Fromonot, Françoise. *Jørn Utzon: the Sydney Opera House*. Corte Madera, CA,
1998.
Giedion, Sigfried. *Space, Time and Architecture: The Growth of a New Tradition*.
Cambridge, Mass., 1982.
Utzon, Jørn. "The Sydney Opera House. What Happened and Why". *Architectural
Record* 5 (1967): 189–192.
Weston, Richard. *Utzon. Inspiration, Vision, Architecture*. Hellerup, 2002.
Wilson, Forrest. "The Sydney Opera House. A Survivor". *Architecture* 78 (1989):
103–110.

Wandel Hoefer Lorch + Hirsch
Cohn, David. "Dresden Synagogue". *Architectural Record* 6 (2002): 102–107.
Leydecker, Karin. "New Synagogue, Dresden". In *DAM Jahrbuch 2002:
Architektur in Deutschland/Architecture in Germany*, edited by Ingeborg Flagge,
Peter Cachola Schmal, Wolfgang Voigt. Munich, 2002.
Long, Kieran. "Out of the Ashes". *World Architecture* (March 2002): 26–33.
Schwarz, Ulrich, ed. *New German Architecture. A Reflexive Modernism*. Ostfildern-
Ruit, 2002.

Makoto Sei Watanabe
"Tombstone for a boom town". *World Architecture* 55 (1994): 124f.
The Japan Architect. *Yearbook 1997. Japanese Architectural Scene in 1997*.
Tokyo, 1998.
Wilquin, Hugues. *Aluminium Architecture, Construction and Details*. Basel, 2001.

Frank Lloyd Wright
Boulton, Alexander O. *Frank Lloyd Wright, Architect*. New York, 1993.
Curtis, William J. R. *Modern Architecture since 1900*. Oxford, 1982.
Jordy, William H., and William H. Pierson. *The Impact of European Modernism in
the Midtwentieth Century*, vol. 5 of *American Buildings and their Architects*.
New York, 1972.
Levine, Neil. *The Architecture of Frank Lloyd Wright*. Princeton, 1996.
Riley, Terence, and Peter Reed, eds. *Frank Lloyd Wright, Architect*. Exhibition cata-
logue, The Museum of Modern Art, New York, 1994.
Twombley, Robert C. *Frank Lloyd Wright. His Life and His Architecture*. New York,
1979.

Illustration Credits

Every effort has been made by the Publisher to acknowledge all sources and copyright holders. In the event of any copyright holder being inadvertently omitted, please contact the Publisher directly.

Our special thanks to the architects who made illustrative material available for this publication.

Numbers refer to pages (t=top, b=bottom, l=left, r=right, c=centre).

Stiftung Archiv der Akademie der Künste, Berlin: 20, 44 t

Tadao Ando Architect & Associates, Osaka: 76 t, 77 b

Tono Arias, Santiago de Compostela: 70 c

artur, Cologne: Archiv Archipress 85; Damien Chelnec/Archiv Archipress 53 t; Peter Cook/View 62 c l; Michel Denané/Archiv Archipress 54 t; Klaus Frahm 104 t r; Richard Glover/View 32/33; Reinhard Görner 45; Roland Halbe 7 l, 23 l, 70 b, 102/103, 104/105, 106 t, 107, 121 t, b l, b c; Hufton+Crow/ View *frontispiece*, 118/119, 121 b r; Werner Huthmacher 113; Wolfram Janzer 64 r, 65; Monika Nikolic 124 t r, b r, 125; Barbara Oppitz/Monheim 7 r; Paul Raftery/View 124 b l; Tomas Riehle 23 r; Dirk Robbers 72/73; Sebastian Schobert 108; Jörg Schöner 43 t; Nathan Willock/View 122 c l, b, 123

Achim Bednorz, Cologne: 25, 34/35, 36 t, 51 t, b l, b r, 110/111

Bilderberg, Hamburg: Ernsting 52; Horacek 55; Mere 42 b r; Zielske 44 b r

Bitter & Bredt, Berlin: 104 t l, 105 t r

Gottfried Böhm, Cologne: 50

Architetto Mario Botta, Lugano: 88 t

British Cement Association: 21

Tom Bronner, Santa Monica, CA: 78 b l, b r

Tilmann Buddensieg, Sinzig: 17

Santiago Calatrava SA, Zurich: 101 b

Enrico Cano: 88 b l, b r, 89

Chicago Historical Society: 18 t

Peter Cook, London: 124 t l

Coop Himmelb(l)au, Vienna: 82 t

William Curtis: 29 t l

Peter Eisenman Architects, New York: 30 b r, 66 t

Gerrit Engels, Berlin: 114/115, 116 c, b, 116/117

Esto, Mamaroneck, NY: Jeff Goldberg 66 b, 67 l, r; Roberto Schezen 60, 61, 63; Ezra Stoller 29 b, 39, 56 t

Norman Foster, London: 109 c, b, 128 b r

Allen Freeman, Washington, DC: 57

Michael Freeman, London: 38 c, 40

Future Systems, London: 122 t, c r

Gehry Partners, LLP, Los Angeles: 118, 120

Glasgow School of Art: 18 b

Zaha Hadid Architects, London: 30 b l, 72, 74 c r

Ardon Bar Hama: 127 t, b l, b r

David Heald, © The Solomon R. Guggenheim Foundation, New York: 38 t

Steven Holl Architects, New York: 134,135,136,137

Eduard Hueber, New York: 69

IFA Bilderteam, Ottobrunn: KHJ 42 b l

Kathleen James: 26

Louis I. Kahn Collection, University of Pennsylvania and Pennsylvania Historical and Museum Commission, © 1977: 62 c r, b

Toshiharu Kitajima, Tokyo: 96/97, 97 b l, b r

laif, Cologne: Langrock/Zenit 44 b l

Fondation Le Corbusier: 37

Daniel Libeskind, New York: 102, 104 b, 105 b

Maki and Associates, Tokyo: 96 t, b

Duccio Malagamba, Barcelona: 106 b r

Mitsuo Matsuoka: 76 c, b

Norbert Miguletz, Frankfurt/Main: 112 l, r

José Rafael Moneo Architecto, Madrid: 106 b l

Eric Owen Moss Architects, Culver City, CA: 78 t, 79 t, b

Studio Murai, Tokyo: 46 t, b

The Museum of Modern Art, New York, © 2003: 64 l

John Nicolai/Courtesy of Pei Cobb Freed & Partners, New York: 59 t

Oscar Niemeyer, Rio de Janeiro: 42 t

Office for Metropolitan Architecture, Rotterdam: 31, 130, 131, 132, 133

Shigeo Ogawa/Shinkenchiku-sha, Tokyo: 77 t

Courtesy of Pei Cobb Freed & Partners, New York: 29 t r, 56 b, 58, 59 b

Renzo Piano Building Workshop, Genoa: 54 b l, 95

Atelier Christian de Portzamparc, Paris: 84

Christian Richters, Münster: 74 t, c l, 75, 80/81, 83, 94/95, 99 t, b l, 100/101

Juan Rodriguez, A Coruña: 71

Richard Rogers Partnership, London: 54 b r

David Rubinger, Jerusalem: 48, 48/49, 49

Moshe Safdie and Associates, Somerville, MA: 126

Sauerbruch Hutton Architects, Berlin: 114 t, 116 t

Photo Scala, Florence/The Museum of Modern Art, New York, © 2003: 30 t

Shokokusha Pub. Co., Tokyo: 47

Álvaro Siza Vieira, Porto: 70 t

Margherita Spiluttini, Vienna: 36 b, 82 b l, b r, 86/87

Staatliche Museen zu Berlin, Kunstbibliothek: Jörg P. Anders/ bpk 2004 22 l, r

Oswald Mathias Ungers, Cologne: 28

Simon Ungers, Cologne: 68

UN Studio, Amsterdam: 98, 99 b r

Jørn Utzon, Haarby: 53 c l, c r

visum, Hamburg: Rudi Meisel 109 t

Wandel Hoefer Lorch, Saarbrücken: 110, 111 b

Makoto Sei Watanabe, Tokyo: *cover*, 90/91, 92, 93

Frank Lloyd Wright Foundation, Scottsdale, AZ: 41 c, b

Nigel Yong/Foster and Partners: 128 t, 128 b l, 129

Front cover: Makoto Sei Watanabe, K-Museum, Tokyo.
Photograph by Makoto Sei Watanabe, see pp. 90–93.
Frontispiece: Frank O. Gehry, Walt Disney Concert Hall
Los Angeles, detail of façade. Photograph by Hufton + Crow,
artur/View, see pp. 118–121.
Pages 32/33: Jørn Utzon, Opera House, Sydney, detail of roof.
Photograph by Richard Glover, artur/View, see pp. 52/53.

Prestel Verlag
Königinstrasse 9
80539 Munich
Tel. +49 (89) 38 17 09-0
Fax +49 (89) 38 17 09-35
www.prestel.de

Prestel Publishing Ltd.
4, Bloomsbury Place
London WC1A 2QA
Tel. +44 (20) 73 23-5004
Fax +44 (20) 76 36-8004

Prestel Publishing
900 Broadway, Suite 603
New York, NY 10003
Tel. +1 (212) 995-2720
Fax +1 (212) 995-2733
www.prestel.com

The Library of Congress Control Number: 2004101169

The Deutsche Bibliothek holds a record of this publication
in the Deutsche Nationalbibliografie;
detailed bibliographical data can be found under http://dnb.ddb.de

Prestel books are available worldwide.
Please contact your nearest bookseller or one of
the above addresses for information concerning
your local distributor.

Translated from the German by Christine Shuttleworth, London

Editorial direction by Angeli Sachs, Sandra Leitte
Copyedited by Cynthia Hall, Rosenheim
Picture research by Sandra Leitte, Charlotte Wilson

Design and layout by Meike Sellier, Munich
Origination by ReproLine Genceller, Munich
Printing by Aumüller, Regensburg
Binding by Conzella, Pfarrkirchen

Printed in Germany on acid-free paper

ISBN 3-7913-3037-3